20TH CENTURY WOMEN SERIES

The Remarkable Lives of
100 WOMEN WRITERS and JOURNALISTS

BROOKE BAILEY

Additional Text Material: Brandon Toropov

BOB ADAMS, INC.
Holbrook, Massachusetts

For my mother, who taught me to write.

Acknowledgments

Thanks are due to Brandon Toropov, Diane Freed, Peter Gouck, and Chris Ciaschini for their input and patience. Susan Robinson's unflagging enthusiasm and effort was a major boost to this project. Rob Oppenheim and John Oakes helped with computer crises. Kara Berdik and Rick Dey deserve mention for their help with individual entries.

The collections of the Boston and Cambridge Public Libraries and the Harvard-Radcliffe library system—particularly the Schlesinger Library—were instrumental in the research for this book.

Special thanks go to Cristina Paglinauan, Rachel Lewis, Todd Bourell, and my family for their support and aid in research.

Published by Bob Adams, Inc., 260 Center Street, Holbrook, MA 02343

ISBN: 1-55850-423-0

Printed in the United States of America.

J I H G F E D C B A

Library of Congress Cataloging-in-Publication Data
Bailey, Brooke.
 The remarkable lives of 100 women writers and journalists / Brooke Bailey.
 p. cm.
 Includes bibliographical references and index.
 ISBN 1-55850-423-0
 1. Women authors—Biography. 2. Women journalists—Biography. I. Title. II. Title: Remarkable lives of one hundred women writers and journalists. III. Series.
 PN471.B35 1994
 810.9'9287'0904—dc20 94-24287
 [B] CIP

Cover Painting: Leonid Mysakov/Irmeli Holmberg Representative

This book is available at quantity discounts for bulk purchases. For information, call 1-800-872-5627.

Introduction

What would happen if one woman told the truth about her life? The world would split apart.

—Muriel Rukeyser

The profiles here are intended as introductions to the lives of some American women who spent good chunks of their lives capturing the world in short stories, plays, print media, novels, screenplays, and poetry.

The motives behind the work they left us were as diverse as the women themselves. Some, Like Ida Minerva Tarbell and Lorraine Hansberry, were driven by causes that were dear to them. Some, like Margaret Bourke-White, were moved to bring us the world in pictures instead of words. And some, like Anne Sexton, seemed driven to use poetry as an outlet for highly subjective visions and experiences.

Most of the women included here left behind gifts that can be found in good libraries. Some of the women are no doubt quite familiar, and some are probably new to you. Some of the works cited will be easier to find than others. But all the stories told between these covers are worth knowing. These are not the only 100 women who could have been selected, but they are the ones who seemed to me likely to offer the most rewarding reading.

In assembling this book, I was struck by two things: the sheer diversity of the experiences of these women, and the fascinating new details that materialized even in the lives of the most well-known women. In the end, producing this volume was a great voyage of discovery for me; may reading it offer you the chance to embark on a fascinating journey of your own.

A word of warning: There is a lot of truth here. If the world seems to split apart around many of these outspoken women, as Rukeyser predicts it will in such a situation, perhaps time will prove that the disintegration was not just the end of an old way of life, but also the beginning of a new one.

—Brooke Bailey

Margaret C. Anderson, 1886–1973

Even as a young woman struggling to support herself in a Chicago bookstore, Margaret Anderson lived with style. As it happened, she worked in a bookstore in a building that had been designed by cutting-edge architect Frank Lloyd Wright. But the stylish thing she most wanted was stimulating conversation, and when it did not materialize for her, she founded the visionary literary magazine *The Little Review*. Contributors to the magazine over the years included Ernest Hemingway, Jean Cocteau, James Joyce, **Amy Lowell**, T.S. Eliot, **Gertrude Stein**, William Butler Yeats, William Carlos Williams, and **Djuna Barnes.**

Anderson escaped her Columbus, Indiana home for Chicago when she was twenty. Home had been comfortable but boring—Anderson craved sharp-edged, competitive conversation, and she hoped to find it in the big city. In addition to clerking at the bookstore, which was housed in the Fine Arts Building, Anderson wrote book reviews for the Chicago *Evening Post* and a religious magazine, *Continent.* Around the beginning of 1914, she gave Theodore Dreiser's novel *Sister Carrie* a positive review. The magazine's editor considered *Sister Carrie* an immoral book, and Anderson lost her promising position with the *Continent.*

With characteristic drive, Margaret Anderson quickly turned this disappointment around. Since she could not speak her peace in someone else's publication, she started her own. With a year's funding from a benefactor and an office in the Fine Arts Building, the first issue of *The Little Review* came out in March of 1914. Within two years it had attracted the support and contributions of Chicago leading lights Frank Lloyd Wright and Emma Goldman.

Anderson had started *The Little Review* to create "good conversation," and soon its pages held some of the best. Many of the magazine's now-legendary contributors were having trouble placing work. In 1918,

after the magazine had moved to New York and Ezra Pound joined the staff as European editor, *The Little Review* began a three-year serialization of James Joyce's masterpiece, *Ulysses*. Not only was *Ulysses* not popularly appreciated, it was then considered scandalous, and in 1920 Anderson and associate editor Jane Heap were convicted of violating obscenity laws and fined $100.

Whenever Anderson felt that her magazine was stagnating, she found a way to shake things up. The September 1916 issue consisted of sixty-four blank pages and a printed statement declaring that since nothing worthy of inclusion was being written at the moment, nothing would be printed. In the early twenties, Anderson began to lose interest in the idea of the magazine. In 1929 the last issue, consisting entirely of artists' responses to a questionnaire about their feelings about art, was published. Respondents included **H. D.**, Jean Cocteau, Edith Sitwell, **Marianne Moore**, and William Carlos Williams.

The same restlessness that had driven the originality of *The Little Review* made Anderson's later years somewhat unsettled. Twenty happy if financially precarious years

> *One magazine had 64 blank pages and a statement declaring that since nothing worthy of inclusion was being written at the moment, nothing would be printed.*

in France with the great love of her life, singer and actress Georgette Leblanc, ended in 1941 with Leblanc's death of cancer. She sought peace and spiritual knowledge in the teachings of the mystic George Gurdjieff, and was comforted by the friendship of Dorothy Caruso (the wife of singer Enrico Caruso). She retired to LeCannet (near Cannes) in 1961 and lived there until her death twelve years later at the age of eighty-six.

TO FIND OUT MORE...

- Anderson, Margaret C. *The Fiery Fountains; The Autobiography: Continuation and Crisis to 1950.* New York: Horizon Press, 1969.

- Anderson, Margaret C. *My Thirty Years' War; The Autobiography: Beginnings and Battles to 1930.* New York: Covici, Friede, 1930.

- Rood, Karen Lane, ed. *Dictionary of Literary Biography: Volume Four. American Writers in Paris, 1920–1939.* Detroit, Michigan: Gale Research Company, 1980.

Gertrude Franklin Horn Atherton, 1857–1948

Novelist Gertrude Atherton first caught the attention of American readers by shocking them. Her heroines were never the self-effacing types in favor at the turn of the century; they defied convention at every turn, enjoying sexual affairs outside of marriage and speaking their minds forcefully. American critics lambasted her works for their "immorality." People bought them in spite of (or perhaps because of) the furor they caused in critical circles.

Atherton's cool, collected heroines, unassailable and of superhuman beauty and intelligence, exhibited an unheard-of sexual independence. When Atherton established herself in American literary circles by making a name for herself in England, she was able to popularize a new vision of womanhood that was diametrically opposed to the self-effacing ideals that had so confined her.

She had learned to distrust marriage at an early age. Her parents, Gertrude (Franklin) and Thomas Horn, were San Francisco socialites woefully unprepared for either marriage or parenthood. They squabbled bitterly, but lavished huge amounts of love and attention on their young daughter. When Gertrude was still a child, Mrs. Horn gained the odd distinction of becoming the first socially prominent San Francisco woman to file for divorce.

At eighteen, Gertrude fell in love with a man who was six years her senior and one of her own mother's suitors, then entered into a disastrous marriage with him. George Atherton came from a socially conscious conservative Catholic family that was profoundly shocked to learn that much of the material in Gertrude's first novel, *The Randolphs of Redwoods,* was based on the Atherton family. (They apparently found the love scenes equally appalling.) When George died from a morphine overdose, Gertrude fled to New York City to write, leaving her young daughter with her stern mother-in-law.

Gertrude Atherton never remarried, but pursued a series of affairs. This choice was

to be reflected in her 1899 novel *Hermia Suydam*, in which Hermia, the heroine, gains a raft of suitors when she reshapes her face with plastic surgery. Suddenly faced with many offers of marriage, Hermia determines instead to simply enjoy the men without commitment. The nation's reviewers were horrified. One went so far as to consult "eight learned doctors of letters," reporting the each and every one of them agreed that *Hermia Suydam* was "the most immoral novel in the English language."

Her newly adopted home city of London, however, loved her. Atherton found herself the audacious American woman whose freely dispensed witticisms enlivened fashionable parties; she was accepted into the toniest circles and well received by the critics. Encouraged, Atherton wrote novels about America, including a love story set on a California ranch (*Los Cerritos*, 1890) and an intrigue based on a notorious murder in New York in which a fed-up wife had poisoned her husband (*Patience Sparhawk and Her Times*, 1897). Her social satire *Aristocrats* (1901) gleefully skewered American celebrities in the letters of a visiting Englishwoman. Published pseudonymously, the novel was an enormous success. Specu-

> *It was rumored that Atherton took a lover for each book she wrote, gaining energy and inspiration from each affair.*

lation on the identity of the book's author was intense (some were convinced it was Oscar Wilde); when the book was near the height of its popularity, Atherton had the pleasure of revealing herself as its writer.

It was rumored in Atherton's youth that she took a lover for each book she wrote, gaining energy and inspiration from each affair. Her career ran for six decades; she completed fifty-six books and pioneered a popular new form, the fictionalized biography.

To the end, Atherton was as unconfined by social restraints as her heroines. In her seventies, she settled in San Francisco, where she ran a literary salon and lived with her widowed daughter Muriel. She never stopped writing—indeed, she never slowed down—until her death at the age of ninety. Her last published piece was a letter nominating Eleanor Roosevelt for president; it was published in the *San Francisco News*.

TO FIND OUT MORE...

- Atherton, Gertrude. *Adventures of a Novelist.* New York: Blue Ribbon Books, 1932.

- Richey, Elinor. *Eminent Women of the West.* Berkeley, CA: Howell-North Books, 1975.

Mary Hunter Austin, 1868–1934

M ary Austin found her home—and her lifelong literary subject—in the Southwest. Her best writing explores the desert landscape she loved, which was to her a place of mystical "intimate immensity." In her spiritual, passionate descriptions of the desert, she often seems to be talking about herself.

Austin did not find the desert until she was twenty. The first two decades of her life were spent in Carlinville, Illinois, where she passed a difficult childhood and adolescence. When she was barely ten years old, her beloved father, a lawyer and voracious reader, died, followed closely by her favorite sister Jeannie. Mary was devastated. Mary had been her father's favorite, and without him and Jeannie she was friendless, for her mother concentrated her affection on Mary's older brother.

She turned inward for solace. She began to write poetry that year, and developed an ability to work with fierce intensity. Later, she was sometimes able to put herself into a sort of writing trance, producing stories at incredible speed. Her ardor helped her to excel in school. She completed her bachelor's degree in two and a half years, studying science and math despite her ambition to be a writer. "I told the head of the English Department flatly that as I expected to write and as he obviously couldn't, I did not propose to study under him," she wrote in a 1910 letter, "so I had all the science I could cram."

Upon her graduation in 1888, Mary and her family moved to California, where they took up residence at the verge of the San Joaquin Valley. Mary taught school until she married Stafford Wallace Austin in 1891. The marriage turned out sadly. Their daughter Ruth was born mentally retarded, a condition Mary was later convinced was caused by her husband's hereditary venereal disease. Mary Austin cared for the girl as well as she could, but when Ruth died in an institution in 1918, she expressed relief along with her grief, writing that she was glad

Ruth had not outlived those who loved her best. Within four years of the wedding, Mary Austin was spending extended periods of time away from her husband. He filed for divorce in 1914.

Mary Austin had experienced modest success placing stories in magazines, and in 1903 published a collection of desert sketches, *The Land of Little Rain*, which is still considered a classic. She moved to Carmel, California, where she joined a group of writers including Jack London and Ambrose Bierce and began to produce books at a rapid pace. A breast cancer scare around 1908 took her to Rome, where she studied Catholic prayer techniques, but the growth slowly disappeared. She extended her tour to England, where her work attracted many admirers. H. G. Wells called her the most intelligent woman in America.

After her cancer scare, Austin produced articles and books with speed and intensity. Often, she used her stature to back causes she considered important: Native American rights, birth control, and, after she moved to New Mexico, Spanish colonial art. Her favorite subject, however, was the desert. She took her readers into "the heart of a lonely land" in her sketches of the de-

She took her readers into "the heart of a lonely land" in her sketches of the desert's remote grandeur.

sert's remote grandeur. In the great outdoor stretches of the desert, Mary Austin found a metaphor for the untracked inner areas of the mind. She described scenes in both minute detail and sweeping expanse.

After more than a decade of restless travel between New York and California, Austin set down roots in New Mexico. Her house in Santa Fe, *Casa Querida* ("Beloved House"), became a warm center for friends and peers. Willa Cather wrote Death Comes for the Archbishop there, and Austin's niece Mary Hunter was her companion at the house. She worked there happily and steadily until her death at the age of sixty-five.

TO FIND OUT MORE...

- Austin, Mary Hunter. *Earth Horizon*. Boston, MA: Houghton Mifflin, 1932.

- Berdik, Kara. "Placing Mary Hunter Austin, 1868-1934." Paper, Harvard University, 1992.

- James, Edward T., ed. *Notable American Women: 1607-1950: A Biographical Dictionary*. Cambridge, MA: The Belknap Press of Harvard University Press, 1971.

- Steineman, Esther. *Mary Austin: Song of a Maverick*. New Haven, CT: Yale University Press, 1989.

Florence Merriam Bailey, 1863-1948

B orn to Clinton Merriam and Levi Hart Merriam of Locust Grove, New York, Florence Merriam Bailey turned her lifelong love of birds into a series of popular nature books.

Florence's father was a banker and, during the Reconstruction period, a Republican member of Congress; her mother was the daughter of a prominent area judge and politician. Her elder brother Clinton Hart, who was to become the first chief of the United States Biological Survey, appears to have helped to inspire a love of natural history in the young girl. Florence attended a private school in Utica, New York, and then studied at Smith College in Massachusetts, where her interest in ornithology blossomed.

Her first book, *Birds through an Opera Glass*, was published in 1889. After working for a time at a branch of Jane Addams's legendary Hull House and visiting Mormon outposts in Utah (her reminiscences were released in book form under the title *My Summer in a Mormon Village*), she published birding guides more frequently: *A-Birding on a Bronco* (1896), *Birds of Village and Field* (1898), and *Handbook of Birds of the Western United States* (1902). The latter two titles are considered landmark books in the history of American bird-watching.

Having married the naturalist Vernon Bailey in 1899, Florence Bailey went with him on the numerous trips he made to the American Southwest for the U.S. Biological Survey in the first three decades of the century. While her husband collected plant and animal specimens, Bailey watched birds and wrote down her observations. (These observations were to form the basis for her *Handbook of Birds of the Western United States.*) A hardy outdoor woman, Bailey often surprised colleagues who assumed from her frail appearance that she was unable to handle the often rough life of a naturalist in the early part of the century. She seemed to relish the long wagon trips and

isolated conditions that were part and parcel of good research work in the West in the 1900s. Together, the couple surveyed the Dakotas, Texas, New Mexico, Arizona, California, and the Pacific Northwest at a time when doing so still meant coming to terms with privation and solitude.

Bailey's credentials in her field were impeccable: she was a founding member of the Audobon Society of the District of Columbia and the first woman fellow of the American Ornithologist's Union. She was also a respected teacher.

Later important works of Florence Bailey's include *Birds of New Mexico* (1928) and *Among the Birds in the Grand Canyon National Park* (1939). Considered one of the best writers on birdwatching of her time, Bailey combined a passionate interest in her subject with a lively prose style that her contemporaries sometimes lacked. In addition to her publishing and research work, she was a board member of a number of social welfare organizations, including the National Child Labor Committee, the National Housing Association, and the Playground and Recreation Association of America.

Two of Bailey's works, Birds of Village and Field *and* Handbook of Birds of the Western United States *are considered landmark books in the history of American birdwatching.*

TO FIND OUT MORE...

- James, Edward, ed. *Notable American Women, 1607–1950: A Biographical Dictionary*. Cambridge, MA: The Belknap Press of Harvard University Press, 1980.

- Unger, Leonard, ed. *American Writers: A Collection of Literary Biographies*. New York: Charles Scribner's Sons, various dates of publication.

Djuna Barnes, 1892–1982

According to the poet Ezra Pound, Djuna Barnes "weren't too cuddly." In her forties, in fact, she became a recluse, cloistering herself in her Greenwich Village apartment and publishing infrequently over the next four decades. Most of her life was spent in some sort of self-imposed exile; first as part of the illustrious group of literary American expatriates in Paris in the 1920s, and later as a self-described "form of Trappist" in her own country, shut off by her own introverted nature.

Barnes's greatest childhood influence was her father's mother, Zadel Barnes. Djuna's father Wald Barnes had indicated his regard for his mother by taking her surname instead of his father's when his parents divorced. Zadel Barnes became Djuna's personal tutor and mentor. A journalist and feminist, she encouraged her granddaughter's early efforts. The family relationships that Djuna grew up among were unconventional, to say the least; her mother and her children lived under the same Long Island roof as her father's mistress and *her* children—ten in all, including the adults. At eighteen, Djuna moved in with the mistress's fifty-two-year-old brother, after a brief and unofficial family ceremony.

The relationship only lasted a few months, and soon Barnes was in New York's Greenwich Village, studying at the Art Students League and the Pratt Institute of Art. Meanwhile, she wrote poems. In 1915, a small collection of her poetry and drawings was published under the title *The Book of Repulsive Women*. After this early success, however, her writing soon overtook her art as her primary form of expression, and she turned her attention to journalism. Barnes tended to throw herself into her topics. She became particularly involved with a story on British suffragists, who occasionally died in prison during hunger strikes from the traumatic effects of forcible feeding. (The 4-foot rubber feeding tubes were sometimes applied with such unsympathetic force that the suffragists died—not of starvation, but of infection from internal injuries or food in their lungs.) As part of her research, Barnes underwent the brutal procedure.

She showed a special flair as an inter-

viewer, and in 1920 went to Europe to conduct interviews for *McCall's* magazine. Many of her more famous interviews, including those with James Joyce, Coco Chanel, and Alfred Steiglitz, were reprinted in a 1985 collection. She cut a dramatic figure abroad, dressing in a sweeping opera cape and embarking on a series of affairs, including a particularly stormy one with sculptor Thelma Wood.

Her work explored intimate themes of sexuality and alienation. She is best remembered for her masterpiece *Nightwood* (1936), which explores the disconnected drifting of a sexually ambiguous woman, Robin Vote, through 1920s Paris. The rootlessness of the protagonist reflects Barnes's own experiences, and the book has been taken as a prime example of American expatriate writing.

Barnes's editor during the writing of *Nightwood* was T. S. Eliot, whom she called "Uncle Tom." After her return to Greenwich Village in 1940, he edited her most difficult work, *Antiphon* (1958), a blank verse play about a family in which sexual abuse contributes to the general dysfunction. Like many of her works, *Antiphon* was received with praise and some puzzlement. One reviewer said that her work "combined a startling sense of dramatic values with an incoherence of expression that made everything she wrote exciting and baffling at the same time."

Barnes's last four decades were spent in almost total seclusion. Her publications became scarcer, and she accepted funding from the National Endowment for the Arts and from old friends and admirers like Samuel Beckett, Peggy Guggenheim, and Natalie Barney. She was so withdrawn that her neighbor and fellow poet e.e. cummings would acidly call to her from his window: "Are ya still alive, Djuna?!" She continued to write, although less prolifically, up until her death at the age of ninety. Her *Creatures in an Alphabet* was published in 1982, the year she died.

> *The rootlessness of the sexually ambiguous female protagonist in her masterpiece* Nightwood *reflects Barnes's own experience.*

TO FIND OUT MORE...

- Baechler, Lea, and Litz, A. Walton, eds. *American Writers: A Collection of Literary Biographies. Supplement III, Part 1.* New York: Charles Scribner's Sons, 1991.

- Gilbert, Sandra M., and Gubar, Susan, eds. *The Norton Anthology of Literature by Women: The Tradition in English.* New York: W. W. Norton & Company, 1985.

- Rood, Karen Lane, ed. *Dictionary of Literary Biography: Volume Four. American Writers in Paris, 1920–1939.* Detroit, Michigan: Gale Research Company, 1980.

Natalie Clifford Barney, 1876–1972

As a young heiress, Natalie Barney made quite a splash in Paris. She had a series of affairs with women who wrote thinly disguised accounts of her magnetism and fickleness in love, and by her early twenties had become something of a legend. According to the rumors, Barney left a trail of lovestruck women in her wake; one poet, it was whispered, had died of unrequited love.

Natalie Clifford Barney's mother was her early inspiration and role model. Alice Pike Barney was an energetic, artistically talented woman who cared little for convention. She brought her daughters with her when she traveled to Paris to study painting, and her generosity and spirit inspired Natalie to emulate her. She learned fluent French, violin, and fencing, and even before she left her family for life in Paris she showed an inclination to disregard conventional standards of behavior.

Barney was always open and experimental in her affairs, and she could afford to be. Her conservative father's death in 1902 left her with the financial resources to live as she pleased, and she chose to settle permanently in Paris. She was a talented writer, but her writing was mostly a by-product of her extraordinary life: memoirs of her literary and artistic friends, love poems from her many affairs, and essays expressing her feminist philosophy. Her writing is less well remembered than the lasting relationships she cultivated over many years with other artistic celebrities in Paris, including **Gertrude Stein**, **Janet Flanner**, Colette, portrait artist Romaine Brooks, and Ezra Pound.

Barney was especially intrigued by writers, several of whom were inspired by her. Remy de Gourmont wrote his *Lettres intimes a l'Amazone* (published posthumously in 1926) to her, and she was the model for the charismatic lesbian characters that appear in Radclyffe Hall's *The Well of Loneliness* (1928) and **Djuna Barnes**'s *Ladies Almanack* (1928). Barney herself

wrote *Pensees d'un Amazone*, a loose collection of her thoughts and witty quips, in 1920.

A more lasting contribution was the function she served as a bridge between French and American writers. Because she was equally comfortable in both languages and cultures, she was able to conduct a salon in her Paris house that brought influential writers from both languages together. An admirable politician, she was able to court the luminaries who especially interested her. She was especially successful in snaring the notoriously egotistical Gertrude Stein, who ran a salon of her own and would not have been pleased by playing second fiddle to anyone. Barney honored her in a special entry in a series of salon presentations on women writers. The two women were close friends until Stein's death in 1946.

Barney continued to run her salon long after its heyday in the twenties, but it was never again quite as influential. She stayed in her beloved Paris for most of her life, with the exception of the German occupation of the city during World War II. Barney spent the war mourning her city and writing to Stein. Her affairs, even in her old age, never slowed down, but she became more adept at maintaining long-term love relationships. She was especially significant in the life of artist Romaine Brooks, another American expatriate. She died in Paris at the age of eighty-five, two years after Brooks's death in 1970.

> *Her writing reflected her life: memoirs of her literary and artistic friends, love poems from her many affairs, and essays expressing her feminist philosophy.*

TO FIND OUT MORE...

- Barney, Natalie Clifford. *Adventures of the Mind.* Translated from the French by John Spalding Gatton. New York: New York University Press, 1992.

- Chalon, Jean. *Portrait of a Seductress: The World of Natalie Barney.* Translated from the French by Carol Barko. New York: Crown Publishers, 1979.

- Rood, Karen Lane, ed. *Dictionary of Literary Biography: Volume Four. American Writers in Paris, 1920–1939.* Detroit, Michigan: Gale Research Company, 1980.

Gwendolyn B. Bennett, 1902–1981

.

Bennett, a gifted essayist and poet, and one of the leading lights of the Negro Renaissance, was the daughter of Joshua and Maime Bennett. The Bennetts taught for a time at an Indian reservation in Nevada, then relocated to Washington, D.C. Her father had hoped to study law; her mother to become a beautician. But trauma struck early when the couple divorced; although her mother was granted custody of Gwendolyn, her father abducted her and, eventually, settled in the New York City area with his daughter. Gwendolyn did not see her mother for the rest of her childhood years.

Whether this unfortunate incident somehow served to inspire the bright young girl to reach for high achievements in the worlds of academia and art is hard to say, but reach for them she did. A talented visual artist as well as a writer, Gwendolyn Bennett won important awards and positions at Brooklyn Girl's High School (she was the first female black student there to be elected to the school's Felter Literary Society). After graduation she studied for two years at Columbia, then completed her work on her degree at Pratt Institute. In 1924, after she had secured a job as a design instructor at Howard University, she won a prestigious scholarship, the Delta Sigma Theta foreign study award. The cash grant allowed her to take a break from teaching and study in Paris for two years at, among other places, the Ecole de Pantheon. In 1926, she returned to the United States and resumed her teaching work at Howard—but lost much of her artistic output from the Paris period in a fire.

In addition to a few short stories ("Wedding Day," 1926, and "Tokens," 1927) Bennett's writing efforts took two primary forms: a series of influential essays on the role of the African-American artist—most notably through her column "The Ebony Flute" in the journal *Opportunity*—and a body of poetry notable for sharp contrasts and vivid sensory images. Her column,

which noted and influenced trends in the black literary and artistic world, serves now as a fascinating document of the Harlem Renaissance of the 1920s. Her cogent, lively prose—always well informed, always ready to issue a challenge to her readers as well as support them—shows that Bennett was interested in broadening the horizons, both geographical and intellectual, of the legendary literary and artistic movement known as the New Negro Renaissance.

The poems, much-anthologized in the years since they were written, often addressed issues of forgotten heritage and self-determination for African Americans in unflinching terms. Some, like "To a Dark Girl," celebrate black standards of physical beauty; others, like "Song," mourn the absence of cultural structures to support and nurture blacks. (Three of its more poignant lines read as follows: "...I sing the heart of a race/ While sadness whispers/ That I am the cry of a soul.")

Bennett's writings—inspired, challenging, and always relentlessly, honestly observant—were rooted in her work as a visual artist and her status as a privileged observer during a remarkably fertile period for black writers and artists. Hers was a unique, eloquent, and evocative voice that chronicled an important time and place in African-American cultural history.

> *"Song" mourns the absence of cultural structures to support and nurture blacks: "...I sing the heart of a race / While sadness whispers / That I am the cry of a soul."*

TO FIND OUT MORE...

- Roses, Lorraine. *The Harlem Renaissance and Beyond: 100 Black Women Writers, 1900–1945.* New York: G. K. Hall, 1990.

- Bennett, Gwendolyn. "The Ebony Flute" (column), *Opportunity* (August 1926–May 1928).

Margery Williams Bianco, 1881–1944

The author of the children's classic *The Velveteen Rabbit* was perhaps most notable for her ability to communicate with children without condescending to them, both in her books and in her daily life. If the ability to experience life on a child's level is essential to the writing of good children's books, Bianco passed the test with flying colors. Her daughter once said, "My mother always treated our toys as though they were just as real to her as they were to us."

Bianco, who wrote twenty books for children, was born in England; she relocated to the United States, where she had spent a good deal of her childhood, some years after her marriage to rare book dealer Francesco Bianco. The couple shared a love for literature and a passion for travel.

Although her first literary efforts were novels, Margery Bianco—who in her own childhood had been a devoted reader of the tales of Hans Christian Andersen—was ready to take a new tack and try her hand at a book for children. She started work on *The Velveteen Rabbit*, a landmark tale that has remained in print for over seven decades. With the book's remarkable success upon publication in 1922, Bianco found herself one of the leading lights in children's literature after her first book in the genre, a "modern fairy tale" that stirred the hearts of both children and their parents.

Her other children's books include *Poor Cecco* (1925), *The Little Wooden Doll* (1925), and *The Skin Horse* (1927). (Bianco's young daughter Pamela provided the drawings for the latter two books.) In the 1930s she offered *Winterbound* (1936) and *Other People's Houses* (1939), which was one of the first works of juvenile fiction to attempt to tackle the serious psychological issues facing older children. Her last book was *Forward, Commandos!* (1944), a wartime piece for boy readers. Although she is remembered primarily for her work for young readers, Bianco was also an influential critic and essayist. Her novels include

The Late Returning (1902).

Of Bianco's work in the often lackluster field of children's literature, Anne Carroll Moore had this to say: "Her respect for children and their opinions was one of her strongest characteristics. She agreed with Kenneth Grahame that children have just as much sense as we have—it is only experience they lack." Most fans of *The Velveteen Rabbit*—and by this point that group probably includes a huge cross-section of English-speaking adults—would not dispute the point. Bianco's personal involvement, her sensitivity, and her fundamental respect for her readers is evident on every page.

Margery Bianco had appeared to be in good health when she died of a cerebral hemorrhage in 1944 in New York City. She was sixty-three.

> *"Her respect for children and their opinions was one of her strongest characteristics. She agreed with Kenneth Grahame that children have just as much sense as we have—it is only experience they lack."*—Anne Carroll Moore

TO FIND OUT MORE...

- James, Edward, ed. *Notable American Women, 1607–1950: A Biographical Dictionary.* Cambridge, MA: The Belknap Press of Harvard University Press, 1980.

- Unger, Leonard, ed. *American Writers: A Collection of Literary Biographies.* New York: Charles Scribner's Sons, various dates of publication.

Elizabeth Bishop, 1911–1979

Poet Elizabeth Bishop's life was punctuated by losses. She lost her mother and father to mental illness and Bright's disease (respectively) before her sixth birthday. At 56, she lost her lover of 15 years, to suicide. "The art of losing's not too hard to master," she wrote in "One Art," one of her most famous poems. She bore these hardships visibly but uncomplainingly. They surface, formalized in carefully structured verses, in some of her poems, and perhaps contributed to the aura of reserve that hovered about her during her later years at Harvard.

Bishop's father died of kidney disease when she was eight months old. Soon after, her mother's mental illness progressed to the point where she was unable to care for her daughter. When Elizabeth was five, her mother was committed to an asylum, and passed permanently out of her daughter's life. The family construction business in Worcester, Massachusetts provided a small lifelong income for Bishop, and she was raised by kind but scattered relatives, including both sets of grandparents.

As a student at Vassar College, she was already on her way to a literary career. She founded a literary magazine, *The Conspirito*, with future novelist **Mary McCarthy**, and established a lifelong relationship with poet-mentor **Marianne Moore**. It was Moore who urged her to forgo medical school to work exclusively on her writing. Bishop's personal income made a modest independent existence possible, so she moved to New York City to be among other aspiring writers.

New York was a disappointment. Bishop soon began a lifelong pattern of restless moving about, punctuated by a few periods of peace. In 1938, she settled in Key West, Florida with Louise Crane, her lover and a classmate from Vassar. During the next eight years, she wrote the body of poems that, published in her first book, *North and South*, won her the 1946 Houghton Mifflin Literary Fellowship. The mid-1940s, however, found her unhappy again, and she sought help from Dr. Anny Baumann and resumed her restless travelling.

While in Rio on a 1951 fellowship from

Vassar, she ate a bad cashew fruit and became quite ill. An old acquaintance from New York, Maria Carlota Costellat de Macedo, housed her while she recuperated. The arrangement soon became permanent, and Bishop was wonderfully, unexpectedly happy in Brazil with Lota for the next fifteen years. In 1952, Bishop wrote Baumann, "I still feel I must have died and gone to heaven without deserving to." Her writing benefited from her newfound stability: she published more often, and her second book won the 1955 Pulitzer Prize.

This long period of happiness was interrupted when Lota suffered a string of physical and nervous breakdowns, exacerbated by overwork. Her illnesses seem to have accelerated in 1967, and in September of that year she overdosed on sedatives in Bishop's New York apartment. Bishop never regained the happiness she had found with Lota. She carried herself with great dignity, but also with a certain reserve and passivity. "...There is that business of 'going on living'—one does it, almost unconsciously—something in the cells, I think," she wrote in 1968.

In 1970, Bishop was invited to Harvard to teach her friend Robert Lowell's poetry classes. She taught there until her death nine years later, but was never as rooted there as she had been in Brazil. "She was very formal," recalled one of her early students at Harvard, Rick Dey. "She inspired respect. But there was something very burnt-out about her." After a brief, unsatisfactory experience living on campus, she moved across the river to an apartment overlooking Boston Harbor. Despite her public reserve, she maintained close private friendships with Lowell and others, and continued to write honest and vivid—though carefully structured—poetry, releasing *Geography III* in 1976. She died in her Boston apartment in 1979.

> *"There is that business of 'going on living'—one does it, almost unconsciously—something in the cells, I think," she wrote.*

TO FIND OUT MORE...

- Gilbert, Sandra M., and Gubar, Susan, eds. *The Norton Anthology of Literature by Women: The Tradition in English.* New York: W. W. Norton & Company, 1985.

- Giroux, Robert. *One Art.* New York: Farrar, Straus & Giroux, 1994.

- Unger, Leonard, ed. *American Writers: A Collection of Literary Biographies. Volume I: Henry Adams to T. S. Eliot.* New York: Charles Scribner's Sons, 1974.

Nellie Bly (Elizabeth Jane Cochrane Seaman), 1864-1922

· ·

Elizabeth Jane Cochran, better known by her pan name Nellie Bly, was born in a small Pennsylvania hamlet named for her father, who had worked his way up from mill worker to mill owner to wealthy local judge. When Elizabeth was twelve, however, he died, leaving her mother with thirteen children and little in the way of an inheritance—children from an earlier marriage took most of it. Later, Elizabeth sued the family banker for mismanaging the money. At nineteen, after a year at teachers' college, Elizabeth's money ran dry and she found herself in need of a job.

Luck entered the picture in the form of an article in the *Pittsburgh Dispatch* that argued that unmarried women should not work, but find a husband. Irate, Elizabeth dashed off a spirited, anonymous reply. The editor was struck by the lively letter and posted an advertisement in the paper in or-

der to track the unknown writer down, and Elizabeth suddenly had a $5-a-month job. She got her pen name from a popular Stephen Foster tune, and developed a taste for exposés with a sympathetic story on sweatshop workers.

When advertisers threatened to pull their funding, the paper took Bly off undercover reporting. Bored, she went to Mexico, where she picked up a little Spanish and irritated the Mexican government by writing about poverty. On her return in 1887, she impressed *New York World* publisher Joseph Pulitzer with her daring story ideas and was hired to attempt the brashest one on the list. The 22-year-old Bly would put on an act in an attempt to get herself committed to an asylum. After ten days inside, the paper would get her out and she would write her story on what she had seen.

Bly's story was written with dramatic

flair, starring herself as the intrepid girl reporter who suffered abusive nurses, rancid food, and punishing cold scrub baths to get her story. The series of articles sparked long-overdue reform of the mental hospitals and prompted the *New York World* to give Bly free rein and a front-page spot. She chose her own stories after that, going undercover to expose an exploitative employment agency, corrupt politicians, prison conditions, and a Central Park pimp.

In 1889, at the age of twenty-five, she pulled the stunt that cemented her fame. She announced to the world that she was going to travel around the world—unchaperoned—in an attempt to beat the fictional time set in Jules Verne's novel *Around the World in Eighty Days*. As a huge American audience charted her progress on maps, she cabled reports back to the paper and made her way methodically through England, France, Italy, the Suez, Sri Lanka, China and Japan. She was hailed with a parade down Broadway when she completed the trip in seventy-two days.

In 1895, Bly married Robert Seaman, a wealthy seventy-two-year-old businessman. When he died in 1904, she took over his steel company and single-handedly reformed it, turning it into a progressive worker's haven complete with a 50-cent-per-visit medical clinic, a gymnasium, and entertainment for employees. Unfortunately, she was swindled out of a large chunk of money by unscrupulous managers, and spent a good deal of time in court battling bankruptcy proceedings.

In 1914, she fled to Europe to escape her financial woes and found herself caught up in the beginning of World War I. Seizing the opportunity, she became one of the first women to report from the Austrian front, sending her stories to the New York *Evening Journal*. On her return to New York in 1919, she worked as a reporter for the *Evening Journal*, writing about the plight of unwed mothers and abandoned children. She contracted pneumonia and died in 1922 at the age of fifty-six.

> *She was hailed with a Broadway parade when she completed a trip around the world in 72 days, beating the fictional 80 days set in Jules Verne's novel.*

TO FIND OUT MORE...

- Belford, Barbara. *Brilliant Bylines: A Biographical Anthology of Notable Newspaperwomen in America.* New York: Columbia University Press, 1986.

- Kroeger, Brooke. *Nellie Bly: Daredevil, Reporter, Feminist.* New York: Times Books, 1994.

- Schlipp, Madelon Golden, and Murphy, Sharon M. *Great Women of the Press.* Carbondale, IL: Southern Illinois University Press, 1983.

Louise Bogan, 1897–1970

Like so many other women poets, Louise Bogan sometimes fought a grim battle with depression. Unlike some of her contemporaries, however, Bogan emerged intact from her troubles. An energetic and productive poet and critic for over half a century, Bogan survived two unhappy marriages and raised her daughter alone while establishing her career.

Bogan was born into an Irish family in Livermore Falls, Maine. Her father, a former ship's captain, worked at the local paper factories in a series of white-collar positions. Her mother was unhappy in her marriage and spent long periods of time away from home. Louise learned to read at eight and was sent to board at Mount St. Mary's Academy in Manchester, New Hampshire at ten. When she was twelve, the family moved to Boston, and for the first time she was made aware of her Irish heritage.

Despite her relatively late start in reading, Bogan was a quick student and a natural poet. She began writing verse at fourteen, and by age seventeen had developed a fairly polished voice. She enrolled at Boston University in 1915, and had several poems published in the university *Beacon*. Bogan was offered a scholarship at Radcliffe for the following year, but by that time the pressures of living at home with her family were too much for her. She skipped Radcliffe to elope with Curt Alexander, a young officer in the army.

It was a marriage she would later call "unfortunate." In 1917, the couple's daughter, Mathilde, was born. Two years later, they had separated, and in 1920 Alexander died. Bogan, still writing poetry in her spare time, turned to her mother for help in child care while she worked at bookstores and libraries. By 1921, her verses were being published in well-known magazines like *The New Republic*, and in 1923, she published her first book, *Body of This Death*, to great acclaim. In 1925, she married fellow poet Raymond Holden.

Bogan and Holden moved to Santa Fe, New Mexico for a year before settling on a farm in Hillsdale, New York. In 1929, Bogan published a second well-received volume of

verse, *Dark Summer*, and all seemed well. But late in 1929, a tragic fire incinerated the Hillsdale house and both poets' manuscripts. They relocated to New York, but Bogan was depressed despite a 1931 appointment to the staff of *The New Yorker* as the magazine's poetry critic. She spent 1934 travelling Europe on a Guggenheim fellowship, and by the time she returned she found that Holden was having an affair and her marriage was over. She suffered a nervous breakdown.

Bogan recovered well, however, and brought a new, open thoughtfulness to both her prose and verse writings. She wrote two more collections of poetry, *The Sleeping Fury* (1937) and *Poems and New Poems* (1941), and published a short series of memoirs in *The New Yorker* in 1943 and 1944. She never remarried, but forged a supportive lifelong friendship with another poet, Theodore Roethke.

Bogan spent most of the 1940, 50s, and 60s writing essays and criticism. She stopped writing poetry altogether from 1943 to 1948, although she held the Library of Congress's Chair in Poetry from 1945 to 1946. She published authoritative collections of American poetry: *Achievement in American Poetry 1900-1950* (1951) and *Collected Poems 1923-1953* (1954). And she wrote her

A tragic house fire consumed many of Bogan's manuscripts.

memoirs in these later years. They were posthumously published in *The New Yorker* in 1978.

Bogan was remarkably active even in her seventies. She published her final book of poetry, *The Blue Estuaries: Poems 1923-1968* (1969) shortly before her retirement from her post at *The New Yorker*, and approved *A Poet's Alphabet* (1970), a collection of her criticism, immediately before her death.

TO FIND OUT MORE...

- Baechler, Lea, and Litz, A. Walton, eds. *American Writers: A Collection of Literary Biographies. Supplement III, Part 1.* New York: Charles Scribner's Sons, 1991.

- Baechler, Lea, and Litz, A. Walton, eds. *American Writers: A Collection of Literary Biographies. Supplement III, Part 1.* New York: Charles Scribner's Sons, 1991.

- Frank, Elizabeth P. *Louise Bogan: A Portrait.* New York: Knopf, 1985.

- Gilbert, Sandra M., and Gubar, Susan, eds. *The Norton Anthology of Literature by Women: The Tradition in English.* New York: W. W. Norton & Company, 1985.

- Sicherman, Barbara, and Green, Carol Hurd, eds. *Notable American Women: The Modern Period. A Biographical Dictionary.* Cambridge, MA: The Belknap Press of Harvard University Press, 1980.

Winifred Black Bonfils, 1863–1936

One of the star reporters for William Randolph Hearst's *San Francisco Examiner*, Bonfils (known to many of her readers as Annie Laurie) was famous for using unorthodox means to get a story before the competition did. Eager to be the first to report on the tidal wave that pummelled Galveston, Texas in 1900, Bonfils took a pick-axe, stuffed her hair under a cap, and passed herself off as a teenaged boy. She snuck onto a police boat, crossed into the disaster area by night, and eventually filed dispatches that left readers hanging on her every word.

Born Martha Winifred Sweet in Chilton, Wisconsin, the future ace reporter was raised by her big sister Ada; she received a solid private-school education thanks to Ada's income as a Federal pension agent. (The Sweets were orphans: their father, a Civil War veteran and an official within the administration of Ulysses S. Grant, died when Winifred was eleven; their mother passed on four years later.) Initially, Winifred had hungered for a stage career. As an aspiring young actress in New York, she met some of the luminaries of the theatrical and literary world, but did not make much headway in her own career. Then she wrote an engrossing letter to her sister in which she described the difficulties of life on the stage. Ada forwarded it to the *Chicago Tribune*, which liked what it saw and printed it.

After a trip west to track down her brother (apparently he had run away from home), Winifred found herself in San Francisco without prospects. She applied to the *Examiner* and won a job as a cub reporter. Her early pieces failed to impress her editor, but she soon developed the lively (some might say overblown) style that would win attention for her during the so-called "yellow journalism" period in which she came to fame.

Her editor was determined to turn his new charge into his paper's answer to Nellie Bly, the adventuring undercover reporter then causing a sensation on the east coast. Winifred was up to the challenge; she put her considerable acting ability to work in a

series of dangerous assignments that resulted in gripping front-page stories.

She posed as a penniless accident victim, "fainting" before a carriage in the street in order to test the efficacy of San Francisco's ambulances and emergency rooms. The treatment she received was abysmal, and the resulting story, written under her pseudonym, Annie Laurie, highlighted the sexual advances foisted upon under her by male attendants. Her account caused a sensation in San Francisco, prompted reforms, and established Annie Laurie as one of the *Examiner's* top reporters.

> *She got an interview with President Benjamin Harrison by hiding beneath a dining table.*

Later assignments allowed her to continue to push the gender barriers of her day: she covered a prizefight, filed dispatches on the polygamous Mormons of Utah, and interviewed President Benjamin Harrison by hiding beneath a dining table on his train and jumping up to surprise the Chief Executive as he sat down for a meal. She also wrote an unforgettable series of articles based on her trip to the leper colony at Molokai in the Hawaiian islands. In 1906, she raced back to San Francisco from Denver when news of the great earthquake broke, and her dispatches for the *Examiner* did much to improve the morale of the ravaged city.

The star reporter's personal life was apparently rocky. There were two marriages, one in 1882 to her coworker on the *Examiner* Orlow Black (it ended after five years), and another in 1901 to the brother of one of the publishers of the *Post*, Charles Bonfils. This marriage did not result in divorce, but there were long periods of separation. Winifred had three children, a son with Black and a son and a daughter with Bonfils. Unfortunately, both of the boys died as children. The daughter, named Winifred, decided not to become a reporter as her mother wished. For reasons that may have had to do with the unhappiness she felt at her sons' deaths and her daughter's career choice, Winifred Bonfils was never particularly happy in marriage. Another factor contributing to the strains on her married life was, of course, her career. Like many reporters, Bonfils appears to have had only one true spouse during her working life: her next deadline.

TO FIND OUT MORE...

- Belford, Barbara. *Brilliant Bylines: A Biographical Anthology of Notable Newspaperwomen in America.* New York: Columbia University Press, 1986.

- Marzolf, Marion. *Up From the Footnote: A History of Women Journalists.* New York: Hastings House, 1977.

- Schlipp, Madelon Golden, and Murphy, Sharon M. *Great Women of the Press.* Carbondale, IL: Southern Illinois University Press, 1983.

Margaret Bourke-White, 1904–1971

Photojournalist Margaret Bourke-White's main obsession, in both her professional and her personal lives, was with image. She revised her glamorous persona as relentlessly as she manipulated the subjects of her photographs. Many of her most famous photographs were carefully planned, including a memorable picture of a listless queue of flood victims in front of a billboard proclaiming "There's no way like the American way."

Margaret White's parents were both great influences on her. Both were demanding perfectionists, and the household was run with an austerity that outlawed small pleasures like chewing gum, funny papers, and silk stockings. Her five-year-old brother, tasting white bread for the first time, thought it was cake. Her remote father, an inventor and engineer, passed on his interest for photography. But Margaret White was selective about the elements of family life she kept; the drive for perfection without regard for comfort became one of her hallmarks, while her father's Jewish last

name was modified when she tacked her mother's maiden name in front of it, becoming Margaret Bourke-White.

Similarly, a dysfunctional first marriage to Everett Chapman, a college classmate, disappeared in later accounts of her life. Her second marriage, in the heady first decade of her fame, was equally brief. The famous Southern author Erskine Caldwell left his wife and three children for her. The only part of the marriage that lasted was their collaborative work on *You Have Seen Their Faces*, a study of poverty in the South. Helen Caldwell, the abandoned wife, later remarked of her romantic rival, "I don't say she was above reproach. She was above self-reproach."

She certainly seemed above the reproach of her fans. She attracted attention as a celebrity in the early days of *LIFE* magazine, when photojournalism brought the news to readers in a new and immediate way. LIFE's first cover story, in 1936, was one of Bourke-White's, and the magazine glamorized its courageous and beauti-

ful young photojournalist in a way that allowed her to charm or bully her way into all sorts of challenging situations. For a 1943 story, "*LIFE's* Bourke-White Goes Bombing," she tagged along on an Air Force bombing mission and even managed to convince the pilots to fly at the angles she needed for the best pictures.

Although World War II Europe was the scene of some of her most conspicuous triumphs, she had many others: she visited the depths of South African mines, the Korean front, and the perilous chill of the Arctic with her camera. She once balanced precariously on a gargoyle sixty-one stories above a Manhattan street for the proper angle. "[She] never had herself fired from a cannon or tried to seduce Joseph Stalin," wrote a former editor at *LIFE*, Timothy Foote. "But nobody...will doubt that she would have done these things without a moment's hesitation had either [prospect] promised to provide a handsome photograph or enhance her reputation as a glamorous photojournalist with access to power."

She was far more concerned with the images in her photographs than with her human subjects—she considered the photographs eternal. Once she dragged Anheuser-Busch tycoon Gussie Busch out of his bed, where he

Bourke-White was one of the most celebrated photographers of her day.

lay with an ice pack on a hernia, for an exhaustingly long photo session. When the reporter assigned to the project protested on the sufferer's behalf, Bourke-White answered, "These little inconveniences will be forgotten tomorrow and my pictures will live forever." A more famous photo of dying Sikh refugees in India came at a higher cost to her subjects. The stark arrangement of white-clothed, emaciated people was posed and reposed in the Indian heat. "We were there for hours," remembered the *LIFE* reporter who accompanied Bourke-White. "They were too frightened to say no."

Bourke-White always thought of herself as a great humanitarian, and there is an irony in the fact that in some of the images she captured, she showed little interest in the immediate comfort of the people in them—yet these photographs actually brought their suffering to wider attention. And, as she predicted, those photographs have lasted and have been celebrated in books and exhibits, long after she succumbed to Parkinson's disease after a twenty-year struggle.

TO FIND OUT MORE...

- Bourke-White, Margaret. *Portrait of Myself*. New York: Simon & Schuster, 1963.

- Goldberg, Vicki. *Margaret Bourke-White: A Biography*. New York: Harper & Row, 1986.

Catherine Shober Drinker Bowen, 1897–1973

Catherine Bowen was the Method actor of biographers. Before writing about her subject, she not only read every available source, she traveled to his hometown, walked his streets, and met his surviving relatives. In her office, she put up portraits of her subject and tried to hear his voice in her mind. Her biographies are intense studies, and they have all the zest of her highly personal approach.

Catherine Drinker was the sixth and last child born into a lively and competitive household on the campus of Haverford College in Pennsylvania. When she was eight, the family relocated to Bethlehem, Pennsylvania for her father's new position as president of Lehigh University. She was taught by tutors and at private schools. As a girl, she wanted to become a professional violinist. She had a considerable talent, which she cultivated at the Julliard School (then called the Institute of Musical Art). But she played more for the love of it than for any professional ambition, and music remained a hobby.

At twenty-two, she married a Lehigh professor of economics, Ezra Bowen, and moved with him to Easton, Pennsylvania, where he worked at Lafayette College. She settled down to write stories and have children, Catherine (1924) and Ezra (1927). When she first saw one of her stories in print, she was hooked. She wrote a daily column for a local paper, and, in 1924, published two books: a children's book called *The Story of the Oak Tree* and a commissioned history of Lehigh University.

Catherine Bowen loosely based her only novel, *Rufus Starbuck's Wife* (1932), on her own experiences. It dealt with the problems in a marriage of two gifted people. Soon after its publication, the Bowens separated. They were divorced in 1936. Back at Lehigh with her two children in 1939, she married surgeon Thomas McKean Downs. Meanwhile, she had stumbled upon her preferred genre: writing.

Appropriately for an amateur violinist,

her first major biography was her 1939 study of the composer Tchaikovsky, *"Beloved Friend": Tchaikowsky and Nadejda von Meck*. No doubt her long experience with music as well as her 1937 visit to the Soviet Union helped to prepare her for this feat. She had considered writing more biographies of musicians, but artists are a volatile lot and she found that their lives often made for depressing research. Instead, she embarked upon a planned series of sketches of more uplifting lives.

Her next two biographies, *Yankee From Olympus: Justice Holmes and His Family* (1944) and *John Adams and the American Revolution* (1950) were written without the benefit of the use of her subjects' unpublished material, but nevertheless were firmly grounded on the available published sources. Critics dubbed her work "fictionalized biography." Irked by the charges, she made ostentatious use of footnotes in *The Lion and The Throne: The Life and Times of Sir Edward Coke, 1552-1634* (1957). This meticulous study won her the American Philosophical Society's Phillips Prize and a National Book Award.

Bowen also wrote several books on writing biography, explaining her intimate approach. Oddly enough, she wrote a history of her family, *Family Portrait* (1970), in which she did not apply those methods to herself. Finally, she wrote part of a biography of Benjamin Franklin, which was published a year after her death as *The Most Dangerous Man in America: Scenes From the Life of Benjamin Franklin* (1974).

> *As a young girl she wanted to become a professional violinist, so it was appropriate that her first major biography was a study of Tchaikovsky.*

TO FIND OUT MORE...

- Bell, Whitfield J., Jr. (Memoir.) Am. Phil. Soc. Yearbook, 1974.
- Obituary. *New York Times*, November 3, 1973.
- Sicherman, Barbara, and Green, Carol Hurd, eds. *Notable American Women: The Modern Period. A Biographical Dictionary.* Cambridge, MA: The Belknap Press of Harvard University Press, 1980.

Kay Boyle, 1902–1992

Novelist and short story writer Kay Boyle's social conscience found its way into most of her fiction. Stories that decried human rights violations and the draft, among other subjects, might have become dry lectures in the hands of a less talented writer. But Boyle's style, best described by writer Stephen Vincent Bennett as "bright as an icicle and light as the bones of a bird," managed to focus intensely on her subject without sliding into sentimentality.

Kay Boyle was born in St. Paul, Minnesota, to wealthy and progressive parents. She spent her early years with them in Europe, then attended school in Washington, D.C. She always knew she wanted to be a writer, and began making up stories at the age of six. The family settled for a time in Cincinnati, where Kay studied violin and met French-born engineer Richard Brault. She moved to New York in 1919, at the age of seventeen, and found a job on the tiny literary magazine *Broom*, where she worked while taking classes at Columbia University. Later, she recalled trembling in awe as she passed tea to the magazine's writers, who included William

Carlos Williams, **Marianne Moore**, and **Elinor Wylie.**

In 1923, she married Brault and moved with him to Paris. The marriage soon soured; she moved in with poet and editor Ernest Walsh and had a daughter by him before divorcing Brault. Meanwhile, she moved in the intense literary circles of Paris in the twenties, befriending such literary lions as **Gertrude Stein**, **Janet Flanner**, and Robert McAlmon. She later wrote a wryly titled memoir of the period with McAlmon, *Being Geniuses Together* (1968). In 1931, she married American painter Laurence Vail, by whom she had three daughters.

Literary recognition came when "The White Horses of Vienna" (1934) became the first of two of Boyle's stories to win the O. Henry prize for the best short story of the year. "Defeat" (1941) was the second. She also won the first of two Guggenheim fellowships in 1934. Her work always attracted more critical than popular acclaim, winning her prestigious placements, including a stint from 1946–1953 as a foreign correspondent

for the *New Yorker*. During her six-decade career, Boyle was a regular and conscientious writer who produced nearly fifty polished books—novels and collections of poetry, essays, and short stories.

Her moral compass always played a part in her writing, and it increasingly dominated her personal life. She married her third husband, liberal writer Baron Joseph von Franckenstein, in 1943. In the early fifties, he became a casualty of anti-communist hysteria. Boyle and von Franckenstein were living in Germany with their two young children when his position with the American Foreign Service was terminated, supposedly to protect national security. The couple spent the next decade struggling to win his reinstatement, which came shortly before his death in 1963.

In the meantime, Boyle had moved to California, where she took a position as a professor of English at San Francisco University to help support her husband in his final illness. She became caught up in the radical movement that swept college campuses in the late sixties, and opened up her Haight-Ashbury apartment to found the San Francisco chapter of Amnesty International. She temporarily lost her job when she called campus president S. I. Hayakawa a Nazi. At the age of sixty-six, she organized an antiwar sit-in at the Oakland Induction Center. For leading the protest, she was sentenced to thirty-one days in Santa Rita Prison. One jailmate was folk singer Joan Baez, who remembered Boyle as "a tough cookie."

> Boyle had a strong social conscience, opening up her Haight-Ashbury apartment in the late sixties to found the San Francisco chapter of Amnesty International.

Boyle never slowed her writing, and she never went out of style. Her last book, a collection of poetry, was published to strong reviews a year before her death. When she died at the age of ninety in 1992, she was one of the last of the group of influential writers who lived in Paris between the World Wars.

TO FIND OUT MORE...

- Ford, Hugh D. *Four Lives in Paris*. San Francisco: North Point Press, 1987.

- Gilbert, Sandra M., and Gubar, Susan, eds. *The Norton Anthology of Literature by Women: The Tradition in English*. New York: W. W. Norton & Company, 1985.

- Mellen, Joan. *Kay Boyle: Author of Herself*. New York: Farrar, Straus & Giroux, 1994.

- Spanier, Sandra Whipple. *Kay Boyle, Artist and Activist*. Carbondale: Southern Illinois University Press, 1986.

Alice Brown, 1856–1948

The daughter of a rural New England farm couple, Alice Brown attended a district school as a youngster and Exeter, New Hampshire's Robinson Seminary after she reached the age of fourteen. Brown seems to have turned seriously to writing after determining that her work as a teacher would never fulfill her. Encouraged by the positive response she had received as a result of the publication of her earliest short stories, she left her native New Hampshire for Boston, found a job on a newspaper, and, at the age of twenty-eight, published her first novel, *Stratford-by-the-Sea*. After a trip to England with her close friend Louise Guiney (with whom she was to write a study of Robert Louis Stevenson), she wrote a book of reminiscences about the trip, *By Oak and Thorn*.

In 1895, Brown got her first taste of real literary success when she published *Meadow-Grass*, a collection of regional stories based on her knowledge of the speech and attitudes of New Hampshire natives. *Tiverton Tales* (1899) mined much the same ground, and was also a success. (The note of realism in her regional stories was a reflection of Brown's childhood years in New Hampshire, to be sure, but it should also be noted that she spent many happy summers in the state as an adult.) In the years that followed *Tiverton Tales*, Alice Brown published more poetry, some plays, biographical articles, short stories, novels, and essays—roughly a book a year for the next three and a half decades. In 1914 her play *Children of the Earth* won a prestigious cash award; although critics admired her work, which concerned the lost dreams of love of an unmarried New England woman, audiences did not take to the piece. Brown also published a biography of her friend Louise Guiney after Guiney died in 1920.

Alice Brown's work began to fall out of favor in the early 1930s; critics of the day seemed to grow impatient with her adherence to styles and idioms that were no longer popular. Her regional fiction had been hailed as both authentic and inspired, and had certainly been well regarded in the earlier years of her career, but as the Great Depression wore on the author found her-

self in search of a new approach that would allow her to touch readers and critics as she once had. Unfortunately, it appears that she never found that new approach.

In her later years she sold the New Hampshire farm at which she had passed so many of her summers and retreated into a steadily more isolated life alone in Boston. She died at Massachusetts General Hospital in 1948 of natural causes, and was buried in Hampton Falls, New Hampshire, the town of her birth.

TO FIND OUT MORE...

- James, Edward, ed. *Notable American Women, 1607–1950: A Biographical Dictionary.* Cambridge, MA: The Belknap Press of Harvard University Press, 1980.

- Unger, Leonard, ed. *American Writers: A Collection of Literary Biographies.* New York: Charles Scribner's Sons, various dates of publication.

> *In the early 1930s her work fell out of favor because of her adherence to styles and idioms that were no longer popular. Though she searched for a new approach to touch her readers, it appears that she never found one.*

Margaret Wise Brown, 1910–1952

rown, best known today as author of the endlessly popular children's book *Goodnight Moon*, was born in New York City, the eldest daughter of Robert and Maude (Johnson) Brown. Her father was a successful executive and the son of a former governor of Missouri; Margaret enjoyed a prosperous home and a top-notch education at some of the best schools in Europe. She received an A.B. degree in 1932 from Hollins College and set out to become a writer.

This was no easy task during the Great Depression, of course, but Brown's obstacles seem to have had to do, at least partly, with her unease with the entire category of adult fiction. Frustrated at her own apparent inability to master the art of plotting, she studied under Lucy Sprague Mitchell and was encouraged to develop children's stories. Brown found she enjoyed writing in this vein and, most significantly, enjoyed testing her stories on kindergarteners by reading to them. She learned to trust the comments of these young people, who today might be called focus group members. When they were bored with a story idea, she changed it. When they suggested a new theme, she listened.

The technique served her well, and there followed from her desk a stream of popular books, including *When the Wind Blew* (1937) and *The Streamlined Pig* (1938). Brown's emphasis on direct sensory impressions may have owed a good deal to her work with Mitchell, but it also arose in no small degree from her willingness to listen to the children in her test groups.

In 1938 Brown became an editor at William R. Scott's publishing house; her specialty was books for children. Her biggest success there was *The Noisy Book*, which she wrote. The book follows the adventures of a blindfolded dog named Muffin who must, with the help of the child to whom the story is being read, identify the sources of a range of sounds. The book was enormously popular and spawned

several sequels.

By the mid-forties, Brown had left editing to focus exclusively on developing her own rapidly growing list of children's books. As ever, she let the young members of her test groups influence the development of her books. In 1947, Harper published what would become a perennial seller, *Goodnight Moon*. In this bedtime classic, the adult world of inanimate objects is seen, as through the eyes of a child, to be a universe laden with friendly companions worthy of an evening farewell. From the instant the book was released, its simple text and captivating drawings made for delightful nighttime reading for parents and children alike; indeed, *Goodnight Moon* has for decades been a staple for hundreds of thousands of households with young children.

> *Brown tested her stories on kindergarteners. When they were bored with a story idea, she changed it. When they suggested a new theme, she listened.*

Brown was known for her insistence on quality illustrations (she worked with some of the most gifted illustrators of the day) and on her early focus on the physical appearance (what would today be called the "format") of books for the very young. She once said that she would establish the first draft of a book in twenty minutes and spend a year polishing the work.

Over a decade and a half, Brown published over a hundred children's books and supplied lyrics for many records. The volume of her work that is still in print is a remarkable testament to her capacity for communication with children. Brown, who never married, died in 1952 in France.

TO FIND OUT MORE...

- Marcus, Leonard S. *Margaret Wise Brown: Awakened by the Moon.* Boston: Beacon Press, 1992.

- Sicherman, Barbara, and Green, Carol Hurd, eds. *Notable American Women: The Modern Period. A Biographical Dictionary.* Cambridge, MA: The Belknap Press of Harvard University Press, 1980.

Pearl Sydenstryker Buck, 1892–1973

P earl S. Buck was both an influential novelist and a great humanitarian. Her critics, though, have argued that the latter interfered with the former. As she became increasingly concerned with using her fiction to carry a message, her work was increasingly criticized for being preachy. But her enormous audience seemed to disagree. As of 1981, she was the most widely translated author in the history of American literature. Only Mark Twain was to come close to this record.

Pearl S. Buck got her social conscience from her parents. Born in Hillsboro, West Virginia, Pearl Sydenstryker was soon brought to China with her parents, who were Presbyterian missionaries. She grew up bilingual among Chinese neighbors, and was greatly influenced by Chinese literature. Her mother required her to write essays outside of school, and helped Pearl make revisions.

Pearl Sydenstryker stood out at Randolph-Macon Woman's College. She was elected to Phi Beta Kappa and was the president of her class, and managed to write a string of short stories and poems as an undergraduate. She stayed on to teach, but soon hurried back to China to (successfully) nurse her mother through a serious illness. In 1917, she married agriculture expert John Lossing Buck, who worked with Chinese farmers through the Presbyterian Board of Foreign Missions. Through his work, Pearl S. Buck became familiar with life on a Chinese farm, which would later be the setting of some of her best fiction.

The Bucks moved to Nanking in 1921, where both taught at the university. Both were saddened to find that their first child, Carol, was mentally retarded. Pearl took her to the United States for treatment, and while there earned a master's degree in English at Cornell. Back in China, her marriage began to unravel even as her writing began to come together. She published her first book, *East Wind: West Wind*, in 1930. Her most famous novel, *The Good Earth*,

THE REMARKABLE LIVES OF

appeared the next year.

Both books examine aspects of Chinese life. *East Wind: West Wind* deals with the tension between the traditional ways and new Western-influenced ideas in an extended Chinese family. In one of the two major plots, a young Western-trained doctor asks his traditional, submissive wife to undo the binding of her feet, a tight swaddling which over the years has stunted their growth and kept them tiny. She does, but only to please her husband. *The Good Earth*, one of the best-selling books ever published, brought Buck's talent for unadorned storytelling together with her sympathy for Chinese peasants. Buck traces universal themes—ambition, the generation gap between parent and child, and marriage—in a rural setting.

> *In the late 30s, although she had a wide and enthusiastic following, some of her novels were published under a pen name in order to handle her enormous output.*

In 1934, Buck moved permanently back to the United States and married publisher Richard J. Walsh. In 1938, she was awarded the Nobel Prize. The Nobel committee lauded her "rich and generous epic description of Chinese peasant life." Meanwhile, her literary output had increased, and although she had a wide and enthusiastic following, her publisher had to publish some of the novels she wrote under a pen name, "John Sedges," in order to handle her enormous output. Buck used her prominent position to back causes dear to her, and increasingly her fiction incorporated her views.

After World War II, Buck founded Welcome Home, an adoption agency for Amerasian children fathered by U.S. soldiers abroad. Buck and Walsh housed the program's two first children in their own home. Later, the Pearl S. Buck Foundation set up centers to aid children in several countries. Buck also worked for mentally handicapped children and the American Civil Liberties Union, and continued to speak out in her fiction at the rate of nearly a book a year until her death at the age of eighty-one. The royalties from her many books still help pay for the programs she helped to establish.

TO FIND OUT MORE...

- Block, Irvin. *The Lives of Pearl Buck: A Tale of China and America.* New York: Crowell, 1973.

- Buck, Pearl S. *My Several Worlds: A Personal Record.* New York: John Day Company, 1954.

- Litz, A. Walton, ed. *American Writers: A Collection of Literary Biographies. Supplement II, Part 1.* New York: Charles Scribner's Sons, 1981.

- Stirling, Nora B. *Pearl Buck, a Woman in Conflict.* Piscataway, NJ: New Century Publishers, 1983.

Emma Bugbee, 1888–1981

Many suffragists described the struggle for the women's vote as a kind of battle. If suffrage was a war, then journalist Emma Bugbee was a frontline correspondent. She was one of the group of women correspondents, including **Lorena Hickok**, who became close to Eleanor Roosevelt. When the former First Lady died in 1963, Bugbee's moving tribute won the Newspaper Reporters Association's award for best feature of the year.

Emma Bugbee was born in Shippensburg, Pennsylvania, and raised in Methuen, Massachusetts. Her father, Edwin Bugbee, a teacher of Greek and French, died when Emma was twelve. Her mother took over his job in order to put Emma and her two younger siblings through Methuen High School and college. Emma's mother was an independent-minded woman who considered wearing a wedding ring a symbol of slavery and who hadn't had to change her name when she got married— her maiden name was Emma Bugbee.

Emma enrolled at Barnard College in New York on her graduation from high school. While studying there, she worked as a campus correspondent for the *New York Herald Tribune* through the college's press club. On her graduation, however, she went back to Methuen to teach Greek at her old high school until a college friend called her in 1910 to say that she needed a substitute at her *Tribune* job until she returned from a trip to Germany—would Emma fill in? Emma would, and when the friend decided to stay in Germany, the job became permanent.

As a woman at the *Tribune*, Bugbee found herself a second-class citizen. She was assigned to the city desk, but she was not allowed to have a desk in the exclusively male newsroom and instead was stuck in a nook on a different floor. She covered women's news, which itself was a low-priority subject. The exception to that rule came when there was a major story on the suffrage struggle; in that case, "women's news" became front-page news, and was covered by a man. The day before a major suffrage parade, a group of women reporters brought their case to *Tribune* editor Ogden Reid, who agreed that the reporters

who covered the small suffrage stories should cover the big ones. Their stories—including Bugbee's—were run.

Bugbee covered a crucial 1911 suffragists' march from New York City to Albany. The difficult December trek took three weeks, and Bugbee had to detour to a telephone or telegraph station every day by 5 p.m. in order to get her report to the paper. In 1914, she finally won her byline and a desk in the city room with a **Nellie Bly**-style stunt: she donned a Salvation Army Uniform and rang a handbell over a collection pail on Fifth Avenue. Her story took aim at the uncharitable New Yorkers who averted their gaze and kept their hands in their pockets.

Bugbee had been covering Eleanor Roosevelt's progressive work for several years while Franklin Roosevelt was governor of New York. When he was inaugurated as President in 1933, Bugbee became part of the close-knit group of women reporters who covered the First Lady, called Eleanor's "girls," or, less flatteringly, "hens." America had never had such an active woman in the White House; Eleanor Roosevelt held her own press conferences and spoke her own mind. Her Monday-morning confer-

ences were for women only, encouraging papers to hire women reporters. A few of these journalists became close family friends, and Bugbee was one of these. She slept in Lincoln's bed and went on vacations with the First Lady.

Like her friend Eleanor Roosevelt, Bugbee had a hand in encouraging women reporters. Her five-book "Peggy" series, starting with the classic *Peggy Covers the News* (1936), inspired many young readers. Until her retirement in 1966, four years after Eleanor Roosevelt's death, she was a welcoming presence for younger women reporters at the *Tribune*. She spent a few years traveling and painting at her Connecticut summer home before moving to a Rhode Island retirement home in 1970. She died there in 1981 at the age of ninety-three.

Like her friend Eleanor Roosevelt, Bugbee encouraged women reporters, and her five-book "Peggy" series inspired many young readers.

TO FIND OUT MORE...

- Belford, Barbara. *Brilliant Bylines: A Biographical Anthology of Notable Newspaperwomen in America.* New York: Columbia University Press, 1986.

- Collins, Jean E. *She was There: Stories of Pioneering Women Journalists.* New York: Julian Messner, 1980.

- Obituary. *The New York Times*, October 10, 1981.

Willa Cather, 1873–1947

Pulitzer Prize-winning novelist Willa Cather found her lifelong subject in the dusty Nebraska plains of her adolescence and early adulthood. Cather had spent her first ten years in Virginia, and the alienation she felt when she found herself on the Great Plains was a core issue for the characters in her most powerful fiction.

Born Wilella Seibert Cather near Gore, Virginia, to a well-established family, Cather liked to be called "Willie" as a child. Her home, until the age of nine, was a three-story brick farmhouse surrounded by fields, woods, and streams; as the eldest child by three years, she spent much of her time on her own, enjoying the outdoors. When the family moved to Nebraska (eventually settling in Red Cloud), Willie was forced to learn to love a very different kind of land: vast, dusty, and grand.

Cather lived in Nebraska until she graduated from the University of Nebraska at Lincoln. She worked briefly at a Lincoln newspaper before moving to Pittsburgh in 1896, where she spent a quiet, almost reclusive ten years teaching English and Latin

and editing and writing for local magazines and papers. During this time, she developed a close relationship with Isabelle McClung, and moved into Isabelle's parents house to share a bedroom with her. It was there that she began to write fiction. Her first break came when publisher S. S. McClure published *The Troll Garden* (1905), Cather's first collection of stories.

McClure offered her a position on his magazine, and Cather moved to New York to gradually rise to the position of managing editor of *McClure's Magazine*. After her first novel, *Alexander's Bridge* (1912), was serialized in *McClure's*, she left the magazine to write full time. Cather had often stayed with the McClungs to write, but in 1913 she had moved into a downtown Manhattan apartment with another woman, Edith Lewis, with whom she shared the rest of her life. Still, Cather was upset by Isabelle McClung's marriage in 1915.

In 1913, Cather published what is probably her best-known novel, *O Pioneers!* In it, Cather drew on her knowledge of frontier life and seemed to come to terms with

the land of her adolescence. The novel's restless, tragic characters are the ones who are unable to cope with the land, but the heroine, Alexandra, is deeply linked with it, a sort of agricultural earth mother. Although Cather's most celebrated works are set in the Midwest, she won her Pulitzer Prize for a war novel. *One of Ours* (1922) has since been eclipsed by *O Pioneers!*, *The Song of the Lark* (1915), and *My Ántonia* (1918).

With the winning of the Pulitzer, Cather's status was assured. She was admired by her contemporaries; the novelist Sinclair Lewis said she deserved the Nobel prize he'd won. She continued to write novels, but found herself increasingly disenchanted with the modern world. In her 1936 book of essays, *Not Under Forty*, Cather wrote that the world as she saw it had been "broken" around the year 1922. Later novels like *Death Comes For the Archbishop* (1927) and *Shadows on the Rock* (1931) explore alienation.

When not working out of the New York home she shared with Edith Lewis, Cather often retreated to Jaffrey, New Hampshire to write undisturbed. When Cather died in 1947, at the age of seventy-three, her wishes that her novel-in-progress be destroyed and that she be buried in Jaffrey were carried out.

> *In* O Pioneers!, *Cather drew on her knowledge of frontier life and seemed to come to terms with the Midwest, the land of her adolescence.*

TO FIND OUT MORE...

- Gilbert, Sandra M., and Gubar, Susan, eds. *The Norton Anthology of Literature by Women: The Tradition in English.* New York: W. W. Norton & Company, 1985.

- Lee, Hermione. *Willa Cather: A Life Saved Up.* London: Virago, 1989.

- Lewis, Edith. *Willa Cather Living: A Personal Record.* Athens, Ohio: Ohio University Press, 1989.

- Unger, Leonard, ed. *American Writers: A Collection of Literary Biographies. Volume I: Henry Adams to T. S. Eliot.* New York: Charles Scribner's Sons, 1974.

Laurie Colwin, 1944–1992

Novelist and food writer Laurie Colwin was never quite famous. She never started a literary movement, and she was not a regular presence on the best-seller lists. Instead, she was one of those special writers whose presence and personality somehow made readers feel she was a friend. In her warm, small-scale novels and short stories, she captured gentle eccentrics in ordinary situations of love and family and made them real. "Not much happens," said Margaret Sullivan in a review of Colwin's last novel, *A Big Storm Knocked it Over* (1993). "But, as usual, that doesn't matter. It works." Perhaps her best writing, however, lay in her intimate essays on food and cooking, in which she lovingly evokes heavenly concoctions and make them seem possible for the rawest amateur cook.

Laurie Colwin was born in New York City, the setting of much of her later fiction. She grew up in a range of cities including Chicago and Philadelphia, and also spent some of her childhood in Lake Ronkonkoma, Long Island. Early on, she developed an interest in food and cooking. In her lovely collection of essays, *Home Cooking* (1988), she recalls making and eating her own food "as a mere youth." She graduated from Bard College in upstate New York in the mid-1960s, and went on to pursue graduate studies at Columbia University.

At Columbia in 1968, she contributed in her own way to student protests by cooking food for protesters during sit-ins. She found entry into the close-knit New York publishing world by working for literary agents and in the editorial departments of publishing houses including Putnam, Pantheon, Dutton, and Viking, and began to work on her own writing. In 1969, at the age of twenty-five, she sold her first story to *The New Yorker*.

As she became more firmly established in the New York literary community, Colwin found inspiration among her peers for her fiction. Her characters, in novels and short stories, tend to be upper-middle class, well-educated New Yorkers with quirky jobs. For example, in her second novel, *Happy All the Time* (1978), one of the main characters is the Manhattan Board of Planning's

garbage expert. Their small oddities make them utterly familiar, and Colwin placed them in simple, common situations centering around love, marriage, and parenthood.

Colwin's fiction was intimate and modest in scale. Her characters are drawn slightly smaller than life, and her novels are relatively short. Small-scale pieces like essays and short stories are best suited to her talent, and critics consider her three collections of short stories, *Passion and Affect* (1974), *The Lone Pilgrim* (1981), and *Another Marvelous Thing* (1986) her best fiction. She was able to write with **Dorothy Parker**'s dry wit, but tempered sharpness with her own gentler, more forgiving sense of humor.

Perhaps most memorably, Colwin wrote gemlike essays on food and cooking, often published in the glossy pages of *Gourmet* magazine. Some of the best are in the collections *Home Cooking* (1988) and *More Home Cooking* (1993). Colwin's obvious love of her subject can inspire enthusiasm for the lowly lemon (Colwin's favorite fruit, because it is equally good in lemony desserts and tuna fish salad). And she often drops useful tips while making her reader salivate. "I never think in terms of time per pound," she wrote in an essay on roasting a chicken. "When the leg bone wiggles and the skin is the color of teak, it's time to eat."

> *"I never think in terms of time per pound," she wrote in an essay on toasting a chicken. "When the leg bone wiggles and the skin is the color of teak, it's time to eat."*

In 1983, at the age of thirty-nine, Colwin married Jurs Jurjevics, editor-in-chief of *Soho Press*. The couple had a daughter, Rosa Audrey, and Colwin's writing was recognized with the awarding of a Guggenheim Fellowship in 1987. Sadly, Colwin died tragically young of a heart attack in October of 1992. She was forty-eight. After her death, a fifth novel and second collection of essays have been published. At her memorial service, the writer Walter Abish said, "Laurie enhanced. It's as simple as that."

TO FIND OUT MORE...

- Obituary. *Newsday*, October 27, 1992.
- Obituary. *New York Times*, October 26, 1992.
- Quindlen, Anna. "Seeing Yourself in the Life and Death of a Kindred Soul." *Chicago Tribune*, February 16, 1993.

Elisabeth May Adams Craig, 1888–1975

A long with **Doris Fleeson** and **Eleanor Van Wagoner Tufty**, Craig was one of the first women to cover the White House. Carefully composed, almost prim, she wore her hair up under proper hats and radiated a sort of grandmotherly aura—until she began to ask questions. From Roosevelt to Kennedy, she politely cornered Presidents with carefully worded queries. Often, she elicited memorable answers. Once she surprised Kennedy by asking what he had done for women lately. "Obviously, Mrs. Craig," he said with a smile, "not enough."

Elisabeth May Adams's childhood was a troubled one. One of nine children of a phosphate miner in Beaufort County, South Carolina, she was placed in a foster home at the age of six after her mother died in childbirth. Her father remarried and raised two of her siblings, but Elisabeth May saw him only twice after his marriage. She withdrew into books and chose to pursue a degree in nursing after high school, ignoring her foster parents' wishes that she be sent to finishing school.

She began writing as well, and in 1909 married *New York Herald* reporter Donald Craig. They had two children together, Donald A. and Betty Adams, and settled into writing together. Donald eventually rose to become chief of the *Herald*'s Washington bureau, but Elisabeth May Craig had a difficult start. Her fiction only brought her rejection letters, and her freelance articles sold occasionally. A committed feminist, she argued, unsuccessfully, for a column on Washington from a woman's point of view. Besides her writing, she was busy organizing groups to promote education; the local P.T.A. was put together under her leadership, and she worked with journalist Florence Yoder to put out a newspaper for children.

Craig first broke into Washington journalism because her husband was horribly injured in a 1923 car accident. He never completely regained his strength, and died

in 1936. Elisabeth May Craig took over some of the work on his "On the Inside in Washington" column, written for a group of Maine newspapers. She was writing under her own by-line by 1931, and had reshaped the column to "Inside in Washington" by 1936. Meanwhile, she had gained the respect of her peers in Washington with her ability to cut to the heart of an issue, and headed the Women's National Press Club in 1943.

Craig was conscientiously apolitical in that she never declared any party affiliation, but her feminism was a part of her and spilled over into her professional life. She led the 1945 push for women's rest rooms near the congressional galleries—not a small issue if spending hours at the galleries is a job requirement—and in 1964 pressed for the inclusion of a women's rights clause in the Civil Rights Act.

Despite her mild, delicate appearance, Craig was a fearless explorer who spent time at the front lines during World War II and the Korean War. In Korea in her early sixties, she endured danger and fleabite to visit Lt. General "Chesty" Puller at division headquarters. She was one of the first accredited women war correspondents, and put in time on a combat ship at sea, in a plane over the North Pole, and in England during the bombing raids of World War II. During her traveling years, she visited every continent except Australia.

From the 1940s until she stepped down in 1965, Craig appeared on the show "Meet the Press" on radio and television. She stopped writing the same year, and died in retirement at the age of eighty-six.

Besides her writing, she organized groups to promote education, including the local P.T.A., and worked to publish a newspaper for children.

TO FIND OUT MORE...

- Marzolf, Marion. *Up From the Footnote: A History of Women Journalists.* New York: Hastings House, 1977.

- Ross, Ishbel. *Ladies of the Press: The Story of Women in Journalism by an Insider.* New York: Harper, 1936.

- Sicherman, Barbara, and Green, Carol Hurd, eds. *Notable American Women: The Modern Period. A Biographical Dictionary.* Cambridge, MA: The Belknap Press of Harvard University Press, 1980.

Mary (Caresse) Phelps Jacob Crosby, 1892–1970

The poets Harry and Caresse Crosby had a deep symbiotic relationship. During their short seven-year marriage, all of Harry's poetry and most of Caresse's was published, with the exception of her *Poems for Harry* (1931), published after his tragic 1929 suicide. Aside from the five volumes of poetry she produced during their time together in Paris, Crosby is known for her part in Black Sun Press and Editions Narcisse, influential presses the Crosbys formed to put their own work into print that eventually put out the work of many more famous writers.

Mary Phelps Jacob Crosby, called Polly, was born in Manhattan, the child of a wealthy and genteel New York family who sent her to private schools. She patented a wireless brassiere as a young woman, a tidbit much remarked upon in her obituaries, and married the child of a wealthy and genteel Boston family, Richard Rogers Peabody. She had two children, William and Polly, by Peabody, but the marriage fell apart under the pressures of Richard's alcoholism and his wife's attraction to another man, Harry Crosby. The Peabodys divorced in 1921 and a year later, the 30-year-old divorcee Polly Peabody married the handsome 24-year-old Harry. The scandal this caused in Boston social circles encouraged them to seek their fortunes in Paris.

Their families' fortunes made it possible for them to aspire to become artists without starving. Both began to write poetry. In her memoirs, Caresse tells the story of choosing a pen name. Along with Harry, she decided that both "Polly Crosby" and "Mary Crosby" sounded a little dull. He suggested she find a name that started with "C" and could be made into a cross with his, and they decided on "Caresse." The "Crosby Cross" they came up with is below, and appeared in Caresse Crosby's first book of poems, *Crosses of Gold* (1925).

```
      H
      A
CARESSE
      R
      Y
```

Editions Narcisse, the Crosbys' press, was named for the couple's whippet dog, Narcisse Noir. It published not only the Crosbys' work, but the work of many important writers in Paris, including **Kay Boyle**, Ezra Pound, James Joyce, and D. H. Lawrence. Both the Editions Narcisse books and those the Crosbys published under another name, Black Sun Press, are highly prized today, not only for the writing but for the beautiful craftsmanship of the printing and binding that the Crosbys insisted upon. Most of Caresse Crosby's poetry was published in small batches by Editions Narcisse, including *Crosses of Gold* (1925), *Painted Shores* (1927), and *Impossible Melodies* (1928). In 1926, Houghton Mifflin happily snapped up her second book of poetry, *Graven Images*.

> **Following her husband's suicide Caresse published Poems for Harry Crosby,** *presenting a complicated mixture of her love, anger, and remembrance of him.*

Despite their highly visible love affair, which both publicly celebrated in their work, the Crosbys' marriage was doomed by Harry's crippling memories of World War I. He had escaped death so narrowly at Verdun that he was haunted for the rest of his life by thoughts of dying. He seemed to try to work them out in his bleaker poems and his diaries, published in 1928 as *Shadows of the Sun*, but fascination turned to attraction and in late 1929 he committed suicide along with his married mistress, Josephine Bigelow. Caresse Crosby carried on, running Black Sun Press and publishing Harry's work. She also put out her own *Poems for Harry Crosby* (1931), which presents a complicated mixture of love, anger, and remembrance.

Back in the United States in 1937, Caresse remarried, but divorced after only about five years. On her own, she continued to sporadically publish under the Black Sun name, and later under the imprint Castle Continental Editions. Although she eventually bought a 500-year-old castle near Rome, she never really settled down in any one place. At the age of sixty-one, she published her memoirs, *The Passionate Years* (1953), and she died seventeen years later at the age of seventy-seven in Rome.

TO FIND OUT MORE...

- Conover, Anne. *Caresse Crosby: From Black Sun to Roccasinibalda.* Santa Barbara, CA: Capra Press, 1989.

- Crosby, Caresse. *The Passionate Years.* New York: Ecco Press, 1953.

- Rood, Karen Lane, ed. *Dictionary of Literary Biography: Volume Four. American Writers in Paris, 1920–1939.* Detroit, Michigan: Gale Research Company, 1980.

- Wiser, William. *The Great Good Place: American Expatriate Women in Paris.* New York: Norton, 1991.

H. D. (Hilda Doolittle), 1886–1961

The poet H. D. is often mentioned for her connections to famous men: her one-time fiancee, Ezra Pound; her psychoanalyst, Sigmund Freud; and her friends William Carlos Williams and D. H. Lawrence. In the last decade, however, H. D.'s life and work have attracted new interest and admiration. She is now generally viewed not as Ezra Pound's puppet in the formation of the Imagist movement in poetry, but as an artist in her own right whose achievements extend far beyond the Imagist poems of her youth.

Hilda Doolittle grew up in Pennsylvania, where her father was a professor of astronomy at Lehigh University and the University of Pennsylvania. At fifteen, she met her brother's schoolmate Ezra Pound (who was then sixteen) at a Halloween costume party. He came as a Tunisian prince. Their friendship became, despite her parents' objections, an on-again, off-again engagement. Later, the relationship evolved back into a friendship. After flunking (of all

subjects) English at Bryn Mawr College, Doolittle went on a trip to Europe with a friend in 1911, and never really came home.

In the tea rooms of the British Museum with Pound in London in 1912, Doolittle showed him some of her poems. They were tersely precise and grounded in Greek mythology, and Pound was struck by them. He mailed them off to *Poetry* magazine in Chicago with the signature: "H. D., Imagiste." In so doing, he gave both her and her poetry a name. H. D. became famous almost overnight. Her first collection of poems, *Sea Garden*, was published in 1916. She became known, at the age of twenty-six, as the standard-bearer of the Imagists, whose poems, written without rigid meter, used no superfluous words and strove above all to get across an image of the utmost clarity.

Pound was a witness at her wedding to novelist and poet Richard Aldington. The marriage did not work out. Both had affairs, one resulting in the birth of H. D.'s daughter Perdita in 1918. They separated soon af-

terwards. Despondent and faced with the responsibility of caring for her baby, H. D. was rescued by the start of a lifelong affair with an English heiress, Annie Winifred Ellerman. The 24-year-old Ellerman, who called herself Bryher, was H. D.'s lover, supporter, and lifelong friend. Free with her inheritance despite the disapproval of her family, who referred to H. D. as "that woman," she later legally adopted H. D.'s daughter, and the two women shared a home.

> **H.D. wrote powerful, memorable poetry that dealt with a goddess-figure.**

In the thirties, H. D. ran into a dry period in her writing. Like **Edna St. Vincent Millay**, she found that early fame was difficult to live up to. She underwent psychoanalysis with Freud from 1933–34, and was (perhaps predictably) diagnosed with penis envy. She recorded her experiences in a 1956 memoir of her psychoanalysis, *Tribute to Freud*. H. D. was selective about the lessons she took from Freud—for example, she rejected his claim that she needed to distance herself from her dead mother—and by 1944 was again writing powerful, memorable poetry that dealt with a goddess-figure.

Those who most admire H. D.'s later poetry consider her booklength poem *Trilogy* (1944–6) a triumph. In it, she combines Mary Magdelene and the Virgin Mary into a single, central woman-figure. *Trilogy*, however, was written at a fragile time, and H. D. suffered a nervous breakdown. She moved to Küsnacht, Switzerland, where her treatment at a sanitorium was paid for by Bryher and where she was happily pampered. Her fifteen years there helped nurture her second major surge of creativity.

H. D. died in a Zurich hospital at the age of seventy-five. During her life, her reputation as a poet suffered after the success of her early short, spare, and stately poems. The longer narrative poems she wrote later in her life have been given more attention since her death, and have drawn praise from notable critics including **Louise Bogan** and Denise Levertov.

TO FIND OUT MORE...

- Gilbert, Sandra M., and Gubar, Susan, eds. *The Norton Anthology of Literature by Women: The Tradition in English.* New York: W. W. Norton & Company, 1985.

- Guest, Barbara. *Herself Defined: The Poet H. D. and Her World.* Garden City, NY: Doubleday, 1984.

- Robinson, Janice S. *H. D.: The Life and Work of an American Poet.* Boston: Houghton Mifflin, 1982.

- Sicherman, Barbara, and Green, Carol Hurd, eds. *Notable American Women: The Modern Period. A Biographical Dictionary.* Cambridge, MA: The Belknap Press of Harvard University Press, 1980.

Dorothy Dix, 1861–1951

Elizabeth Merriwether Gilmer, better known as Dorothy Dix, was the "Dear Abby" of her day. Her readers wrote in scores with sensitive questions on love and courtship, difficult in-laws, money, religion, even recipes. She answered her mail personally, with characteristic directness. She became so popular that there was a Burma Shave ad with her name in it: "Love and Whiskers Do Not Mix—Don't Take Our Word, Ask Dorothy Dix."

Elizabeth Merriwether was the first of three children born to an old Virginia family that lost most of its holdings in the Civil War. They retained a sense of grandeur, however, eating scrounged meals off the silver plates that had shrewdly been buried during the war. Elizabeth's mother died when she was a teenager, and her father brought in a strict cousin to act as stepmother. Elizabeth fled home by marrying her new stepmother's brother, George Gilmer, when she was twenty years old.

George Gilmer, ten years her senior, was a poor choice. It soon became apparent that he struggled with mental illness, which required periodic stays in institutions. It also made him a terribly moody and unstable businessman, and the couple was plagued by money woes. Elizabeth Gilmer suffered a nervous breakdown after several years of trying valiantly to make the marriage work, and her father took her to recuperate at Bay Saint Louis, Mississippi. A neighbor there, Eliza Nicholson, asked her to write for the paper she owned and ran, the *New Orleans Daily Picayune.* Gilmer accepted, and joined the staff in 1894.

She soon had her own column, "Dorothy Dix Talks," and worked hard to make it a success. She readily absorbed criticism and advice, and prided herself on being punctual with deadlines. Her secret weapon was the safety deposit box in which she kept enough columns to cover a three months' absence. Soon she was successful enough to be a target for William Randolph Hearst's *New York Journal*, which wooed her for a year before she accepted their offer to join the staff.

In New York, she maintained her advice column, and was also set to work covering

murder trials. Her extraordinary empathy made her an ideal interviewer, and she was able to get the rather intimate details that were the quarry of the "sob sister" reporters, whose rather sensational stories boosted circulation and created a niche for some women reporters. It was not, however, Gilmer's niche, and in 1917 she told her editor she was fed up with murder trials and took a job with the Wheeler Newspaper Syndicate.

Gilmer was happy in syndication. She moved back to New Orleans, where she read her mail at seven every morning and wrote six columns a week, dividing her time between short moralistic essays and the time-honored question and advice columns. In these, she often had her crispest quips. In reply to the young woman who wondered if she should warn her fiancé about her false teeth, she wrote, "Marry him and keep your mouth shut." She developed a comfortable routine, and in 1929 she was freed from her marriage when George Gilmer died in an institution. She never thought about divorcing him; in time it became a point of honor for her to endure, since she made her living advising others to hang in there.

Her popularity did not waver throughout her long career. She eventually earned a salary of $90,000 a year, and she wrote several books capitalizing on the success of her column, including *How to Win and Hold a Husband by Dorothy Dix* (1939). Dorothy Dix faithfully answered over fifty years' worth of readers' letters, dictating from her bed as she neared ninety. She died in 1951, a month after her ninetieth birthday.

> *Punctual with deadlines, her secret weapon was the safety deposit box in which she kept enough columns to cover a 3 months' absence.*

TO FIND OUT MORE...

- Belford, Barbara. *Brilliant Bylines: A Biographical Anthology of Notable Newspaperwomen in America.* New York: Columbia University Press, 1986.

- Kane, Harnett Thomas. *Dear Dorothy Dix: The Story of a Compassionate Woman.* Garden City, NY: Doubleday, 1952.

- Sicherman, Barbara, and Green, Carol Hurd, eds. *Notable American Women: The Modern Period. A Biographical Dictionary.* Cambridge, MA: The Belknap Press of Harvard University Press, 1980.

- Schlipp, Madelon Golden, and Murphy, Sharon M. *Great Women of the Press.* Carbondale, IL: Southern Illinois University Press, 1983.

Rheta Louise Childe Dorr, 1872–1948

J ournalist Rheta Dorr was appalled by the epitaph she once read on a woman's tombstone: "Also Harriet, wife of the above." Dorr spent her career with a strong awareness of the invisibility of women and their problems. Her articles on historical events such as the Bolshevik uprising in Russia or the labor struggles in turn-of-the-century America or the American involvement in World War I are warmed by her sensitivity towards the women involved in them.

Rheta was a feminist at a young age. Born in Omaha, Nebraska, she was impressed as a teenager by the speeches of Susan B. Anthony and Elizabeth Cady Stanton. She had to sneak out of the house to hear them. Rheta spent a year at the University of Nebraska at Lincoln before dropping out, and began to support herself with jobs at the Lincoln post office and an insurance underwriting firm. At twenty-three, she moved to New York City, where she was exposed to a wider range of attitudes towards women and was swept up in the exciting circle of the Art Students League.

Two years later, she married a forty-year-old Seattle businessman, John Pixley Dorr, and moved with him to Seattle to raise a family. Julian, their son, was born in 1896. Marriage and motherhood had not changed her desire to define herself by her own actions, and she began to write stories and send them to New York newspapers. The marriage broke up over her continued activity and committed feminism. She was left with the sparse salary of a freelance writer, a two-year-old son, and her own determination to make her mark.

As the sole wage earner for her family of two, she was a sympathetic reporter for striking women workers after she returned to New York in 1898. She went undercover, living with her son in the immigrant community on the Lower East Side in order to investigate the lives of women gold beaters, new entries into a predominantly male trade. This was the first of a range of under-

cover explorations in several cities in which she marched along striking shirtwaist makers, saw babies born on factory floors, and experienced appalling work conditions and low wages first-hand. She rejected the argument that women should be paid less than men because they were usually not the main breadwinners for their families. Too many of the women she met were the main or only earners barely supporting their families.

After an unscrupulous collaborator at *Everybody's Magazine*, William Hard, first tried to steal her research and then published a distorted version under her name, Dorr spent two-and-a-half years writing for *Hampton's Magazine*. Her first book, *What Eight Million Women Want*, was a collection of the *Hampton's* articles, many of which continued her exploration of women and work.

In her spare time, Dorr was an ardent suffragist, organizing marches and traveling to England to explore the women's suffrage movement, led by Christabel Pankhurst. In 1914, she helped Pankhurst write an autobiography. During World War I, she was an early foreign correspondent. As usual, she threw herself into the research for her articles on the Bolsheviks in Russia, marching with the women's "Battalion of Death" and observing first-hand the horrors of battle. The articles were syndicated in American papers and her book, *Inside the Russian Revolution*, was published in 1917. Another wartime book, *A Soldier's Mother in France* (1918), was written after her son was sent to the Western Front.

Back in America, Dorr wrote two more books, the memoir *A Woman of Fifty* (1924) and *Susan B. Anthony: The Woman Who Changed the Mind of a Nation* (1928). In her sixties, her long journalistic career was curtailed by poor health, and her later years were saddened by the death of her son, who had become vice-consul in Mexico. She died in 1948 at the age of eighty-one.

> *A single mother, she rejected the argument that women should be paid less than men because they were usually not the main breadwinners for their families.*

TO FIND OUT MORE...

- Belford, Barbara. *Brilliant Bylines: A Biographical Anthology of Notable Newspaperwomen in America.* New York: Columbia University Press, 1986.

- Dorr, Rheta Louise Childe. *A Woman of Fifty.* New York: Funk & Wagnalls, 1925.

- Edwards, Julia. *Women of the World: The Great Foreign Correspondents.* Boston, MA: Houghton Mifflin, 1980.

- Filler, Louis. *Crusaders for American Liberalism.* New York: Harcourt, Brace, 1939.

Alice Dunbar-Nelson, 1875–1935

. .

Alice Dunbar-Nelson hated playing second fiddle to anyone. She would not have been happy with the way she is primarily remembered: as the widow of the poet Paul Laurence Dunbar, who was one of the first African-American poets to rise to prominence. But Dunbar was only a small part of her life. Dunbar-Nelson was twenty-seven when they separated and thirty-one when he died, and was already an important figure in her own right: an activist for civil rights and women's suffrage, a poet and short story writer, and a peerless journalist.

Alice Ruth Moore was born in New Orleans, Louisiana, the second daughter of a seaman and an ex-slave. Her family was among New Orleans's social elite, and her fair skin gave her an added mark of superiority in the city's color- and class-conscious Creole community. "Complexion did, in a manner of speaking, determine one's social status," she recalled in her diary. Later in her life, that sense of personal importance would carry her through difficult times when money was short and her work was underappreciated.

She had her first book privately printed when she was twenty. *Violets and Other Tales* (1895), a slim collection of poems and short sketches, is not considered her best work, but a poem from this collection nevertheless attracted the attention of Paul Lawrence Dunbar. The young poets began to correspond, and were married in 1898. Dunbar's poetry, with its distinct use of dialect, was winning him unprecedented recognition for an African-American poet (although never enough money to support the young couple). Alice Dunbar worked in the New York public school system to help pay the bills, and in the meantime wrote *The Goodness of St. Roque and Other Stories* (1899). Her poetry and stories have a feminist bent, but unlike her husband's, they do not approach the subject of race.

The marriage did not last. The Dunbars were separated in 1902. Paul Dunbar, ravaged by alcoholism and tuberculosis, died

four years later at the age of thirty-three. Alice Dunbar relocated to Wilmington, Delaware, where she worked for eighteen years as the head of the English Department at Howard High School and agitated for women's rights. She made a name for herself as an impressive public speaker. In 1916, she married Robert John Nelson. He was the publisher of a civil-rights newspaper, the *Wilmington Advocate.* Although this marriage was a strong working partnership, he was not the love of Dunbar-Nelson's life.

Dunbar-Nelson wrote a brilliant regular column on race issues for the *Washington Eagle,* and edited anthologies like 1914's *Masterpieces of Negro Eloquence* and 1920's *The Dunbar Speaker and Entertainer.* Keeping her first husband's famous name may have niggled her—she hated to live under anyone's shadow—but it helped win attention. Although she was well-known locally as a speaker, writer, and activist, neither she nor Nelson earned enough for a comfortable living, and any financial boost was important. Still, her convictions came first. In 1920, she lost her teaching job for ignoring the school district's rules against political activity. In 1921, as the first black woman to sit on the State Republican Committee of Delaware, she was part of a group of African-American activists who confronted President Harding at

> *In addition to her poetry and fiction, she wrote a brilliant column for the Washington Eagle.*

the White House. The group failed to convince him to give clemency to 61 African-American soldiers incarcerated after a "race riot" in Houston, Texas.

In 1922, Dunbar-Nelson became a Democrat when the Republican party let an anti-lynching measure slide. She threw herself with typical energy into its activities, backing the party's unsuccessful 1928 Presidential candidate, Al Smith, with her formidable talent for public speaking. Her pride kept her strong through a difficult period from 1928 to 1931, when she was the executive secretary of the Quaker-supported American Interracial Peace Committee.

The conflict between Dunbar-Nelson's pride and her often difficult financial situation was a constant drain on her energies. Her death at the age of sixty came, ironically, shortly after her second husband won a position on the Pennsylvania Athletic Commission that freed the couple from financial worries for the first time in their two-decade marriage.

TO FIND OUT MORE...

- Dunbar-Nelson, Alice. *Give Us Each Day: The Diary of Alice Dunbar-Nelson.* Edited by Gloria T. Hull. New York: W. W. Norton & Company, 1984.

- Gilbert, Sandra M., and Gubar, Susan, eds. *The Norton Anthology of Literature by Women: The Tradition in English.* New York: W. W. Norton & Company, 1985.

Jessie Redmon Fauset, 1882–1961

"It seems strange to affirm—as news for many—," wrote Zona Gale in the introduction to Jessie Fauset's 1931 novel *Chinaberry*, "that there is in America a great group of Negroes of education and substance who are living lives...quite unconnected with white folk save as these are casually met." Fauset populated her fiction with characters drawn from this group at a time when white readers expected African-Americans, whether in fact or fiction, to be poor and uneducated.

Fauset's novels sprang from her own experience. She was the daughter of a well-educated and very literary Philadelphia family. Her father, who was her role model after her mother died when Jessie was still a small child, was an Episcopal minister, and her brother became a writer and a school principal. The family's focus on education helped Fauset excel in public high school and at Cornell University, from which she graduated in 1905. She was probably the first black woman to be elected to Phi Beta Kappa at Cornell.

After she received her master's degree at the University of Pennsylvania, Fauset began to teach high school in Washington, D.C. Writing, however, was a family talent, and in her early thirties Fauset began writing articles for the NAACP's magazine, *The Crisis*, which was edited by W.E.B. Du Bois. The magazine was influential as a showcase for talented young African-American writers, and Fauset became one of its four staff writers. In 1919, she became its literary editor.

It was a time when attitudes were shifting. African-American writers, artists, and performers were, for the first time, becoming widely recognized. Alain Locke's landmark anthology *The New Negro* (1925) exemplified the literary changes that characterized the Harlem Renaissance: a new focus on writers like Fauset, **Zora Neale Hurston**, and Langston Hughes, who all celebrated ethnicity instead of playing it down. Each of them drew inspiration from their own lives, presenting a remarkably

rich and varied picture of African-American experience in the 1920s; Hurston, for example, wrote evocatively of rural Florida, while Fauset focused on the relatively privileged Philadelphia setting of her childhood.

During her time at *The Crisis*, Fauset was a crucial shaper of the "New Negro" literature. It was her responsibility to choose the literary entries for the magazine, and she mentored many young writers, sending them encouraging letters and inviting them to her home. To use Langston Hughes' term for her, Fauset was one of the "midwives" of the Harlem Renaissance. In 1926, she left the magazine to return to teaching and, in 1927, to marry businessman Herbert E. Harris.

A shaper of the "new Negro" literature, she chose literary entries for the NAACP's magazine The Crisis, *mentoring young writers and inviting them to her home.*

Fauset's novels always reflected her firm conviction that no one could succeed without self-acceptance. Prejudice could be overcome, but not self-loathing. Her second novel, *Plum Bun* (completed in 1929), centers around a light-skinned young artist who restlessly seeks acceptance in the white circles of New York art by "passing" as white. She eventually succeeds in finding happiness only when she drops the pose. *Plum Bun* met resistance from publishers; one editor complained that the characters wouldn't fit white readers' expectations of African-Americans. Despite the fact that Fauset took all her novels from her own experience, some were not yet ready to believe that African-Americans like Fauset and her characters existed.

Fauset had always hoped to write biographies of influential African-Americans. As a teacher, she saw a great need for role models, and she decried the absence of nonwhites in the classroom curriculum. She herself never had the chance. Writing could not support her, and she wrote only three novels after leaving *The Crisis*. She died in Philadelphia in 1961.

TO FIND OUT MORE...

- Branzburg, Judith Vivian. *Women Novelists of the Harlem Renaissance: A Study in Marginality.* Ph.D. dissertation, University of Massachusetts, 1983.

- Dannett, Sylvia G. L. *Profiles of Negro Womanhood. Volume II: 20th Century.* Yonkers, NY: Educational Heritage, Inc., 1966.

- Sicherman, Barbara and Green, Carol Hurd, eds. *Notable American Women: The Modern Period. A Biographical Dictionary.* Cambridge, MA: The Belknap Press of Harvard University Press, 1980.

- Sylvander, Carolyn Wedin. *Jessie Redmon Fauset: Black American Writer.* Troy, NY: Whitston Publishing Company, 1981.

Edna Ferber, 1886–1968

Novelist, journalist, and playwright Edna Ferber's forceful personality never went unnoticed. When at the start of World War II, she asked her friend George Kaufman what she could do to help the war effort, he replied, "Well, Edna, you could be a tank."

Ferber's mother was the effective head of the family from the time Edna was a child. When her husband Jacob's eyesight failed him, Julia Ferber took over the family store and the raising of their two daughters. Edna was born in Kalamazoo, Michigan, and raised all over the Midwest: Chicago, Illinois, where Julia Ferber's family lived; Ottumwa, Iowa; and Appleton, Wisconsin. Edna, who was Jewish, recalled her Midwestern neighbors as anti-Semitic. She escaped into books, reading prolifically and excelling in school. On her graduation at seventeen from Appleton's Ryan High school, however, she found herself stuck, with no money for college. Instead, she went to work at the local paper, the *Appleton Daily Crescent*, for three dollars a week.

According to her great-niece, Julie Goldsmith Gilbert, Ferber's relationship with her mother was complicated. After Jacob Ferber's death, Edna supported her mother with her writing. But as much as she emulated Julia Ferber's competence, Edna's feelings for her were never simple. She once compared the pleasure of her mother's company to a case of typhoid, but remained tied to her until Julia died. On her deathbed, Julia reportedly sighed, "Oh Edna...I ruined your life."

In addition to the burden of helping to support her family, Edna Ferber found reporting terribly strenuous. She moved from the *Crescent* to the *Milwaukee Journal*, where she earned fifteen dollars a week. At twenty-four, she collapsed from the stress and left journalism, never to fully return. But her years writing on deadline had been better training than college, and she kept the lessons she'd learned: hard work, research, and daily deadlines. She was self-disciplined enough to put these into practice on her own.

Ferber quickly began to produce vivid

fiction, publishing her first novel, *Dawn O'Hara*, in 1911, and the first of a series of stories about saleswoman Emma McChesney in 1913. These stories were a hit in the pages of *Cosmopolitan* and *The American Magazine*, and in 1915 they were dramatized in *Our Mrs. McChesney*, starring Ethel Barrymore. After a year of covering politics in Chicago and a trip to Europe, Ferber settled into New York life.

Her sharp wit made her a favorite at the Algonquin, where she often lunched with such notables as Moss Hart, Mike Todd, and Alexander Woollcott. Gilbert reports that Woollcott once sniped at Ferber's chic, broad-shouldered suit. "Why, Edna, you look almost like a man," he said. "Why, Aleck, so do you," she replied.

> *"Why, Edna, you look almost like a man," Alexander Woolcott sniped at her in her chic, broad-shouldered suit. "Why, Aleck, so do you," she replied.*

Meanwhile, her writing became increasingly popular. With the backing of a Chicago friend and mentor, her best-selling 1924 novel *So Big* won a Pulitzer Prize. That year, she began a long collaboration writing plays with George S. Kaufman. Their best-known collaboration, *Dinner at Eight* (1932) was made into a movie, with a screenplay by **Frances Marion**. Other productions followed from Ferber's novels: *Saratoga Trunk* (1941) and *Giant* (1952) both went to Hollywood, and *Show Boat* (1926) was made into a much-revived Jerome Kern/Oscar Hammerstein musical, which Ferber loved, in 1927. When she first heard the song "Old Man River," she later recalled, "My hair stood on end, tears came to my eyes. I knew that this...was a song that would outlast Kern and Hammerstein's day and my day and your day."

Sixty-seven years later and twenty-six years after Ferber's death, the musical is still playing on Broadway.

TO FIND OUT MORE...

- Ferber, Edna. *A Peculiar Treasure.* New York: Doubleday, Doran & Company, Inc., 1939.

- Gilbert, Julie Goldsmith. *Ferber, A Biography.* Garden City, NY: Doubleday, 1978.

- Sicherman, Barbara and Green, Carol Hurd, eds. *Notable American Women: The Modern Period. A Biographical Dictionary.* Cambridge, MA: The Belknap Press of Harvard University Press, 1980.

Mary Frances Kennedy Fisher, 1908-1992

Food writer M.F.K. Fisher wrote about far more than just food. As the critic Frances Taliaferro commented, calling her a leading food writer would be like calling Cézanne "the leading painter of apples." For Fisher, eating was a metaphor for life. She savored both. Her writing was luscious. As one admirer wrote, "The woman cannot write an ugly sentence." Her flawless prose helped bring the simple food of Provence to American readers. Her autobiographical musings on what she considered the three intertwined human needs—food, security, and love—charm readers with the force of her personality.

Raised Episcopalian and therefore outcast in a Quaker community in Whittier, California, Mary Frances Kennedy was the descendant of five generations of writers and journalists, including both parents. "I was a writer practically from the very beginning," she told interviewer Richard Leviton. "It was just heredity, not my fault." After an abortive stab at college, she married Albert Young Fisher, a student of English and French literature, in 1929 and moved with him to Dijon, France. There Mary Frances Fisher discovered simple, fresh French peasant food and fell in love with it.

Returning to Southern California in 1932, Fisher began to put her thoughts and joys on paper, and in 1937 they were collected in a book, *Serve it Forth*. She had communicated with the publishers by mail, and when she paid them a visit in person they were shocked and dismayed to learn that "M.F.K. Fisher" was a woman. They protested. She could not possibly be M.F.K. Fisher; a woman could not have written *Serve it Forth*. She kept the gender-ambiguous pen name throughout all three of her marriages.

She divorced Albert Fisher in 1938. A marriage to Dillwyn Parrish ended with his death in 1941, and her third marriage, to publisher Donald Friede, ended in divorce in 1951, leaving her with two young daughters. This is the sort of detail M.F.K. Fisher glossed over in her own writing. "I'm writ-

ing about peaches and fresh string beans. It's not necessary to say, 'Yes, that's my third husband, we slept together from such-and-such....' If that's what people want, tough." Instead, she wrote about her life by writing about oysters' sex lives, or the scum her grandmother skimmed from strawberry jam, or the way the town of Dijon smelled.

She always wrote her essays with some loved person in mind as the audience. They are inviting and warm. But she never could stand to read them herself—she once threw up after following a therapist's advice that she try—and considered her best work a 1949 translation from the French of Jean Anthelme Brillat-Savarin's *The Physiology of Taste*, which Fisher subtitled "Meditations on Transcendental Gastronomy." Perhaps this is because they shared the same philosophy on food and life: "Animals feed themselves; men eat; but only wise men know the art of eating," wrote Brillat-Savarin.

For Fisher, part of the art of eating was to be adventurous. She was always thrilled to discover new cuisines; after discovering the joys of Japanese food in 1978, she wrote *Japanese Cooking: A Simple Art* (1980). David Eames attributed shifts in American

> *She wrote about her life by writing about oysters' sex lives, or the scum her grandmother skimmed from strawberry jam, or the way the town of Dijon smelled.*

tastes to the fact that "Mrs. Fisher has been at our elbow—scolding, cajoling, insisting that we try the new, try just one bite." "There's only one thing I don't think I could eat," she told Richard Leviton, "and that's a grilled eye."

Although old age and Parkinson's disease made cooking impossible after the early 1980s, Fisher continued dictating from her wheelchair and, later, her bed until a year before her death. Her many friends and admirers kept her life full of small pleasures, often visiting her at her ranch in Glen Ellen, California. She always had gifts of fresh fruit or oysters to enjoy and too much fan mail to answer. She died at home at the age of eighty-three.

TO FIND OUT MORE...

- Akst, Daniel. Obituary. *Los Angeles Times,* June 24, 1992.

- Ferrary, Jeannette. *Between Friends: M.F.K. Fisher and Me.* New York: Atlantic Monthly Press, 1991.

- Fisher, M.F.K. *Among Friends.* New York, Knopf, 1971.

- Lazar, David, ed. *Conversations With M.F.K. Fisher.* Jackson, MS: University Press of Mississippi, 1992.

- Leviton, Richard. "M.F.K. Fisher and the Art of Eating." *East West,* Vol. 19, No. 10 (October, 1989), p. 46.

Janet Flanner, 1892–1978

For an expatriate American writer in Paris, Janet Flanner had an unusual aversion to the word "I." She wrote vivid and eloquent pieces for the *New Yorker* over the course of her fifty-year career that at least implied that she must have lived through some interesting experiences. She profiled Hitler, for example, and regularly wrote in her column "Paris Journal" about friends like **Djuna Barnes**, **Gertrude Stein**, **Carson McCullers**, **Kay Boyle,** and Ernest Hemingway. But she wrote under a carefully constructed alternate identity, with the pen name "Genet," and never could bring herself to write an autobiography.

If her cool distance from her readers was in some way a reaction to her childhood, she can hardly be blamed. Her mother was an imposing figure, a beautiful would-be actress who let her three daughters know that she blamed them for keeping her from a spectacular career on the stage. Her father, a well-to-do mortician who was considered an upstanding member of the Indianapolis community, committed suicide

in the chapel of his funeral parlor when she was nineteen. After attending college at the University of Chicago, Flanner permanently fled the Midwest by marrying a classmate and moving to New York.

The marriage did not last long after its usefulness as an exit for Flanner had ended. Soon, she had found the central love of her life in Solita Solano, a reporter for the *New York Tribune*. In 1921, Solano and Flanner moved to Paris together in search of a new world, and they found one in the community of artists and writers who made the city their home in the teens and twenties. Within five years of her arrival, Flanner had published an autobiographical novel, *The Cubical City* (1926).

Flanner lived with Solano for most of the next twenty years, and they were close all their lives. Solano was Flanner's editor and bookkeeper even after the relationship had moved towards friendship. But this was only the first of three love affairs that went on, more or less simultaneously, for a large part of Flanner's life. She met the writer **Natalie Barney** when she arrived in

Paris; ten years later, another American woman, Noel Haskins Murphy, joined the mix. Unlike Barney, Flanner was extremely uneasy with her nonmonogamous status, and took pains to hide her lovers from each other.

Flanner had once said that she "planned to spend her life hanging around the [Left Bank café] Deux Magots," and editor Harold Ross decided to take advantage of that hip attitude in a column for *The New Yorker*. He chose for her an androgynous pseudonym, "Genet," and she brought real flair to the gossipy pieces she wrote for him. She made a name for herself—or rather, for Genet— with her profile of Hitler, which showcased her sharp powers of observation. "He has a fine library of six thousand volumes, yet he never reads," she wrote. "Books would do him no good—his mind is made up."

Fiction had been difficult for Flanner to write; she had found it both too revealing and too self-indulgent. For the same reasons, autobiography proved impossible. She left no record beyond her articles, in which she is present only as a shadowy but chic observer, brushing shoulders unobtrusively with prominent figures. She fretted that her

At The New Yorker, she wrote under an androgynous pseudonym, "Genet," and brought real flair to the gossipy pieces she wrote, including a profile of Hitler.

work had no lasting value. But her writings, which have been collected in a range of volumes, have a sort of lasting immediacy, partly because she is such an unobtrusive factor in her own writing. Some of her pieces still effortlessly evoke their setting: the bleakness of occupied Paris in the forties, for example, or the hum of the Deux Magots in the interwar years. She wrote for *The New Yorker* from the twenties until her death at the age of 86 in 1978.

TO FIND OUT MORE...

- Flanner, Janet. *Paris Journal.* Edited by William Shawn. New York: Atheneum, 1965.

- Flanner, Janet. *An American in Paris: Profile of an Interlude Between Two Wars.* New York: Simon & Schuster, 1940.

- Rood, Karen Lane, ed. *Dictionary of Literary Biography: Volume Four. American Writers in Paris, 1920–1939.* Detroit, MI: Gale Research Company, 1980.

- Wineapple, Brenda. *Genet: A Biography of Janet Flanner.* New York: Ticknor & Fields, 1989.

Doris Fleeson, 1901–1970

Doris Fleeson, political columnist, had a flair for delivering a pithy phrase. She skewered politicians galore in her syndicated column. Richard Nixon drew her ire in the 1950s; prophetically, she complained that "He just doesn't know how to leave bad enough alone." She was a fierce feminist and supporter of the underdog at a time when Washington, and journalism, were comfortably male- and white-dominated.

Fleeson was the product of a small town. She was the baby in a family of six children, and grew up in Sterling, Kansas, where her father ran a clothing store. She was educated locally, graduating from the University of Kansas with coursework in journalism in 1923, and one of her first jobs was at the Pittsburg, Kansas *Sun*. But she had ambitions to work in a bigger town, and at twenty-five she moved to New York to break into reporting there.

At first, she took a job in Long Island with the *Great Neck News*, but within a year she had won a coveted staff position at the *New York Daily News*. With typical tenacity, she worked her way up to covering New York politics. Fleeson married her *Daily News* colleague John O'Donnell in 1930; they had a daughter, Doris, and moved to Washington, D.C. in 1933 to take on national politics together in a co-written column, "Capitol Stuff."

The column highlighted their personal and political differences. She was a great admirer of Eleanor and Franklin D. Roosevelt, whom she knew from New York politics, and was dismayed to find her husband was not. The breakup of their marriage, which ended in divorce in 1942, sent Fleeson back to New York. In 1943, however, she found a new job with the *Woman's Home Companion* as a war correspondent, and on her return she struck out on her own, writing a political column that at first had only two publishers.

Her clear analysis and biting criticisms began to gain her attention, not all of it flattering. But her column became widely published and her opinion much respected. Doris Fleeson became an imposing figure on the Hill, always perfectly put together, always ready with just the right difficult

question. She used her growing influence to espouse causes great and small, from the lack of women's rest rooms in congressional galleries to the lack of minority reporters in journalism. She was furious at the exclusion of women from the all-male Gridiron Club, which was a source of political news for other reporters, and she took special interest in mentoring young women reporters.

By the time John F. Kennedy became President, she was at the top of her profession, along with Walter Lippmann and Arthur Krock. She was probably the most feared of all political commentators. Kennedy quipped that he "would rather be Krocked than Fleesonized." Despite her public passions, her personal life was tranquil. Fleeson had married former Navy secretary Dan Kimball in 1958, and they lived happily together in the city. She died within two days of his death in the summer of 1970.

> *At the top of her profession along with Walter Lippmann and Arthur Krock, President Kennedy quipped that he "would rather be Krocked than Fleesonized."*

TO FIND OUT MORE...

- Belford, Barbara. *Brilliant Bylines: A Biographical Anthology of Notable Newspaperwomen in America.* New York: Columbia University Press, 1986.

- Sicherman, Barbara, and Green, Carol Hurd, eds. *Notable American Women: The Modern Period. A Biographical Dictionary.* Cambridge, MA: The Belknap Press of Harvard University Press, 1980.

- Further information about Doris Fleeson is in the Ruth Cowan Nash Papers at the Schlesinger Library at Radcliffe College.

Mildred Gilman, 1896–1994

Mildred Gilman was a successful "sob sister," a woman reporter who bluffed her way into the good graces of the people involved in high-profile scandals in order to write colorful, emotionally over-wrought stories for the tabloids. Journalistic objectivity played no part in this kind of reporting, and Gilman later cheerfully confessed to making up the details in her stories. In fact, she fibbed her way into her first newspaper job.

Mildred Evans was born in Chicago, Illinois, to George Dickinson and Eva Campbell Evans. Mildred's father, a furniture manufacturer, opposed her education, but both her mother and her godmother, botanist Mary Agnes Meara Chase, proved strong role models. Eva Evans taught her daughter to keep a diary to learn to write, and Chase brought Mildred to suffrage demonstrations. While earning her college degree at the University of Wisconsin, Mildred wrote her first semiautobiographical novel, *Fig Leaves.*

Immediately after her graduation in 1919, she married writer James Ward Gil-

man. After bearing him a son and running a bookstore in Springfield, Massachusetts, the marriage disintegrated and Mildred Gilman moved to New York. She landed a job as the personal secretary to the author and columnist Heywood Broun, who had read *Fig Leaves*, and she wrote a second novel, *Headlines* (1928), which included fictionalized stories based on real newspaper headlines. The year it was published, she set out to find a job in journalism.

Armed with a forged letter of recommendation from a recently dead editor (so that the forgery couldn't be checked), Gilman impressed the editor of the *New York Journal* enough that he asked her how much she would work for. She told him a technical half-truth: that she had never worked for a paper for less than $100 per week (scale pay for male reporters was then $60 per week). She had in fact never worked for a paper at all, but the editor had no way of knowing that. He had read *Headlines* and assumed that she knew what she was talking about. And since Mildred was a quick learner, she turned out to be well

worth her $100 salary.

Gilman proved especially adept at ingratiating herself with the people she needed to interview. In one highly publicized murder case, Gilman posed as a nurse to gain access to the accused murderer's wife. She was so sympathetic that the woman allowed her to stay in her home for two days, until Gilman's angry competition called the police to have her removed. Other stories required her to dodge the amorous advances of interviewees or to create imaginative details, including a fabricated "love diary" of a man who had killed a sixteen-year-old girl and then committed suicide. The real diary was in police possession.

She was engaged to fellow reporter Robert Wohlforth when she began to cover the Triple X murder case. Mysterious letters addressed to the *Journal* had correctly predicted a murder in Queens. A couple parked in a car was the target. The man was killed, the woman spared. Gilman and a photographer went to Queens to pose as decoys, and were not approached, but when the killer sent a taunting note identifying Gilman, she balked and quit her job. Wohlforth also left his paper, and the two moved to Connecticut, settled down, and

> **With a forged letter of recommendation from a recently dead editor (so that the forgery couldn't be checked), Gilman landed her first newspaper job at the New York Journal.**

had two children.

Gilman continued to write sporadically, selling her third novel, *Sob Sister* (1931) to Hollywood for $10,000. During Hitler's rise to power, she interviewed Herman Göring, and she wrote articles for *Redbook, American Mercury, Reader's Digest,* and *McCall's.* She and Wohlforth had sixty-three happy years of marriage, and she lived to see four grandchildren born before her death in Connecticut at the age of ninety-seven.

TO FIND OUT MORE…

- Belford, Barbara. *Brilliant Bylines: A Biographical Anthology of Notable Newspaperwomen in America.* New York: Columbia University Press, 1986.
- Collins, Jean E. *She Was There: Stories of Pioneering Women Journalists.* New York: J. Messner, 1980.
- Obituary. *The New York Times,* January 6, 1994.
- Obituary. *Minneapolis Star Tribune,* January 6, 1994.

Ellen Anderson Gholson Glasgow, 1873–1945

Ellen Glasgow fought to distinguish her novels from the Southern pulp romances that other writers churned out. It sometimes was difficult, for she shared with the writers of those novels an ability to churn out a book at least once every other year, enormous popularity, and (in retrospect) a certain amount of class prejudice and racism. But she did manage to capture Virginia society in her pages with a saving measure of ironic detachment, and when she chose she could dash off a line as sharp as any **Dorothy Parker** ever wrote.

Ellen Glasgow was a proud descendant of old Virginia blood. She identified strongly with her mother, whose family was more aristocratic than her father's, and in her memoirs painted both herself and her mother as perfect Southern belle martyrs: beautiful but sensitive, and weakened by constant trials, smiling bravely through any pain. Ellen was raised with the help of an African-American nanny (she was one of ten children) who reportedly described her as "born without a skin." When Ellen was twenty, her mother died. Bereaved, she destroyed the manuscript of her first novel.

The early events of her life are shadowy because no records or correspondence from before 1912 exist. Glasgow claimed that her eldest sister, Emily, accidentally destroyed them when cleaning house.

She was forced to rewrite her first novel from scratch. This melodramatic work had a troubled birth: after it was rejected for the first time, its seventeen-year-old author tore it up. She rewrote it only to once again destroy it at her mother's death, and the third rewrite was not accepted for publication until she was twenty-four. Despite its difficult passage, *The Descendant* (1897) did well.

She began to crank out novels every other year. In them, crisply ironic tidbits are mixed in with sloppily sentimental passages. She had a particular weakness for the myth of the Southern belle, and her female characters are often upper-class, bravely suffer-

THE REMARKABLE LIVES OF

ing symbols of Womanhood At Its Best. Still, her novels were popular, and she was tremendously shrewd as her own agent, switching publishing houses whenever it suited her and pursuing carefully arranged interviews in order to present her novels in the best possible light. Meanwhile, she unsuccessfully sought a cure for the progressive deafness that plagued her for the rest of her life.

In this, she was enormously successful. In her later years, the tempests of her young life had passed. Her first love, a married man she calls "Gerald B—" in her memoirs, and her closest siblings Frank and Cary had all died. In the thirties, the acclaim she had long sought as a "realistic" writer of the South came home to her, and she was widely considered a major figure in American literature. She received multiple honorary degrees from prestigious Southern colleges like Duke, William and Mary, and the University of North Carolina. Her 1941 novel *This is Our Life* was made into a movie with Bette Davis, and in 1942 she received the Pulitzer Prize for fiction.

In the last years of her life, she performed the ultimate manipulation of her image in writing her memoir, *The Woman Within* (1954). In the absence of other records, she was able to present her vision of herself before 1912 in her own words. As quoted in *Notable American Women*, her close friend James Branch Campbell described it as a "beautiful and wise volume which contains a large deal of her very best fiction."

> *With a weakness for the myth of the Southern belle, her female characters are often upper-class, bravely suffering symbols of Womanhood At Its Best.*

TO FIND OUT MORE...

- Gilbert, Sandra M., and Gubar, Susan, eds. *The Norton Anthology of Literature by Women: The Tradition in English.* New York: W. W. Norton & Company, 1985.

- Sicherman, Barbara, and Green, Carol Hurd, eds. *Notable American Women: The Modern Period. A Biographical Dictionary.* Cambridge, MA: The Belknap Press of Harvard University Press, 1980.

- Unger, Leonard, ed. *American Writers: A Collection of Literary Biographies. Volume II.* New York: Charles Scribner's Sons, 1974.

Susan Glaspell, 1882–1948

Susan Glaspell and her husband George Cram Cook were the founders of the Provincetown Players, the "little theater" group that first staged the plays of Eugene O'Neill and sparked a new era in American theater. Glaspell, herself an accomplished novelist and short story writer, began writing plays for the Players, and went on to win a Pulitzer Prize with her 1930 play *Alison's House.*

Glaspell grew up with two brothers in Davenport, Iowa. The Glaspell family was not wealthy, but it was one of the oldest in Davenport and took pride in its Midwestern roots. Susan Glaspell enrolled at Drake University in Des Moines, where she began to write short stories. On her graduation in 1899, she worked for a couple of years as a reporter, but finally settled on establishing herself as a creative writer in 1901. Her early publications were short stories that appeared in such magazines as *Harper's Monthly* and *Woman's Home Companion.* Her first novel, *The Glory of the Conquered* (1909), was a commercial success, but it stayed safely within established conventions of the romantic novel. Her later novels were

more ambitious. *The Visioning* (1909) tackled such sensitive topics as natural selection, divorce, and the union movement; *Fidelity* (1915) cast light on the narrow societal roles afforded to women. There was also a collection of short stories, *Lifted Masks* (1912), based on her journalistic work.

Glaspell married progressive writer George Cram Cook in 1914 and co-founded the Provincetown Players with him the following year. The latter development marked not only the beginning of Glaspell's career as a playwright, but eventually came to be seen as one of the watershed events in the history of American theater. The Provincetown Players provided support and exposure for a whole generation of important playwrights, most notably Eugene O'Neill.

Glaspell, who not only wrote for the Players but acted and directed there as well, was named president of the fledgling group. She wrote a number of one-acts (including *Trifles*, 1917), and collaborated with her husband on a full-length satire of Freudian theory called *Suppressed Desires* (1915). Her first full-length solo drama, *Bernice,* was

produced in 1919, and the experimental work, *The Verge*, in 1921.

By 1922, the Provincetown Players (who had moved to New York) were no longer an obscure underground assembly of starving artists; they were the premier outlet for new American theatrical fare. That change of focus carried organizational and commercial implications that Glaspell and her husband found difficult to accept. In 1922, they left the company for an extended period of travel in Greece; Cook died during the sojourn.

> **She co-founded the legendary Provincetown Players.**

After the death of her husband, Glaspell traveled extensively and met Norman Matson, a writer whom she wed in 1925. During this period she wrote the novels *Brook Evans* (1929) and *Fugitive's Return* (1929), and the plays *The Comic Artist* (a collaboration with Matson, 1928) and *Alison's House* (1930), for which she received the Pulitzer Prize. *Alison's House* dealt with a family's struggle to decide whether or not to publish a group of poems written by their relative Alison Stanhope, dead for eighteen years. Stanhope's brilliant poems, which have just surfaced, chronicle a love affair with a married man; they could bring scandal to the family. Like many of Glaspell's dramas, *Alison's House* explores the limitations of small-town concepts of morality and propriety.

Although she worked in various capacities in the theater after *Alison's House*, Glaspell did not write any more drama, preferring instead to focus on her fiction. Her later novels included the successful *Morning is Near Us* (1940). Truth be told, Glaspell probably would have preferred to be remembered as a novelist rather than as a playwright, but her work for the stage had a far greater impact. Glaspell's bold stage experimentations, combined with her support of new and unconventional work, had a major impact on the American theater.

She died in Provincetown of pneumonia on July 27, 1948.

TO FIND OUT MORE...

- Baechler, Lea, and Litz, A. Walton, eds. *American Writers: A Collection of Literary Biographies. Supplement III, Part 1.* New York: Charles Scribner's Sons, 1991.

- James, Edward T., ed. *Notable American Women: 1607–1950: A Biographical Dictionary.* Cambridge, MA: The Belknap Press of Harvard University Press, 1971.

- Magill, Frank N., ed. *Great Women Writers: The Lives and Works of 135 of the World's Most Important Women Writers from Antiquity to the Present.* New York: Henry Holt, 1994.

- Waterman, Arthur E. *Susan Glaspell.* New York: Twayne Publishers, 1966.

Caroline Gordon, 1895–1981

Considered by some "the most neglected figure of the southern literary renascence," novelist Caroline Gordon remains something of an enigma more than a decade after her death. Her marriage to the poet Alan Tate dominated forty years of her life and much of her literary work, as, indeed, it must dominate any reasonable assessment of her career. Gordon's epic, unyielding rage at Tate's casual infidelities had a habit of filtering into her novels and stories, which frequently dealt with love-hate relationships between men and women.

Gordon, the daughter of a Kentucky preacher, married Tate in 1925 when she was five months pregnant. (They had met while Tate was visiting Vanderbilt University.) Before she published her first short story in 1929, she had been a private secretary to the English writer Ford Madox Ford. (Her critical study of Ford's work, *A Good Soldier: A Key to the Novels of Ford Madox Ford*, boasts an enviable familiarity with her subject's work.)

One of Gordon's early novels, *Aleck Maury, Sportsman*, was said to have been based on her father's life. Much of her later output, however, was profoundly affected by her complex relationship with Tate, whom she divorced when she was fifty, then remarried, then divorced again. Current accounts of the couple's life chronicle a talented, angry woman who was not above flinging china around the house when venting her anger at Tate's behavior. Gordon was nevertheless deeply connected to the poet—and, apparently, to her rage toward him. Tate's 1933 affair with one of Gordon's cousins was the flashpoint of the ongoing conflict between the two, but there were many, many other such incidents in later years. That she continued to simultaneously love the man and cultivate a fury for his many failings seems clear. Her fury toward Tate—a man who had, after all, clearly demonstrated himself as incapable of monogamy—appears to have become a permanent component of her identity. (The couple apparently continued to maintain many intellectually and emotionally incendiary aspects of their intricate relationship even after their second divorce.)

Throughout their stormy partnership, Tate and Gordon nurtured and supported other writers, often at a distinct cost to their own work. Among the writers Gordon personally championed were such giants as Flannery O'Connor and William Faulkner. Her own output often suffered by comparison with that of such figures; her husband's poetic work, too, often overshadowed her. Gordon also suffered from more than her fair share of bad luck. Her novel *None Shall Look Back*, a Civil War saga, had to compete with Margaret Mitchell's *Gone With the Wind*, released in the same year (1936). Other of her notable works included *Penhally* (1931), *Green Centuries* (1941), and *The Strange Children* (1951). These all received what might best be described as middling popular and critical attentions.

> The main theme of Gordon's work—the "chronic misunderstandings and inadequacies between men and women"—is now a popular topic with today's fiction readers.

The main theme of Gordon's fictional work, as one of her biographers has put it, was the "chronic misunderstandings and inadequacies between men and women." Given the popularity of that topic with today's fiction readers, Gordon's often challenging work may yet find the audience it deserves.

Caroline Gordon's rich literary career spanned more than half a century. She published nine novels and two books of short stories; she was at work on a tenth novel, *The Narrow Heart*, at the time of her death after surgery in San Cristobal de las Casas, Chiapas, Mexico. She was eighty-six.

TO FIND OUT MORE...

- Obituary. *The New York Times*, April 14, 1981.
- Makowsky, Veronica. *Caroline Gordon: A Biography*. New York: Oxford University Press, 1989.
- Rood, Karen Lane, ed. *American Writers in Paris, 1920–1939*. Detroit: Gale Research Company, 1980.
- Stuckey, W. J. *Caroline Gordon*. New York: Twayne Publishers, 1972.
- Unger, Leonard, ed. *American Writers: A Collection of Literary Biographies*. New York: Charles Scribner's Sons, 1974.
- Waldron, Ann. *Close Connections: Caroline Gordon and the Southern Renaissance*. New York: Putnam, 1987.

Lorraine Hansberry, 1930–1965

Lorraine Hansberry's best-known play, *A Raisin in the Sun*, was much praised for its unflinching honesty about the deferred dreams of an African-American family much like her own. That honesty was a hallmark of her life. She had a tremendous capacity for self-reflection and the courage to speak out about her convictions—which were not always as popular as her award-winning play.

Hansberry's life called for courage very early on. When she was eight, her parents moved the family from their home on the South Side of Chicago to Hyde Park, a wealthy neighborhood of white residents. The family was forced to dodge threats, curses, and bricks. Lorraine's mother, Nannie, took to keeping vigils with a gun. After an Illinois court evicted the Hansberrys, her father, Carl, was deeply embittered by the long court struggle which followed; even though the Supreme Court upheld the family's right to live where they chose, the experience convinced him that even America was deeply and hopelessly racist. He was preparing to move to Mexico when he died

suddenly at the age of fifty-one.

After two years spent studying stage design at the University of Wisconsin, Hansberry quit to pursue a career in painting. But with remarkable self-knowledge— she was only twenty—Hansberry quickly decided that she had no talent for painting and moved to New York City. There, she met and, in 1954, married songwriter and music publisher Robert Nemiroff, the son of the white family who owned a restaurant where she supported herself briefly as a waitress. He became one of her greatest friends and supporters.

Hansberry tried for the next four years to express her convictions in a play. In 1957, after several abortive attempts, she completed *A Raisin in the Sun*, a powerful play about an African-American family that moves into a white neighborhood. It took some time to win the necessary support to produce the play in New York, but when it premiered in March of 1959, it became an instant hit. It ran for nineteen months and beat out entries by Tennessee Williams and Eugene O'Neill for the 1959 Drama Critics

Circle Award. At twenty-nine, Hansberry was the youngest person and the first African-American ever to win the award.

She used her new-found prominence to take visionary public stands, in speeches, essays, and plays, on issues that concerned her. Her most ardent criticism was reserved for bigotry in its many forms: against women, against African-Americans, against gays, against radical thought. Nemiroff later used a line from her play *The Sign in Sidney Brustein's Window* to sum up her attitude towards social injustice: "I care. I care about it all. It takes too much energy not to care."

"I care. I care about it all. It takes too much energy not to care."

Her tongue-in-cheek essay "In Defense of the Equality of Men" (1961) pointed out that American women were discouraged from seeking fulfillment through any means other than home and family two years before Betty Friedan's *The Feminine Mystique* brought that idea widespread attention.

A Raisin in the Sun made predominantly white audiences see the Younger family as human beings, not amusing stereotypes. A brave and eloquent champion of the civil rights struggle, Hansberry spoke of it in terms like "revolt" and "revolution."

Towards the end of her life, she turned her sharp critical eye on herself and found that her marriage was not what she wanted. She and Nemiroff were divorced in 1962, but they remained close friends. Critic Margaret Wilkerson, who is putting together a biography of Hansberry, quoted Nemiroff in a 1994 *Seattle Times* article. "By the end of her life," he told Wilkerson, "she realized she was a lesbian." It took courage and self-knowledge to leave such an amiable marriage, even though she realized it was not right for her. She would need all that courage and more the next year, when, at age thirty-three, she found out she had cancer.

Despite the progression of her illness, she continued to write and lecture whenever possible, even leaving her bed on occasion to speak out. She died at 34, leaving Nemiroff to spend the rest of his life publishing and promoting her astonishing body of articles, essays, and partly finished plays.

TO FIND OUT MORE...

- Dannett, Sylvia G.L. *Profiles of Negro Womanhood. Volume II: 20th Century.* Yonkers, NY: Educational Heritage, Inc., 1966.

- Gilbert, Sandra M., and Gubar, Susan, eds. *The Norton Anthology of Literature by Women: The Tradition in English.* New York: W. W. Norton & Company, 1985.

Lillian Hellman, 1907–1984

Lillian Hellman, playwright and activist, woman of principle and celebrated memoirist, was said to be at her best when she was angry. During her storied career, she had plenty of opportunities to be at her best.

Hellman was born in New Orleans in 1907; her family moved north to New York after her father's business failed. She attended Columbia and then worked as a manuscript reader in the late twenties and early thirties, eventually reviewing and analyzing hundreds of playscripts for a theatrical production firm. The experience was the foundation of her later playwriting career.

For a woman to have written a successful Broadway play in the early 1930s—when the theatrical world was male-dominated and prone to certain unfortunate stereotypes about women writers—was remarkable enough. But for her to have succeeded with *The Children's Hour*, a sensitive, groundbreaking drama about two small-town teachers accused of a lesbian affair, was truly staggering. The play ran for 691 performances on Broadway, changed forever the

way the theater world looked at "women writers," and broke new ground with regard to what could or couldn't be discussed in the American theater. Her successful later plays included *The Little Foxes* (1939) and *Another Part of the Forest* (1946), each of them chilling portraits of a ruthless Southern family.

With her friend Dorothy Parker and her longtime companion Dashiell Hammett (her first marriage to writer Arthur Kober ended after seven years), Hellman was active in the fight against Fascism during both the Spanish Civil War and World War II. Both she and Hammett were eventually blacklisted during the McCarthy years as Communist sympathizers. Hellman, called before the House Un-American Activities Committee, explained that while she was willing to explain her own activities in prior years, she would not provide the names of others to the committee. Her famous refusal to name names is today remembered as a rare instance of personal courage in the face of blind conformity and anti-Communist hysteria. But the couple paid for their convic-

tions; paying work was hard to come by under the blacklist, and Hammett spent five months in jail for contempt of Congress. Apparently, Hellman never regretted the decision they made to stand their ground; she was quoted as saying "'You have to live by your own standards, even if you're going to be lonely and unpopular."

Hellman's long-term relationship with Hammett, a mystery writer, lasted until his death in 1961. After that, Hellman began to teach and work on her memoirs. This phase of her career saw her take her place as one of the country's foremost women of letters: she won the National Book Award for *An Unfinished Woman* (1969), and followed this with the moving book of reminiscences *Pentimento* (1973). *Pentimento* featured an account of a friend Hellman referred to as "Julia" who had struggled in the underground to defeat Fascism in Europe; this portion of the book was made into an acclaimed film starring Vanessa Redgrave. *Scoundrel Time* (1976) offered Hellman's memories of the McCarthy era, and was also widely praised.

Near the end of her life, Hellman suffered from many physical problems: she

> *During the anti-Communist hysteria of the McCarthy years, Hellman refused to name names. "You have to live by your own standards, even if you're going to be lonely and unpopular," she said.*

was, in the weeks before her fatal heart attack, half-paralyzed, legally blind, unable to eat or sleep, and in constant pain. When a friend asked, "How are you, Lillian?" she responded, "Not well." "Why?" she was asked. "This is the worst case of writer's block I've had in my life," she answered.

At her funeral on her beloved Martha's Vineyard in 1984, playwright and cartoonist Jules Feiffer recalled Hellman's stinging 1952 rebuke to the Congressional committee: "I cannot and will not cut my conscience to fit this year's fashions." Eulogizing Hellman, Feiffer said, "Others saw her as courageous at these times of her life. I don't think she saw it that way. She knew of no other thing to do."

TO FIND OUT MORE...

- Feibleman, Peter S. *Lilly: Reminiscences of Lillian Hellman.* New York: Morrow, 1988.

- Hellman, Lillian. *Scoundrel Time.* Boston: Little, Brown, 1976.

- Hellman, Lillian. *Three by Lillian Hellman, with new commentaries by the author.* Boston: Little, Brown, 1979.

- Wright, William. *Lillian Hellman: The Image, the Woman.* New York: Simon & Schuster, 1986.

Josephine Herbst, 1892–1969

Novelist and journalist Josephine Herbst's true calling only became apparent after her death, when her moving (but incomplete) memoirs were published. Her accounts of her turbulent love life—and her knack for popping up in interesting places at crucial times—make *The Starched Blue Sky of Spain* (1991) the most compelling writing of this fascinating woman's career.

She was born in Sioux City, Iowa, and was raised in a middle-class environment there. Her mother constantly voiced the opinion that Josephine was capable of great things. After graduating from the University of California at the age of 26, Herbst took off for Greenwich Village, where she struck up acquaintances with such figures as H. L. Mencken, Max Eastman, Floyd Dell, and Mike Gold. It was Mencken who got Herbst her first writing job, at *The Smart Set*. There followed an intense affair with the writer Maxwell Anderson—a married man and the father of five children—who got her pregnant. After this relationship ended (he had persuaded her to have an abortion),

she made her way to Europe in 1922, where she wrote, struggled, and met and fell in love with the writer John Hermann. The two married and returned to New York, but their marriage was a stormy one. Nevertheless, when Hermann became a Communist, Herbst followed his lead and wrote inflammatory magazine pieces, worked on behalf of striking farmers and miners, and lent her name to a number of Communist fronts. Her political convictions, which led her to cover many of the most momentous international events of the day, were evidently quite deep. Even after Hermann, an epic philanderer, had run off to Mexico with another woman a decade and a half later, Herbst refused to cooperate with Federal investigators tracking down the (legitimate) lead that it was Hermann who had introduced then-Communist operative Whitaker Chambers to Alger Hiss in 1934.

Herbst's was a life of danger and adrenaline, set in Cuba, Spain, and Germany when those countries were in turmoil, and beside Ernest Hemingway when that writer was, at times, similarly uninviting. Many of

the events she took part in and wrote about—notably the Spanish Civil War—can be said to be core events in the romantic vision of radicalism that is still popular today. Although praised during her career for her novels, current critics are more inclined to favor Herbst's absorbing memoirs, which capture a time of idealism and outright radicalism as few other writers have.

Set among some of the most famous people and events of the century, her recollections are emotional, unforgettable, sometimes exhilarating, sometimes disastrous journeys—not unlike the author's own turbulent life.

Herbst was a loud opponent of the war in Vietnam and a supporter of the struggle for black civil rights in the sixties. Looking back over the course of her long, eventful years, she wrote, "The real events that influence our lives don't announce themselves with brass trumpets, but come in softly, on the feet of doves. We don't think in headlines; it's the irrelevant detail that dreams out the plot." If these are strange words coming from the pen of a woman who had once been a prominent foreign correspondent, covering some of the most important international news events of the day, they were neverthe-

less words earned as the result of years of experience and reflection. Through tumult and chaos—and, indeed, through details both relevant and irrelevant—Josephine Herbst lived life on her own imperious terms.

> "The real events that influence our lives don't announce themselves with brass trumpets, but come in softly, on the feet of doves. We don't think in headlines; it's the irrelevant detail that dreams out the plot," she wrote.

TO FIND OUT MORE...

- Langer, Elinor. *Josephine Herbst.* Boston: Little, Brown, 1984.

- Grossman, Ron. "A Lesser Novelist's First-Class Memoirs," *Chicago Tribune,* September 18, 1991.

- Lynn, Kenneth. "Josephine Herbst: The Life of the Party," *Washington Post,* August 12, 1984.

Lorena Hickok, 1893–1968

In 1933, journalist Lorena Hickok decided that her close friendship with First Lady Eleanor Roosevelt somewhat compromised her position as an objective reporter. Stepping down from her position with the Associated Press, she used her reporter's skills to investigate Depression-era America, uncovering poverty and disease in rural America for the Federal Emergency Relief Administration.

Hickok's childhood was not a nurturing one. Her mother died when Lorena was thirteen, and her father was a frustrated tyrant who beat his children. She was born in East Troy, Wisconsin, but the family moved repeatedly, following her father's sporadic employment. Her mother's cousin, whom Lorena called "Aunt Ella," helped her leave home at fifteen. With Aunt Ella's loving support, she was able to finish high school in Battle Creek, Michigan, and attend (but not complete) college at the University of Minnesota.

At twenty, Hickok began to work for the local *Battle Creek Evening News*. She soon left for the *Milwaukee Sentinel*, where she was put to work on the society pages. She worked her way to a byline and was soon writing feature stories, although her beat was covering celebrities. Hickok found a congenial new home at the *Minneapolis Tribune* in 1917. Thomas J. Dillon, the paper's managing editor, gave her free rein to cover a wide range of subjects, including sports, politics, and crime. She referred to Dillon as "the Old Man," and she was dubbed "Hick" and welcomed into the paper's stable of writers.

After a decade spent honing her skills as an interviewer at the *Tribune*, Hickok moved to New York, where she joined the Associated Press. One of her regular subjects there, Franklin D. Roosevelt, led to Hickok's coverage of Eleanor Roosevelt during the presidential campaign of 1932. The two women became fond friends, and soon were corresponding regularly. They often vacationed together, visiting Puerto Rico on one trip and the west coast on another. Later, Hickok wrote warmly of her friend in *Reluctant First Lady* (1962).

To avoid a possible conflict with her

THE REMARKABLE LIVES OF

journalistic integrity, Hickok left the Associated Press after Franklin D. Roosevelt's inauguration in 1933. She took a unique position at the Federal Emergency Relief Administration, roaming the country as an investigator and reporting to Administration head Harry Hopkins. Many of her passionate accounts of the poverty and hopelessness she found are in the Franklin D. Roosevelt Library in Hyde Park, New York. Her reports provided important feedback for the Roosevelt administration's New Deal policies, illustrating the desperate need for aid in America's rural communities.

In 1940, she began work for the Democratic National Committee, where she served four years as executive secretary for the Women's Division. Meanwhile, she lived in the White House with the Roosevelts and cultivated friendships with prominent political women, including New Jersey Congresswoman Mary Norton. In 1945, however, her diabetes, which had long made her work more difficult, forced her to retire from her Washington activities.

She turned her talent towards biography, completing books on both Roosevelts, Helen Keller, and Keller's teacher Anne Sullivan Macy between 1956 and 1961. A final biography of labor leader Walter Reuther was finished after her death by Jean Gould. Despite the incapacitating complications of her diabetes, which included the loss of her eyesight, she continued to write until her death in 1968.

Given free reign to cover a wide range of subjects while at the Minnesota Tribune, she referred to managing editor Thomas Dillon as "the Old Man," and she was dubbed "Hick."

TO FIND OUT MORE...

- Faber, Doris. *The Life of Lorena Hickok: Eleanor Roosevelt's Friend.* New York: W. Morrow, 1980.

- Ross, Ishbel. *Ladies of the Press: The Story of Women in Journalism by an Insider.* New York, Harper, 1936.

- Sicherman, Barbara, and Green, Carol Hurd, eds. *Notable American Women: The Modern Period. A Biographical Dictionary.* Cambridge, MA: The Belknap Press of Harvard University Press, 1980.

Marguerite Higgins, 1920-1966

Marguerite Higgins was one of the few women reporters who survived the purges of women from jobs in journalism after the men returned home from World War II. Women, who had been called to fill in for the absent men in all fields of work during the war, were urged after the crisis to step aside for the men. Many women lost their jobs, and left the work world to start families. Higgins, however, continued to work *while* starting a family. She had two children and won a Pulitzer Prize for foreign correspondence in the fifties.

Higgins was born abroad, the only child of an American importer working in Hong Kong and his French wife. The three Higginses moved to California when Marguerite was three years old. Marguerite was a strong student. She graduated from the Anna Head School in Berkeley in 1937 and the University of California at Berkeley in 1941, and was accepted as a master's candidate in journalism at Columbia University.

When she completed her master's degree in 1942, she was hired as a reporter by the *New York Herald Tribune*. Higgins had worked for the paper earlier as a student campus correspondent from Columbia. It was an opportune time for her to start work in journalism, for the draft was opening up positions for women across the country. Higgins's 1942 marriage to Stanley Moore proved no obstacle to her work, for she was a dedicated and fiercely competitive reporter. Within three years, Higgins had risen to the post of Berlin bureau chief for the *Herald Tribune*. Along with photojournalist **Margaret Bourke-White**, she covered the liberation of the German concentration camps. She won the 1945 New York Newspaper Women's Club Award for best foreign correspondent for this work.

Her first marriage ended in divorce in 1948, but her career continued to flourish despite the return of male rivals. In 1950, she became the paper's Far East bureau chief and traveled to Korea to cover the war

there. Her blond good looks didn't help her there; officers thought she should be at home and often ordered her away from the front lines. One even went so far as to order her out of the country. But she won the support of General Douglas MacArthur, and stayed on to compete with the *Herald Tribune*'s ace reporter, Homer Bigart, in covering the war. Both journalists won Pulitzer Prizes for the articles they produced in their efforts to top each other.

After her return to the States, she married the former U.S. Intelligence director for Berlin, Lt. General William E. Hall, in 1952. The couple made a home in Washington, D.C., and had two children, Lawrence O'Higgins and Linda Marguerite.

> Despite officers' orders to stay away from the front lines, she won a Pulitzer Prize for her coverage of the Korean war for the **New York Herald Tribune.**

Meanwhile, Marguerite Higgins continued to travel and write for the *Herald Tribune*, uncovering early stories on the Bay of Pigs nuclear crisis in 1962 and on the emerging problems in Vietnam as early as 1963. Her 1965 book on Vietnam, prophetically titled *Our Vietnam Nightmare*, criticizes the American approach to the conflict.

In 1963, Higgins began writing a column for the New York *Newsday* that was syndicated in ninety-two other papers. Her work took her far afield. On one 1965 trip to Pakistan, India, and Vietnam, she contracted a deadly tropical infection, leishmaniasis, which cut short her travel. She was able to return to Washington for treatment, but after a few months, she succumbed to the disease at the age of forty-five.

TO FIND OUT MORE...

- Belford, Barbara. *Brilliant Bylines: A Biographical Anthology of Notable Newspaperwomen in America.* New York: Columbia University Press, 1986.

- Higgins, Marguerite. *War in Korea: The Report of a Woman Combat Correspondent.* Garden City, NY: Doubleday, 1951.

- May, Antoinette. *Witness to War: A Biography of Marguerite Higgins.* New York: Beaufort Books, 1983.

- Schlipp, Madelon Golden, and Murphy, Sharon M. *Great Women of the Press.* Carbondale, IL: Southern Illinois University Press, 1983.

- Sicherman, Barbara, and Green, Carol Hurd, eds. *Notable American Women: The Modern Period. A Biographical Dictionary.* Cambridge, MA: The Belknap Press of Harvard University Press, 1980.

Peggy Hull, 1889–1967

Peggy Hull was the first woman accredited as a war correspondent by the U.S. government. Her thirty-one-year career encompassed military reporting on six fronts, including front-line work in the Sino-Japanese conflict of the early 1930s. On one occasion during that war, while being driven to interview a Chinese general, her car came under fire. She and her driver made their way to a space inside a nearby Chinese tomb. As the sounds of the advancing Japanese army became harder to ignore, her driver fled the shelter—and was shot on sight. The soldiers began to advance toward the tomb, but Hull emerged with her hands held high and her hair down, praying that she would not be mistaken for a combatant. As it happened, her captors understood some English and took at face value her explanation that she had had no idea there was fighting in the area. Years later, upon meeting a Japanese general who had heard the story, she was admonished to give up her job or risk ending her life on a battlefield. She did neither.

Hull was born Henrietta Eleanor Goodnough in Bennington, Kansas. She began her newspaper career at the tender age of sixteen, and married a newspaperman, George C. Hull, at twenty-one. When the couple moved to Honolulu, George became the city editor of the *Honolulu Evening Bulletin* and Peggy worked as a reporter. She left George Hull, who had a drinking problem, in 1914, and wrote stories for whatever papers she could convince to take her on. At the *Minneapolis Tribune*, she stopped using her real name on bylines and replaced it with the snappier "Peggy Hull."

In 1916, when the Ohio National Guard was sent to the Mexican border to help apprehend Pancho Villa, Hull covered the story for the *Cleveland Plain Dealer*. It was the first of her military assignments. Hull was liked by her many colleagues, who seem to have viewed her as a mascot of sorts. Some fellow reporters arranged for her to emerge on horseback side-by-side with General John Pershing as he pranced by for photographers, leading his troops out of Mexico. The image of the "girl reporter" next to the great general was seen around the world.

After that, war assignments came fairly regularly, although it should be said that much of Hull's popularity had to do with the novelty of a female reporter being anywhere near a war zone in the first place. Hull, who knew what it took to get an assignment, played to, rather than against, such sentiments. In World War I, as she would in later conflicts, she focused not on hard-nosed battlefield reporting, but on the human interest side of the engagements. She rarely filed pieces that competed with those of male reporters, choosing instead to develop a monopoly of sorts on "her" kinds of stories. Her pieces were, for the most part, light, conversational dispatches that told of the real problems and triumphs of everyday American soldiers. Readers back home ate it up.

> *She put a human face on the great movements of men and armaments.*

Over the years, Hull traveled to Paris, Siberia, Shanghai, Marseilles, Hong Kong, and, during World War II, the Pacific theater of war. Combatants and colleagues recalled her as a motherly figure, confirming that much of her success lay in her ability to project an image that males would find comforting rather than threatening. She was "bitten" by her job just as completely as any other wartime correspondent, however, and she pursued it with a passion and a dedication that won her many allies in a male-dominated environment.

Hull wrote two books, *The Inside Story* (1940) and *I Can Tell It Now* (1964), both based on her wartime work. Like many of her colleagues, she had trouble balancing home and family demands. She married three times. Of her own work, she said that she specialized in "the little stories, the small unimportant stories which meant so much to the G.I., but for which no editor would use his wire service and which no 'spot news' correspondent had time to seek out and write." Hull put a human face on the great movements of men and armaments—and brought a smile to the lips of serviceman and civilian alike.

She died in a California hospital, of cancer, in 1967, at the age of seventy-seven.

TO FIND OUT MORE...

- Belford, Barbara. *Brilliant Bylines: A Biographical Anthology of Notable Newspaperwomen in America.* New York: Columbia University Press, 1986.

- Smith, Wilda M. *The Wars of Peggy Hull: The Life and Times of a War Correspondent.* El Paso, TX: Texas Western Press, 1991.

- Schlipp, Madelon Golden, and Murphy, Sharon M. *Great Women of the Press.* Carbondale, IL: Southern Illinois University Press, 1983.

Fannie Hurst, 1889–1968

Although her star has since faded, Fannie Hurst was the best-paid writer of her day. She wrote novels filled with colorful if stereotyped characters, and donated much of her sizeable income to social causes.

Hurst led a sheltered middle-class, midwestern childhood in St. Louis, Missouri. Her parents, Rose and Samuel Hurst, envisioned a safe, comfortable future for their only child, but Fannie had an adventurous spirit. After graduating from a local college in 1909, she left home permanently to live an exciting life in New York. Her parents thought she was in New York to pursue a graduate degree at Columbia, but as far as Hurst was concerned the best schooling to be found in New York was on the street. In wide-eyed search of new experiences, she worked as a bit player on Broadway and as a waitress, and visited poor neighborhoods and night court sessions.

She found it a little more difficult to gain entry into the literary world. In St. Louis, she had published a story in a local weekly magazine as a teenager. In New York, she collected a string of rejections before the *Saturday Evening Post* finally paid her $30 for a short story in 1912. With that small start, her career was launched. Soon afterwards the *Saturday Evening Post* was paying her ten times as much for another story, and other publications followed, offering her ever-increasing amounts for her work.

In 1915, Hurst secretly married pianist Jacques Danielson. It was a unique relationship. Because Hurst firmly believed that a traditional marriage would stifle her and her talent, she and Danielson made unusual arrangements: separate apartments, different names, and the secrecy—which she gave up in 1920. Despite the seeming formality of their situation, theirs was a loving and romantic marriage, symbolized by the calla lily (the first flower Danielson ever gave her) that Hurst habitually wore. She was sharply criticized when she announced her five-year-old marriage, but she was eventually proven right by time. Unlike many writers (who seem to have a divorce rate approaching that of movie stars), she had a

wonderfully fulfilling marriage that lasted until Danielson's death in 1952.

By the mid-twenties, her books had made her one of the most popular and best-paid writers in the country. Hurst was not only popular but extremely prolific as a writer, producing nearly a title a year in the twenties. She made the most of her position as a widely read author, often incorporating her feminist views into her fiction to advance her favorite causes. Her books include *Lummox* (1923), *Back Street* (1931), and *Imitation of Life* (1933).

Hurst worked to help Jewish refugees escape from Germany during World War II, and she was a constant promoter of creative writing. Her donations of a million dollars apiece to Washington University and Brandeis funded new professorships in creative literature at both of those schools.

Despite her forward-looking ideas about the equality of the sexes, Hurst's novels now seem somewhat dated. She often used stock, gender-stereotyped characters to prove her points, reducing the impact of her message and distracting attention from the merits of her fiction. Nevertheless, both her views and her success as a woman nov-

She kept her marriage to Jacques Danielson a secret—separate apartments, different names—believing that a traditional marriage would stifle her and her talent.

elist were ahead of their time. She continued writing and publishing well into her seventies, and (after Danielson's death) wrote an autobiography titled *Anatomy of Me* (1958). She died at the age of seventy-eight.

TO FIND OUT MORE...

- Hurst, Fannie. *Anatomy of Me: A Wonderer in Search of Herself.* London: Jonathan Cape, 1959.
 - Lotz, Philip Henry. *Distinguished American Jews.* New York: Association Press, 1945.
 - Sicherman, Barbara, and Green, Carol Hurd, eds. *Notable American Women: The Modern Period. A Biographical Dictionary.* Cambridge, MA: The Belknap Press of Harvard University Press, 1980.
 - Hurst's papers are in the Hurst Collection at Brandeis University and in the Berg Collection in the New York Public Library.

Zora Neale Hurston, 1901–1960

Zora Neale Hurston is best known as the author of the exuberant novel *Their Eyes Were Watching God*. Like the heroine of that book, Hurston pursued her goals with an intensity that began in childhood. She became a brilliant scholar of anthropology and folklore disciplines that melded perfectly with her own talent for storytelling. In her novels and stories, the characters ring uncannily true, with the quirks and motives of real people.

Hurston was born in Eatonville, Florida, an independent community that was the first all-black town to be incorporated, as well as the first to attempt to organize its own separate government. Hurston and her neighbors took pride in the fact that Eatonville was more than just "the black back-side of an average town." Her happy childhood there came to an end after her beloved mother died and her father remarried a woman to whom Zora took an instant dislike. She had always read anything she could get her hands on (including a dog-eared collection of Milton's poetry that she found in a trash bin), but education was difficult now that she found herself a virtual orphan.

Nevertheless, she worked odd jobs to support herself, leaving town as a lady's maid for an actress in a traveling theater troupe. After getting her high school diploma in a night school in Baltimore, she was urged to apply to Howard University. She ran out of tuition funds after a year and a half, but her writing in a Howard literary magazine attracted the attention of an editor who suggested she try her luck in New York. She arrived in early 1925 with $1.50 and "a lot of hope." A live-in job with novelist **Fannie Hurst** gained Zora rent-free housing, important contacts, and a scholarship to Barnard the following fall.

While conscious of her position as a "sacred black cow," Hurston was determined to take advantage of her situation. She studied anthropology under Franz Boas and, along with Langston Hughes, started a

literary magazine, *Fire*. She became the school's first known African-American graduate in 1928.

While she was a promising scholar in anthropology, Hurston's writing took over after a series of trips (1927–1932) to the South and the Bahamas to study traditional folklore, songs, and hoodoo. She published a vivid account of her experiences, *Mules and Men*, in 1935, that describes her enthusiastic participation in her own research. She went through an arduous initiation under a hoodoo doctor, Luke Turner, who claimed the "queen of conjure," Marie Leveau, as his aunt. And she returned to Eatonville to collect the folktales she remembered from childhood. Her best-loved novels, including *Their Eyes Were Watching God* (1937), were set in Eatonville.

> **Hurston was Barnard's first-known African-American graduate.**

Despite her brilliant promise, Hurston never quite gained stability. A relationship with white patron Charlotte Mason soured when Mason claimed control of Hurston's work, blocking her from publishing research and stories. Two marriages ended in divorce, and academic posts proved difficult for her to win. Her growing conservatism alienated other African-American intellectuals, and her later work was not well received.

In 1950, she was working as a maid in Miami. She supported herself for a while with freelance articles, but publishers weren't buying her work, and in 1956 she was evicted from her house. She was too proud to ask relatives for help, and ended up in the St. Lucie County Welfare Home. She died in 1960. Although her last years were sad and lonely, she left the triumphant work of her prime for rediscovery by a new generation of readers.

TO FIND OUT MORE...

- Dannett, Sylvia G.L. *Profiles of Negro Womanhood. Volume II: 20th Century.* Yonkers, NY: Educational Heritage, Inc., 1966.

- Gilbert, Sandra M., and Gubar, Susan, eds. *The Norton Anthology of Literature by Women: The Tradition in English.* New York: W. W. Norton & Company, 1985.

- Rose, Phyllis. *The Norton Book of Women's Lives.* New York: W. W. Norton & Company, 1993.

- Sicherman, Barbara, and Green, Carol Hurd, eds. *Notable American Women: The Modern Period. A Biographical Dictionary.* Cambridge, MA: The Belknap Press of Harvard University Press, 1980.

Inez Lenore Haynes Gillmore Irwin, 1873–1970

W riter and suffragist Inez Irwin chronicled the feminist movement in her early studies *Story of the Women's Party* (1921) and *A Hundred Years of American Women* (1933), capturing the pioneering spirit of its leaders. But she was not merely an historian. Irwin was also a prizewinning fiction writer, a children's author, and an energetic supporter of writer's organizations.

Inez Haynes had a wonderful, though chaotic, childhood. Her father, Gideon Haynes, brought five children to his second marriage, and his young new wife, Emma Jane Hopkins Haynes, bore ten more. Inez was born in Brazil, where the Hayneses attempted to start a coffee business. After the business failed, the family settled in Boston. Other ventures never earned enough to make the enormous family more than barely comfortable, but the Hayneses thrived on Boston's cultural resources, making good use of the public library and free lectures.

Inez was apprehensive about the future facing her as a young woman. Her mother was constantly pregnant or giving birth. She turned to her single aunts for inspiration—one was an ordained minister—and by the age of fourteen was a self-declared suffragist. After her high school graduation, she taught for a time before marrying journalist Rufus Hamilton Gilmore in 1897. That same year, she entered Radcliffe College, where she spent three years studying English as a special student and emerging as a campus leader, cofounding the College Equal Suffrage League with suffragist Maud Wood Park.

The Gillmores moved to New York, where they easily moved into literary circles. They hobnobbed with **Gertrude Stein** in Paris on a 1909 trip, and Inez published her first novel, *June Jeopardy* (1908). It was followed fairly regularly by others, including *Phoebe and Ernest* (1912) and *The Californiacs* (1916). Meanwhile, her marriage failed. She left Gillmore in 1913, secured a

California divorce, and married divorced journalist and biographer William Henry Irwin in 1916. The second marriage was a warm and supportive one, and it lasted until William Irwin's death when Inez was sixty-five.

They were able to work together during World War I, when both traveled Europe to write about the fighting in Italy and France. Inez Irwin's time there was cut short by a serious illness requiring surgery. Though she was forced back to New York by this development, she was not sidelined for long; in 1918 she began working with the National Women's Party to ratify the Nineteenth Amendment, granting American women the right to vote. The amendment was passed two years later.

Meanwhile, Irwin continued to write fiction. Her feminist ideals influenced her fiction as well as her choice of nonfiction subjects, coloring works like *Angel Island* (1914) and *The Women Swore Revenge* (1946). In 1924, she won the prestigious O. Henry award for short fiction with her story "The Spring Flight." She also continued writing children's fiction. She had launched her long-running series of "Maida" books (*Maida's Little School, Maida's Little House*) in 1910 with *Maida's Little Shop*.

> *A writer of children's fiction, Irwin launched her long-running series of "Maida" books in 1910 with Maida's Little Shop.*

She wrote eleven books for the popular series, publishing the last one in 1951.

In the twenties, thirties, and forties, Irwin turned her attention to writers' organizations like the Authors Guild and the Authors' League of America. She served terms as the president of each of these associations, and headed the board of directors of the World Center for Women's Archives until it was forced to close in 1940 because of lack of funds.

After her husband's death in 1948, Irwin retired and left New York to live peacefully at her summer place in Scituate, Massachusetts. She died twenty-two years later at the age of ninety-seven.

TO FIND OUT MORE...

- Obituary. *The New York Times,* October 1, 1970.
- Sicherman, Barbara, and Green, Carol Hurd, eds. *Notable American Women: The Modern Period. A Biographical Dictionary.* Cambridge, MA: The Belknap Press of Harvard University Press, 1980.
- Irwin's papers are at the Schlesinger Library at Radcliffe College.

Shirley Hardie Jackson, 1916–1965

Novelist and short story writer Shirley Jackson's protagonists often are placed in ordinary situations that suddenly turn very odd. In her own life, she daily found herself in such a predicament: In her mid-thirties, she developed agoraphobia—a crushing fear of open or public places—and had difficulty leaving her house.

Jackson had a comfortable childhood. She was born in San Francisco and raised in Burlingame, a suburb of San Francisco, where her father was an executive at a lithography company. When his job transfer took the family to Rochester, New York, in 1933, Shirley had trouble adjusting to her new surroundings. Her first attempt at attending college, at the University of Rochester, was unhappy and she returned home in 1936 to work on her writing.

After a year off, Jackson switched to Syracuse University. This time she was much more successful. She met Stanley Edgar Hyman there, who was to become a literary critic and, immediately after graduation, her husband. At Syracuse, they founded a controversial literary magazine, *Spectre*, which attracted attention by criticizing campus policy and trying to print male nudes in its pages. Hyman and Jackson's marriage in 1940 caused a different sort of fuss, for neither Jackson's Protestant family nor Hyman's Jewish one was happy about their interfaith marriage.

Nevertheless, the young couple moved to New York City to launch their literary careers and a family. Between 1942 and 1951, they had four children. Meanwhile, Jackson began writing the short stories that would make her name while Hyman landed a job at *The New Republic*. *The New Republic* became the first national magazine to print Jackson's work in 1941. That year, Hyman moved to *The New Yorker*, where he worked for the rest of his career. In 1943, *The New Yorker* printed Jackson's story "After You, My Dear Alphonse."

In 1945, having firmly established themselves in New York, Jackson and Hyman

moved the growing family to Burlington, Vermont, where Stanley Hyman taught on and off at Bennington College for many years. Jackson, meanwhile, took up the public role of housewife and faculty wife while privately pursuing her writing. In 1948, *The New Yorker* published her most famous story, a sinister tale simply entitled "The Lottery." She also began to write wry semifictional memoirs of her time there with her children, drolly titled *Life Among the Savages* (1953) and *Raising Demons* (1957).

> *She wrote wry semifictional memoirs of her years raising children, drolly titled* **Life Among the Savages** *and* **Raising Demons.**

The memoirs paint a very ordinary picture of suburban motherhood: handling the house, driving kids from place to place, making dinner. After the family returned from a two-year stay in Westport, however (1949–51), things changed for Jackson. She developed agoraphobia, a condition that plagued her for most of the rest of her life. While it posed no immediate threat to her writing, it made normal functioning as a wife and mother difficult. She underwent therapy, but the fears did not substantially subside for more than a decade.

She produced several novels, of which *We Have Always Lived in the Castle* (1962) is widely regarded is the best. Soon after the publication of this account of a super-

naturally disturbed teenage girl, her agoraphobia eased somewhat, and she found herself freer than ever. She had received the Edgar Allen Poe Award in 1961 for "Louisa, Please," but sadly, she had only a short time to enjoy her breakthrough. In 1965, she died suddenly of a heart attack at the age of forty-eight.

TO FIND OUT MORE...

- Friedman, Lenemaja. *Shirley Jackson.* Boston: Twayne Publishers, 1975.

- Gilbert, Sandra M., and Gubar, Susan, eds. *The Norton Anthology of Literature by Women: The Tradition in English.* New York: W. W. Norton & Company, 1985.

- Oppenheimer, Judy. *Private Demons: The Life of Shirley Jackson.* New York: Putnam, 1988.

- Sicherman, Barbara, and Green, Carol Hurd, eds. *Notable American Women: The Modern Period. A Biographical Dictionary.* Cambridge, MA: The Belknap Press of Harvard University Press, 1980.

Georgia Douglas Camp Johnson, 1877–1966

One of the most prominent of all black women who wrote during the legendary New Negro Renaissance period, Georgia Camp Johnson was a playwright and poet whose circle of friends included such luminaries as W.E.B. Du Bois, Angelina Weld Grimké, Langston Hughes, and **Zora Neale Hurston**.

She was born in Atlanta on September 10, 1877 to George and Laura Camp. She studied music extensively at both Atlanta University and Howard University. In 1903, Georgia Camp married a politician and lawyer named Henry L. Johnson; they settled in Washington, D.C. and had two sons. Their home was a gathering place for some of the most celebrated black artists and intellectuals of the day. (When her husband passed away in 1925, Johnson supported herself by working at a series of government positions.)

In 1918, Johnson published a book of poems, *The Heart of a Woman*. This was followed by the volumes *Bronze* (1922) and *An Autumn Love Cycle* (1928). The first of those volumes dealt with the problem of lost love and the often-rocky emotional landscapes facing a modern woman; later work dealt more explicitly with racial issues. Johnson wrote of her poetry, "My first book was *The Heart of a Woman*. It was not at all race conscious. Then someone said she has no feeling for the race. So I wrote *Bronze*. It is entirely race conscious." Indeed it was. Many of the poems in her later collections use the sufferings of Jesus as a metaphor for the trials of those facing racial discrimination.

Johnson was also an accomplished playwright. Her works for the theater include *Blue Blood* (1928), *Plumes: Folk Tragedy*, which won *Opportunity* magazine's award for best new play of the year (1927), and *A Sunday Morning in the South* (1928). The last of these is a troubling, unflinching depiction of the lynching of an innocent black man of nineteen. Although perhaps a bit didactic by current standards,

the play was a daring and honest examination of social problems that had gone unexamined on the stage for far too long. It examined with brutal honesty such troubling issues as the collusion between Southern police and Ku Klux Klan members, and the horrific effects of unchecked white hysteria.

Active in a number of progressive causes, including the Pan-African movement and various human rights campaigns, Johnson had a strong social conscience. She was an active member of the Congregational church, and she worked in the Roosevelt Administration's Federal Theater Project to develop socially aware dramas. (Unfortunately, none of her pieces was selected for production by the Project.)

Johnson's work was passionate, lyrical, and, when the occasion called for it, informed by a profound sense of social outrage at the injustices suffered by her people. Reviewers of her work hailed her "intense conviction"; although her work is not as well known today as it once was, a new generation of readers may now be ready to discover her considerable talent.

> *"My first book was The Heart of a Woman. It was not at all race conscious. Then someone said she has no feeling for the race. So I wrote Bronze. It is entirely race conscious."*

TO FIND OUT MORE...

- Article, Georgia Camp Johnson. *Opportunity* magazine, July 1927.

- Roses, Lorraine. *The Harlem Renaissance and Beyond: 100 Black Women Writers, 1900–1945.* New York: G. K. Hall, 1990.

Elizabeth Garver Jordan, 1865–1947

. .

One of the pioneering female editors, Jordan held a series of positions that were considered at the time to be the exclusive province of males. She became the assistant Sunday editor of the *New York World* in 1897, then the editor of *Harper's Bazaar* magazine, and then literary advisor at Harper and Brothers. It was Jordan who accepted the first novel from a young writer by the name of Sinclair Lewis.

Elizabeth Jordan was, first and foremost, a whirlwind. Even while she was holding down a full-time job, she made the time to focus on her own writing, and her record on that score is impressive: twenty-eight works of fiction (including a number of short story collections), a Broadway play, and a key role in helping suffragist Anna Howard Shaw develop her popular autobiography. All of this, plus her editing work, led to some very full calendars—it is said that she was in the habit of working eighteen hours a day—but somehow she also found time to host glittering parties, show off at the keyboard as an accomplished pianist, perfect her ice skating technique, keep up a voluminous correspondence with the leading literary figures of the day, and play the occasional round of golf. She was, in short, an overpowering force—the "I-want-it-all-now" woman of her day. (In truth, however, one of the demands of today's modern career woman, that of children and family, was not Jordan's; she lived in New York with her mother and an extensive support staff.)

When asked to offer her advice for other women seeking to enter the field of journalism, Jordan was blunt about the challenges such a career entailed. Such a woman, she said, would need "tact, a cool head, clear judgment, the ability to think and act quickly, a good understanding of human nature, and above all, an up-again-and-take-another spirit which no amount of discouragement can break...Her sex will hinder her one hundred times to once that it will help her. Her best work will be taken as a matter of course, and anything less than her best as a deliberately

planned and personal injury."

Jordan was the eldest child of William and Margaretta (Garver) Jordan; her father was a successful owner of meat markets and real estate entrepreneur who actively encouraged his daughter's interest in writing and helped her get her first job as a reporter. After a few false starts in the Midwest, she settled in New York, tracked down the *World's* editor, John Cockerill, and talked her way into a job.

Her stories focused on sensational crimes and on the hardships of urban life, sometimes ending with pleas to her readers to send in contributions to aid the destitute subjects of her articles. At a time when bylines and author credits were by no means automatic, Jordan emerged as one of the premier feature writers in the city.

An ardent supporter of the women's suffrage movement, Jordan pounced on Anna Howard Shaw when she heard that Shaw, the president of the National Women's Suffrage Association, was nursing a broken ankle. During the six weeks of her convalescence, Shaw dictated 200,000 words. Combining this with her own research, Jordan produced the 1915 autobiography, *The Story of a Pioneer.*

Her later work in movies did not turn out well, and she returned to the task of writing fiction, completing about a book a year. But it is for her work in the newspaper arena that Jordan will probably be best remembered. She served as an important transitional figure in that industry: an intelligent, ambitious woman who could outwrite, out-organize, and out-hustle anyone else on the staff—and who pulled down the top jobs as a result. This career path was in startling contrast to the roles women had been allowed to fulfill on newspapers at the time. Jordan's career was no freak or publicity stunt. It was the genuine item. The obstacles she faced and overcame from her male colleagues can only be imagined, but overcome them she did, with deft, personalized writing, layout techniques that were decades ahead of their time, and the unflagging enthusiasm that became her hallmark.

Elizabeth Jordan wrote professionally well into her seventies, stopping only when her poor eyesight made it impossible to continue. She died in 1947 at the age of eighty-one.

> *She was a pioneering woman journalist...and a social whirlwind.*

TO FIND OUT MORE...

- Belford, Barbara. *Brilliant Bylines: A Biographical Anthology of Notable Newspaperwomen in America.* New York: Columbia University Press, 1986.
- Jordan, Elizabeth. *Three Rousing Cheers.* New York: Appleton-Century Company, 1938.
- Schlipp, Madelon Golden, and Murphy, Sharon M. *Great Women of the Press.* Carbondale, IL: Southern Illinois University Press, 1983.

Nella Larsen, 1891–1964

The shy, often reclusive Larsen, once considered one of the most promising writers of the Harlem Renaissance, was the daughter of a West Indian father and a Danish mother. Her racial status was apparently a source of great personal and social struggle for much of her life. In an account of her life for her publisher, Larsen, a Chicagoan by birth, described how for most of her life she avoided her own white family members for fear of embarrassing them. All indications are that she was shunned by most of her relatives; her inability as an adult to completely assimilate herself within African-American society was apparently also a source of considerable pain.

After attending a dizzyingly long list of schools and pursuing a seemingly equal number of careers, Larsen settled in New York in 1915. In 1919, she married Dr. Elmer S. Imes, a physicist whose connections in the exciting intellectual world of the Harlem scene helped launch Larsen's literary career. On her own, she had also established friendships with such luminaries of the period as James Weldon Johnson and W.E.B. Du Bois. Larsen published short stories at first (the early ones under a pseudonym). Encouraged by those in her circle to continue writing, she completed her most important work, *Quicksand*, in 1928.

Quicksand, which is frankly autobiographical, follows the wanderings of a young woman named Helga Crane, who is of West Indian and Danish descent. Cast off by her own relatives, she becomes friends with a rich young widow who provides her with entrée to the sparkling Harlem scene of the teens and twenties. But even when a part of high society, Helga must still come to terms with her own racial identity; after a series of trips and a lost love affair, she marries a black southern preacher and moves with him to Alabama, apparently believing that she has at last encountered a spiritual fulfillment that will help her resolve all of her questions. After giving birth to four children, she concludes that she is still restless and dissatisfied. She decides to leave her husband, then becomes pregnant for the fifth time. On this ambiguous note, the novel ends.

Helga Crane wanders in search of a sense of acceptance and fulfillment and never finds it; in her alienation, reviewers saw not only the dilemma faced by persons of mixed blood, but by all who found themselves shortchanged by a social order obsessed with issues of class, gender, and race. The book was a critical success; its follow-up, *Passing*, dealt with cultural conflicts arising out of the choices made by two African-American sisters light enough to "pass" in white society. (Helga Crane could not.)

While tackling some of the most troubling aspects of social stereotyping and cultural collision, Nella Larsen managed to imbue her characters with a sense of humanity; her novels do not feel dogmatic. Contemporary critics, after half a century, praise her sensitive portrayals of both the black experience and the fact of gender-based oppression.

Larsen was awarded a Guggenheim fellowship the year after *Passing* was published. Unfortunately, she did not go on to complete the promising literary career that appeared to have opened to her after the publication of her first two novels. The fellowship gave her the opportunity to begin

> *In Quicksand, Helga Crane, a woman of mixed descent, wanders in search of a sense of acceptance and fulfillment and never finds it. Nella suffered similar pain in her lifetime.*

two new novels, but she finished neither. After her marriage to Imes ended in divorce in 1933, Larsen withdrew from the literary scene; apparently she did not attempt to write anything of any literary consequence for the next thirty years. (Or, if she did, she hid, mislaid, or destroyed her work.) For the twenty years before her death in 1964, she worked as a night nurse in various New York hospitals.

TO FIND OUT MORE...

- Roses, Lorraine. *The Harlem Renaissance and Beyond: 100 Black Women Writers, 1900–1945.* New York: G. K. Hall, 1990.

- "The Author's Explanation." *Forum*, April 1938.

Margaret Laurence, 1926–1987

Margaret Laurence was one of the premier Canadian literary figures of the century, and certainly the single most successful Canadian novelist of that time. Her novels include *This Side Jordan* (1960), *The Stone Angel* (1964), *A Jest of God* (1966; the novel was the basis for the acclaimed film *Rachel, Rachel*), *The Fire-Dwellers* (1969), and *The Diviners* (1974). She also published books on African literature, including *A Tree for Poverty* (1954) and *Long Drums and Cannons: Nigerian Dramatists and Novelists* (1969).

A good deal of Laurence's work was set in the town of Manawaka, a thinly veiled version of Neepawa, the Manitoba town in which she grew up. Born Jean Margaret Wemys, her parents died when she was a child; she was raised by an aunt. Laurence decided as a young girl to become a writer, composing pieces for school magazines and, eventually, winning a position as a reporter for the *Winnipeg Citizen*. After marrying civil engineer Jack Laurence, she

moved with him to England and then to Somalia and Ghana; the African phase of her life provided her with a great deal of material that would be incorporated into her later work. The couple had two children, and returned to Canada in 1957. They separated in 1962; Laurence returned to England about that time, but eventually returned to her native country.

Of her youth in her home town in Manitoba, Laurence had both stinging memories of Depression-era struggles for subsistence and a certain wonderment at the grandeur of the natural surroundings. "A strange place it was," she wrote, "that place where the world began. A place of incredible happenings, splendors and revelations." But many of her portraits were not of splendors, but of what *Maclean's* magazine referred to as "the devils of her childhood: death, the Depression, and what Prairie folk always refer to as 'the everlasting drought.'"

Her novels highlighted the struggles of strong women grappling for their own iden-

tities while trying to find a way to make ends meet in a world dominated by men. They usually raised eyebrows, as they seem to have been meant to do. Of her own life and work Laurence once said, "It is my feeling that as we grow older we should become not less radical, but more so." But she was apparently discouraged by the controversy her 1974 book *The Diviners* aroused, and she withdrew from her literary efforts, but retained a quiet confidence in the enduring worth of her life's work. Speaking of her novels, she insisted that they had been written "in order to clarify, proclaim, and enhance life—not to obscure and demean and destroy it."

Laurence was a staunch feminist, a Canadian nationalist, and an untiring advocate for human rights and the elimination of nuclear weapons, but she was terrified in front of crowds. Nevertheless, she made her appearances at rallies for the various causes she supported, knowing that doing so would help win public attention. She usually trembled with fear and clutched the back of a chair when she spoke. But she spoke.

Her masterpiece, *The Diviners*, closes with the words "Look ahead into the past,

> *Her novels highlighted the struggles of strong women grappling for their own identities while trying to find a way to make ends meet in a world dominated by men.*

and back into the future until the silence." It was a fitting summation of her own career. Laurence died of cancer in Lakefield, Ontario, at the age of sixty.

TO FIND OUT MORE...

- Laurence, Margaret. *Dance on the Earth: A Memoir.* Toronto: McClelland and Stewart, 1989.

- Thomas, Clara. *The Manawaka World of Margaret Laurence.* Toronto: McClelland and Stewart, 1975.

- Morley, Patricia. *Margaret Laurence: The Long Journey Home.* Montreal: McGill–Queen's University Press, 1991.

- Hind–Smith, Joan, Gabriel Roy, and Frederick PhilipGrove. *Three Voices: The Lives of Margaret Laurence.* Toronto: Clarke, Irwin, 1975.

Audre Lorde, 1934–1992

When Adrienne Rich won the National Book Award in 1974 for her book of poems, *Diving Into the Wreck*, she amazed the literary world by refusing the prize—at least on the terms on which it had been offered. To turn the award down outright would have been remarkable enough, but Rich used the occasion to deliver a stinging indictment of the male literary establishment. She announced that she would accept the award in concert with the two other feminist writers who had been nominated, Alice Walker and Audre Lorde.

"We symbolically join here," the trio announced to a stunned press corps, "in refusing the terms of patriarchal competition and in declaring that we will share this prize among us, to be used as best we can for women." It was, for feminist writing, at any rate, a watershed moment in American letters.

Lorde, although not as well known as the two women with whom she shared the 1974 award, was an important figure in her own right. An outspoken member of the lesbian community, her cogent attacks on homophobia and discrimination took the form of essays, poetry, and autobiographical writings. She was an untiring activist as well as a gifted writer. When New York Governor Mario Cuomo named her the state's Poet Laureate, he noted that "(h)er imagination is charged by a sharp sense of racial injustice and cruelty, of sexual prejudice...She cries out against it as the voice of indignant humanity. Audre Lorde is the voice of the eloquent outsider who speaks in a language that can reach and touch people everywhere."

Lorde, born to West Indian parents in New York on February 18, 1934, came to refer to herself as "a black lesbian feminist warrior poet." She was in fact a published poet at fifteen, and she graduated from Hunter College in 1959. After postgraduate work at Columbia, she worked as a librarian in the early 1960s. She published *The First Cities*, her first volume of poems, in 1968. Thereafter she wrote and taught at a number of institutions of higher learning. Her moving fight against breast cancer was chronicled in *The Cancer Journal* (1980),

published at a time when public awareness of the disease was not as great as it is today. It was a critical success. Of her later experience with cancer, Lorde would write, "The struggle with cancer now informs all my days, but it is only another face of that continuing battle for self-determination and survival that black women fight daily, often in triumph."

Lorde was deeply committed to progressive causes, and did not hesitate to fuse them with her literary efforts. Lorde's activism informed her literary efforts and vice versa. In her extremely popular essay "Poetry Is Not a Luxury," she wrote: "The quality of light by which we scrutinize our lives has a direct bearing upon the product which we live, and upon the changes which we hope to bring about through those lives."

The obvious commitment to social issues that underlies Lorde's writing was extravagantly praised by reviewers who favored her—and looked upon with more than a little skepticism by her detractors. Few denied that a real sense of passion and commitment was to be found in her work, however, and her writings will no doubt stand as compelling embodiments of both her time and her movement.

"The quality of light by which we scrutinize our lives has a direct bearing upon the product which we live, and upon the changes which we hope to bring about through those lives," she wrote.

In 1989, Lorde won an American Book Award for her collection of essays, *A Burst of Light*. Shortly before she died of liver cancer, she was given a new African name: Gambia Adisa. It translates as "Warrior: She Who Makes Her Meaning Clear." Rarely in literature is an author's pseudonym so apt.

TO FIND OUT MORE...

- Jump, Harriet Devine. *Diverse Voices: Essays on Twentieth-Century Women Writers in English.* New York: St. Martin's Press, 1991.

- Lorde, Audre. *The Cancer Journals.* Argyle, NY: Spinsters, Ink, 1980.

- Lorde, Audre. *A Burst of Light.* Ithaca, NY: Firebrand Books, 1988.

Amy Lowell, 1874–1925

Born in Brookline, Massachusetts, Amy Lowell enjoyed a solid education and the significant resources of a wealthy family of high achievers. Percival Lowell, who became a noted astronomer and postulated the existence of a planet beyond Neptune, was one older brother; Abbott Lawrence Lowell, who assumed the presidency of Harvard in 1909, was another. Amy Lowell had the run of her father's extensive library and took full advantage of it, devouring volumes of Romantic poetry. At the tender age of thirteen, she had written her first book, *Dream Drops, or Stories from Fairy Land, by a Dreamer*. (Her mother had it offered at a charity fundraiser.)

Lowell traveled a good deal and had dreams of becoming an actress, but this ambition didn't work out. (She battled weight problems for most of her life, and this may have had something to do with what she and others saw as limited opportunity in this area.) In 1902, Lowell was so moved by a theatrical performance she had witnessed that she committed some of her impressions to verse. In 1912 she released her first book of poetry, *A Dome of Many-Coloured Glass*. In 1915, she visited England, met Ezra Pound, and became associated with the Imagist movement. (Indeed, she took up leadership of the movement when Pound disowned it.) She published a three-volume anthology of Imagist poetry between 1915 and 1917.

Influenced by Pound, T. S. Eliot, **Hilda Doolittle**, and, above all, by her lifelong companion Ada Russell, whom she met around the time her first collection was published, Lowell went on to compose a body of poetry notable for its evocative, sensuous imagery. She was an enthusiastic proponent of polyphonic prose, a form of free verse that fuses poetry and prose, but current critics do not rank these efforts of hers with her best work. Of her strong and specific visual sense, Robert Frost wrote, "(her verses are) forever a clear resonant calling off of things seen." Major books of Lowell's poetry include *Men, Women, and Ghosts* (1916) and *Can Grande's Castle* (1918). Her collection *What's O'Clock* (1925) earned the Pulitzer Prize. Lowell also

wrote a good deal of criticism and a controversial biography of John Keats, a poet who had influenced her profoundly.

Lowell, who seems as an adult to have had little interest in the high society world in which she was raised, flouted existing social convention as few New England women before her had. She was an eccentric in both her writing and her personal habits, a woman who rarely rose before midafternoon, was known to work all day in a massive bed surrounded by pillows, and covered windows and mirrors in black drapes when traveling. And she loved Ada Russell; indeed, some of Lowell's most impressive poems are love verses composed for her untiring critic, aide, secretary, and life companion. Although Lowell grew up in privileged surroundings and was independently wealthy after the death of her parents, she faced her share of hardships: her years were marked by depression and numerous physical ailments arising from her severe weight problems. She died of a cerebral hemorrhage on May 12, 1925.

> *She rarely rose before midafternoon, was known to work all day in a massive bed surrounded by pillows, and covered windows and mirrors in black drapes when traveling.*

TO FIND OUT MORE...

- Benvenuto, Richard. *Amy Lowell.* Boston: Twayne Publishers, 1985.

- Gould, Jean. *Amy: The World of Amy Lowell and the Imagist Movement.* New York: Dodd, Mead, 1975.

- Lawrence, David Herbert. *The Letters of D. H. Lawrence & Amy Lowell, 1914–1925.* Edited by E. Claire Healey and Keith Cushman. Santa Barbara: Black Sparrow Press, 1985.

- Sicherman, Barbara, and Green, Carol Hurd, eds. *Notable American Women: The Modern Period. A Biographical Dictionary.* Cambridge, MA: The Belknap Press of Harvard University Press, 1980.

Mary McCarthy, 1912–1989

McCarthy, one of the leading lights of twentieth-century American letters, was born to well-to-do parents in Seattle. Tragedy struck when she was only six: both her mother and father died of influenza. She spent most of her remaining childhood years in a series of Catholic schools, posting sparkling grades at seemingly every opportunity. She graduated Phi Beta Kappa from Vassar in 1933. In the subsequent years of the decade she embarked on a brief marriage; dabbled in left-wing politics; married for a second time and bore a son; and, at the urging of her second husband, the critic and author Edmund Wilson, began her career as a writer.

She wrote stories for *Partisan Review*, *Southern Review*, and *Harper's Bazaar*. Although she separated from Wilson in 1945 and married again, she continued along the path Wilson had encouraged her to travel, securing a Guggenheim fellowship in 1948. (She would win another in 1959.) Her novel *The Oasis* appeared in 1949 and was well received, as was her memoir *Memories of a Catholic Girlhood* (1957).

McCarthy's third marriage ended and yielded to a fourth, to a State Department official with whom she relocated to France in 1961. During the 1960s she enjoyed huge commercial success with the publication of *The Group* (1963), which followed the choices of a group of Vassar graduates through the 1930s. The book was also seen, however, as a source of insights on the emerging feminist movement of the 1960s. Betty Friedan's landmark work *The Feminist Mystique* had been published in the previous year; she and McCarthy each received extensive mainstream media coverage during this period. The time for open discussion of feminist issues had come, and McCarthy was one of the chief early influences on this discussion as it unfolded in the literary world. (She would later become one of the most prominent opponents to American involvement in Vietnam.)

Later fictional offerings included *Birds of America* (1971) and *Cannibals and Missionaries* (1979). The 1980s were marked by a protracted literary feud between McCarthy and **Lillian Hellman** arising from the

former's curt assessment of the latter's veracity during a television talk show. After a series of seemingly endless court wranglings, cocktail-party conflicts, and written attacks and counterattacks by the two women and their various proxies, the controversy ended when Hellman died in 1984 and her lawsuit against McCarthy was dropped before trial.

During the course of her long and remarkable career, Mary McCarthy earned praise as a critic, novelist, essayist, and social commentator—praise she richly deserved. She was a keen observer of (and, to a degree, an influencer of) the massive changes taking place in her society, and she left a lasting body of work that will be read for years to come. She died in New York on October 25, 1989.

> *In the 1960s, the time for open discussion of feminist issues had come, and McCarthy was one of the chief early influences on this discussion as it unfolded in the literary world.*

TO FIND OUT MORE...

- Gelderman, Carol. *Mary McCarthy: A Life.* New York: St. Martin's Press, 1988.

- Grumbach, Doris. *The Company She Kept.* New York: Coward—McCann, 1967.

- Magill, Frank. *Great Women Writers.* New York: Henry Holt, 1994.

- McCarthy, Mary. *Memories of a Catholic Girlhood.* New York: Harcourt Brace Jovanovich, 1957.

- McCarthy, Mary. *How I Grew.* San Diego: Harcourt Brace Jovanovich, 1987.

- McKenzie, Barbara. *Mary McCarthy.* New York: Twayne Publishers, 1967.

Anne O'Hare McCormick, 1880–1954

Journalist Anne McCormick was intensely private in the name of her work. Unlike **Margaret Bourke-White**, whose appeal as a photojournalist lay as much in her manipulation of her own image as in her ability to manipulate images on film, McCormick assiduously avoided revealing herself to the public. She sought to capture her stories unvarnished, without the taint of personal flair. From 1936 until her death in 1954, she served on the *New York Times* editorial board as the specially designated "freedom editor," encouraged to use her typewriter both to defend and pursue freedom.

Anne O'Hare was the oldest of three girls born into an Irish Catholic family. She was born in England, but grew up in Columbus, Ohio. Shortly before she graduated from high school, her father, an unsuccessful insurance company manager, had deserted the family. Her mother sold a volume of her own poetry, *Songs at Twilight* (1898), door to door and ran a dry-goods

store to support the family until Anne's graduation in 1898. Anne went to work with her mother in Cleveland for the *Catholic Universe Bulletin*, where she was the associate editor and her mother was a columnist and the editor of the women's section.

In 1910, Anne married Francis J. McCormick, an importer and engineer whose career dictated that he make frequent business trips abroad to purchase goods. Anne McCormick moved with him to Dayton, Ohio, where she continued to write articles and poetry on a freelance basis for publications including the *New York Times Magazine*, *Smart Set*, and *Reader Magazine*. She often joined her husband on his trips abroad, and she found a way to make the trips useful to her career in 1921 when she wrote a letter to the *New York Times* suggesting that she serve the paper as a sort of freelance foreign correspondent.

It turned out to be a wonderful relationship. The paper was so happy with the articles she sent on the rapid shifts in Europe

that they made her a regular correspondent within a year, and created for her the thrice-weekly column "In Europe." After she joined the editorial board in 1936, it was renamed "Abroad." Her regular trips to Europe in a fascinating period of European history and her habit of quietly removing herself from the scene she wished to present made her a perfectionist as a correspondent. She interviewed Mussolini, Roosevelt, Hitler, Stalin, and Churchill, and she tracked the escalating tensions in Europe with a scholar's analytical eye.

In 1937, her superb articles made her the first woman awarded a Pulitzer Prize for foreign correspondence. Despite the increased attention this accomplishment brought her, she continued to resist book offers from publishers, preferring to devote her energies to journalism. (She published only one full-length book, a study of the post-revolution Soviet Union, in 1928.) From 1936, she was a regular contributor to the paper's editorial page.

Her professional cool was not just a journalistic ethic to her, but a way to side-step bias against women reporters. If you were able to avoid feminine stereotypes, she explained, and adopt a "masculine" professionalism, it might be possible to "sneak" past prejudices. In her work, she was able to do much more than simply avoid this sort of attitude. She rose completely above it. When she died in New York in 1954, the *New York Times* blacked out the borders of the "Abroad" column in mourning and published a personal tribute to her on the editorial page.

> *She explained that if you were able to avoid feminine stereotypes and adopt a "masculine" professionalism, it might be possible to "sneak" past prejudices.*

TO FIND OUT MORE...

- Belford, Barbara. *Brilliant Bylines: A Biographical Anthology of Notable Newspaperwomen in America.* New York: Columbia University Press, 1986.

- McCormick, Anne, and Sheehan, Marion Turner, eds. *The World at Home.* New York: Knopf, 1956.

- Sicherman, Barbara, and Green, Carol Hurd, eds. *Notable American Women: The Modern Period. A Biographical Dictionary.* Cambridge, MA: The Belknap Press of Harvard University Press, 1980.

Carson McCullers, 1917–1967

Carson McCullers burst on the New York literary scene at the age of twenty-three with a triumph of a novel, *The Heart is a Lonely Hunter*. She followed it up with a quick succession of rapturously received plays and fiction, meriting a retrospective of her work at the young age of thirty-four. But her life and career took an abrupt turn towards the tragic after that point, and neither ever recovered. Today she is remembered as a sort of literary wunderkind whose notable work was completed in her teens, twenties, and thirties.

Lula Carson Smith was the first of three children born in Columbus, Georgia, to Lamar and Vera Smith. Her father was a jeweler and watch repairman. Lula was an odd, dreamy child who decided at ten that she would be a celebrated concert pianist. At fifteen, however, she contracted rheumatic fever and began to wonder if she had the stamina for such a physically demanding career. She chose another hobby—writing—and attacked it with zest.

Lula experimented with several different forms of expression: poetry, a novel, and some desperately dramatic plays that she tried rather unsuccessfully to produce in the family living room with the help of her mother and sister. She moved to New York at seventeen after graduating from high school, bringing tuition money for writing classes at Columbia and more musical training at the Julliard School of Music. The money was either lost or stolen, but she supported herself with odd jobs (dog walker, pianist, waitress) while enrolled at Columbia.

At nineteen, she suffered another attack of rheumatic fever and returned to Columbus to recuperate. Meanwhile, she started work on her first serious novel, *The Heart is a Lonely Hunter* (1940) and published her first short story, "Wunderkind," in *Story* magazine. At twenty, she married Reeves McCullers, an aspiring writer. The problem with their partnership was partly due to their differences as writers. Carson (as she had called herself since adolescence) was enormously talented and little inclined towards domesticity. Reeves was not talented, and resented the confusion

that resulted over their gender-defined roles when *The Heart is a Lonely Hunter* made his wife an instant literary success.

To complicate matters, the twenty-three-year-old prodigy found herself deeply and painfully in love with the beautiful Swiss writer Annemarie Clarac-Schwarzenbach. Her affections were not returned, but the McCullers' marriage broke up in 1940. McCullers was awkwardly trapped in the limelight. She eagerly sought love and attention, but others found her oddly needy and self-destructive. She did the only thing she could do well, under the circumstances: she wrote a series of highly acclaimed works, cementing her reputation as a talented writer of regional fiction. Among these is her well-known short story, "The Ballad of the Sad Café," which was honored by publication in the 1944 *Best American Stories*.

In 1945, Carson and Reeves McCullers re-married, only to separate again in 1948. The year before, she had—at age thirty—suffered two incapacitating strokes, and after the separation she attempted suicide. She recovered, however, and in 1949 was reunited with Reeves. Meanwhile, her career flourished. In 1950, her play *The Member of the Wedding* was a smash hit, and in 1951 Houghton Mif-

Her husband's resentment over the success of The Heart is a Lonely Hunter *and Carson's unrequited love for a beautiful Swiss writer led to the breakup of her marriage.*

flin published three novels and seven stories in a special collection of her work. But she was devastated as her marriage fell apart once again in the early fifties. Reeves McCullers committed suicide in 1953.

Nothing seemed to go right for McCullers after that. Although her previous works continued to sell, none of her later plays or novels caught on. Her personal life turned into a ghastly series of mishaps and illnesses: breast cancer, pneumonia, a punishing fall, several strokes, and a heart attack all hit when she was only in her forties. Still, she doggedly continued to write, despite the lukewarm reception her works received. She died at the age of fifty in Nyack, New York.

TO FIND OUT MORE...

- Carr, Virginia S. *The Lonely Hunter: A Biography of Carson McCullers*. 1975.

- Gilbert, Sandra M., and Gubar, Susan, eds. *The Norton Anthology of Literature by Women: The Tradition in English*. New York: W. W. Norton & Company, 1985.

- Sicherman, Barbara, and Green, Carol Hurd, eds. *Notable American Women: The Modern Period. A Biographical Dictionary*. Cambridge, MA: The Belknap Press of Harvard University Press, 1980.

Frances Marion, 1890–1973

Frances Marion, screenwriter, lived what looked like a glittering Hollywood life, complete with numerous divorces, a palatial Hollywood Hills mansion with a 60-seat theater, one happy marriage to cowboy star Fred Thompson, and two Academy Awards for her screenplays. Yet she remained unimpressed by it all, urging her two sons to pursue other lines of work and using her Oscars as doorstops. Her irreverent attitude towards the film business is displayed in her famous description of the Oscar statuette: "a perfect symbol of the picture business: a powerful athletic body...with half his head, the part that held his brains, completely sliced off."

Frances Marion was christened Marion Benson Owens in San Francisco. She changed her name at twenty-one. She grew up the middle child in a family of three, attending local high schools and college at the University of California at Berkeley. She originally had artistic aspirations, and took classes at the Mark Hopkins Art School; at eighteen, she married her nineteen-year-old instructor. They were divorced in 1909. An-

other early marriage also ended quickly. Marion worked briefly as a model for advertisements and as a reporter for the *San Francisco Examiner* before landing a job at the Bosworth Studios in 1915.

In her work, at first, she was an all-around gofer, helping on sets and in the cutting-room, filling in for bit parts, and making suggestions on scripts whenever she dared. But in 1916 her first screenplay, for *The Foundling*, was made into a film starring Mary Pickford, and by 1917 when she moved to Paramount, she was already recognized as a writer of screenplays. At the end of World War I, she met Army chaplain Fred Thompson in a military hospital where he was recovering from a broken leg, and in 1921, she married him.

Marion's friend Mary Pickford launched Thompson's film career when she cast him in a 1921 film, "The Love Light." With Marion's behind-the-scenes support—she wrote many screenplays anonymously for him—he became a Hollywood success as quickly as she had, and by 1925 drew $10,000 a week by 1925 as a star of Holly-

wood westerns. They moved into a glamorous mansion together and raised two sons, Fred, Jr. and Richard Gordon whom they adopted. Sadly, the happy marriage came to an end in 1928 when Thompson died of tetanus.

A fourth marriage to director George Hill in 1930 was an unhappy one, and ended in divorce after a year. Hill later committed suicide while working with Marion on a 1934 film, *The Good Earth*. Despite the upheaval in her personal life, she continued to achieve great success with her scripts, writing at an incredibly prolific rate and perfecting her crowd-pleasing formula. She rewrote **Edna Ferber**'s play for the film *Dinner at Eight* (1933) and won the first screenwriting Academy Award given to a woman in 1930 for *The Big House*. A second one came for her 1931 film *The Champ*.

Marion knew audiences were suckers for happy endings, and that is exactly what she delivered, again and again. In 1937, her matter-of-fact guide to screenwriting titled *How to Write and Sell Film Stories* focused on what the audience wanted to see instead of what might constitute good art. To her, Hollywood was a business, and she had no

She called the Oscar statuette a symbol of the film business: "a powerful athletic body...with half his head, the part that held his brains, completely sliced off."

qualms about writing the suicide out of the end of *Anna Karenina*, replacing it with a crowd-pleasing romantic reunion between Anna and Vronsky.

Toward the end of her life, Frances Marion turned away from film to write novels and return to her first love, art. She published six novels between 1935 and 1973 and worked on her sculpture in her spare time. She died in Los Angeles at the age of eighty-four.

TO FIND OUT MORE...

- Marion, Frances. *Off With Their Heads: A Serio-comic Tale of Hollywood*. New York: Macmillan, 1972.

- Marion, Frances. *Valley People*. New York: Reynal & Hitchcock, 1935.

- Sicherman, Barbara, and Green, Carol Hurd, eds. *Notable American Women: The Modern Period. A Biographical Dictionary*. Cambridge, MA: The Belknap Press of Harvard University Press, 1980.

Eve Merriam, 1918–1992

E ve Merriam wrote a broad spectrum of works, including plays, poetry, and children's books. Her lightning-quick reversals and impish twists attacked social preconceptions and forced her readers to look at the absurdities of modern life. Interestingly, it was one of her children's books that brought her the most notoriety. *The Inner City Mother Goose* (1969) sharply reimagined the familiar old rhymes from an inner city dweller's point of view. "Run, run father, go away," went one of her revised nursery rhymes. "Welfare worker is due today." Outraged civic officials sought to have it banned from libraries.

Merriam was born in 1918 in the Kensington section of Philadelphia; she was the daughter of Max and Jennie Moskovitze, operators of a modest chain of clothing outlets. She relocated to New York after graduating from the University of Pennsylvania in 1937, and worked for a time as a writer, radio host, and advertising worker before embarking on her literary career. Her first published collection of poems was *Family Circle* (1946), the recipient of Yale's Younger Poets Prize.

Merriam's cutting wit was on display in her 1960 book *Figleaf*, which lampooned the fashion industry. That book offered concise definitions of some of the prevailing ad-copy buzzwords of the day, including "exclusive" ("a product offered to the broadest possible mass market") and "timeless" ("a style that remains fashionable for more than one season.") In 1965, she taught, at New York University, the first American college course on women's studies.

Her children's books included *Halloween ABC* and *It Doesn't Have to Rhyme*, each of which earned praise from such organizations as the National Councils of Teachers of English. *The Inner City Mother Goose*, which Merriam referred to in an interview as the "second most banned book in America," was the basis of the 1972 musical *Inner City*, which provided a Tony award-winning role for actress Linda Hopkins.

Her most prominent theatrical success, however, was *The Club*, a 1976 off-Broadway

success that featured seven women playing men and dressed in Edwardian garb, singing outlandish songs and making inept chauvinistic jokes that they find hilariously funny. An example: "Here's to our wives and sweethearts—may they never meet." The incongruity of having such material delivered by a female cast proved struck a chord with audiences, and the unexpectedly popular project has enjoyed numerous revivals around the country since its initial production. It was a welcome success for Merriam; producers had apparently been quite skittish about *The Club* at first. Her play *Out of Our Father's House*, which traced the lives of famous and not-so-famous American women, also won critical praise. (When Jimmy Carter reached the White House, he arranged for a special production of the play there.)

> *"Run, run father, go away. Welfare worker is due today,"* she wrote, *sharply reimagining a familiar rhyme from an inner city dweller's point of view.*

Three of Merriam's four marriages ended in divorce; her last husband, the screenwriter Waldo Salt, died in 1987. Merriam died of cancer in New York City on April 11, 1992, at the age of seventy-five.

TO FIND OUT MORE...

- Obituary. *The Los Angeles Times,* April 14, 1992.
- Obituary. *The Chicago Tribune,* April 13, 1992.
- Obituary. *The Houston Chronicle,* April 13, 1992.
- Obituary. *The New York Times,* April 13, 1992.

Josephine Miles, 1911–1985

Throughout her life as a writer and educator, poet Josephine Miles's movement was hampered by rheumatoid arthritis, a condition that had plagued her since childhood. Her mind, however, was agile and active. In her career at the University of California at Berkeley (where she was, in 1947, the first woman to win tenure in the English department), she either wrote or edited over two dozen collections of poetry, winning an array of fellowships and honors in the process.

Miles was born in Chicago in 1911. After she completed her B.A. degree at U.C.L.A. in 1932, she moved on to U.C. Berkeley, where she was to pursue both her graduate work and her career as a faculty member. Miles enjoyed a long and successful career as a teacher, but she was a poet first and foremost. Her published work includes *Lines and Intersections* (1939), *Local Measures* (1946), *Bent* (1967), *To All Appearances: Poems New and Selected* (1975), *Coming to Terms* (1975) and her *Collected Poems* (1984).

Many creative writers find academic life stifling and something of a hindrance to their literary efforts. Miles's lively and unpretentious body of work, however, composed almost entirely during her four decades as an instructor at Berkeley, demonstrate that her duties there were no hurdle for her. Her own explanation for this was that her activities as a teacher precluded "the chance to lose sight of new ideas and arguments."

If Miles's poems were usually fresh and filled with a sense of real life as it is lived in the real world, her critical works were the serious, scholarly tomes of a brilliant English professor pursuing a lifelong passion for her subject. In her respected academic writing, she dealt with the changing patterns in English poetic language over the course of four centuries. That a by-the-numbers intellectual should also have been an accomplished contemporary poet—and a companion of such figures as Allen Ginsberg (who showed her a pre-publication draft of the Beat classic *Howl*)—is part of the enduring charm of Josephine Miles's remarkable career.

Part of the measure of the career of a poetry teacher, of course, is the quality of the later output of her students. Miles's track record is enviable in this regard; her students went on to publish over fifty volumes of poetry and garnered two National Book Awards.

For her own part, Josephine Miles was inducted as a member of the American Academy of Arts and Sciences and the American Academy and Institute of Arts and Letters. During her distinguished career, she was the recipient of a Guggenheim fellowship and a fellowship for Distinguished Poetic Achievement from the American Academy of Poets. After her retirement from active teaching duties, she was named professor emeritus of English at Berkeley, and was one of only twelve faculty members in the entire university system to hold the title of university professor. She died of pneumonia on May 11, 1985. She was seventy-three.

> *Miles's track record as a poetry teacher is enviable: her students went on to publish over 50 volumes of poetry and garner two National Book Awards.*

TO FIND OUT MORE...

- Obituary. *The Washington Post,* May 17, 1985.

- Obituary. *The Los Angeles Times,* May 18, 1985.

- Obituary. *The Chicago Tribune,* May 15, 1985.

Edna St. Vincent Millay, 1892–1950

.

Edna St. Vincent Millay was an enormously popular poet in her own time. Her lyrical name, her red hair, and her accessible poems conspired to make her a romantic public figure. But her reputation suffered later in her career, when more experimental writers like **Gertrude Stein** and **Marianne Moore** became more widely respected. For a time after her death, serious women poets like **Anne Sexton** and **Sylvia Plath** strove to avoid the old-fashioned "simplicity" of Millay's style. Her poems have nevertheless endured, and by the time the centenary of her birth came around her work had gained a new measure of respect.

Millay was born in Rockland, Maine. When she was twelve, her father deserted the family, leaving her mother to care for her and her two younger sisters. The family's financial situation was difficult. Luckily, Millay's talent bloomed early. At twenty, she gained an instant reputation when her poem "Renascence" won a contest for placement in the annual literary anthology *The Lyric Year*. Although she did not win a cash prize, the exposure gained by the publication of her poem attracted the attention of the cognoscenti, who steered her towards Vassar College.

She was a standout in drama and poetry at Vassar, and on her graduation in 1917 moved to artsy Greenwich Village. Although she grew weary of hearing about "Renascence," her early success and her poise helped her become something of a literary celebrity in New York. "We all wandered in after Miss Millay," **Dorothy Parker** later wrote. "We were all being dashing and gallant, declaring that we weren't virgins, whether we were or not." More triumphs, however, were on the way. Millay wrote pulp pieces for magazines under the pseudonym "Nancy Boyd" to pay the bills, and in her spare time wrote volumes of poetry. *The Harp-Weaver* (1923) won the Pulitzer Prize.

During the 1920s and early 1930s, Mil-

lay was at the height of her popularity and productivity. Her poetry was widely loved for the same reason it was later rejected: its easy simplicity. Her best-known poems tend to have the measured beat of a song instead of the complicated rhythm of speech, and they rhyme neatly. Their meaning is clear in the first reading rather than the third or fourth. Later critics thought them light, even frivolous. But her seventeen-verse *Sonnets From an Ungrafted Tree* (1923) is anything but frivolous. It paints a haunting picture of a woman waiting by the deathbed of her husband as her loveless marriage comes to a slow end.

She became more political as her career progressed. After marrying Eugen Jan Boissevain, the widower of American feminist Inez Milholland, Millay became involved in the (unsuccessful) case against the execution of Nicola Sacco and Bartolomeo Vanzetti, convicted in the murders of a shoe factory paymaster and guard in Braintree, Massachusetts. And she began to write more of what she herself called "propaganda," or poems that took up political causes like women's rights and anti-Fascism.

By the 1940s, her reputation had declined somewhat, but her intense concern for political causes never waned. In 1944, worn by the horrors of World War II, she suffered a nervous breakdown. Still, in her last years she was lovingly supported by Boissevain, and they lived out their lives together in their Austerlitz, New York home. She died in 1950, only a year after her husband's death.

> *"We all wandered in after Miss Millay,"* Dorothy Parker wrote, *"...being dashing and gallant, declaring that we weren't virgins, whether we were or not."*

TO FIND OUT MORE...

- Magill, Frank N., ed. *Great Women Writers.* New York: Henry Holt, 1994.

Gabriela Mistral, 1889–1957

Chilean poet Gabriela Mistral, the first Latin American to win the Nobel Prize in Literature, was born Lucila Godoy Alcayaga. When she was three years old, her father abandoned the family, and the future poet was raised by her mother and half sister, each of whom was a teacher. The inquisitive child spent some time in the local schools, but, in a devastating series of events that would leave their mark, was falsely accused of a minor infraction, taunted by fellow students, and pelted with rocks. After that, her half sister taught her at home. In later years, after the family moved, young Lucila began to write for local publications, placing her first piece at the age of fourteen. She took a job as a teacher's assistant in 1905. This marked the beginning of the primarily home-tutored young woman's acclaimed career as an educator. Indeed, no matter how much praise her later poetry earned her, she always described herself as a simple country teacher. (And she was, by all accounts, an excellent one; a grateful Chilean government eventually designated her "The Nation's Teacher.")

Her poetry (for which she adopted the pen name by which she is now widely known) was first published in book form in 1922, the year she left Chile for Mexico to help institute educational reforms there. Although her voice was distinctively Latin American, Mistral's topics were universal: love of children, the miracle of childbirth (and yet she herself had no children), the pain of the doomed love affair, and the necessity of justice in a fundamentally unjust world. Her lyrical, passionate verses, steeped in idealism, eventually found an enthusiastic international audience. Some critics faulted her for perceived metrical and other technical deficiencies, but the vast majority came to understand the deeper emotional truths to which her work pointed. Important collections of her work include *Desolacion* (1922), *Tala* (1938), and *Lagar* (1954). (Characteristically, the poet donated the proceeds from *Tala* to support efforts to care for children left homeless during the Spanish Civil War.)

Mistral traveled extensively for most of

her adult life. Although she is today remembered primarily as a poet (the Nobel award in 1945 certainly had a great deal to do with that), she was in fact something of a renaissance woman. She wrote articles that were published in newspapers the world over, was an unyielding advocate for educational reform, served as Chilean consul in a number of European and Latin American posts, and taught literature at some of the best schools in the United States. As if all of these accomplishments were not enough, she also served as Chile's representative to the United Nations for a stretch in the 1950s.

What is one to make of such a person? It is as though she lived several lives concurrently, each of them rich, rewarding, and unforgettable. Mistral was an educator; she was a diplomat; she was a reformer; she was, perhaps most memorably, the poet whose work defined, for a global audience, Latin American lyricism and passion. She was, in short, a whirlwind of activity and idealism, and a reminder of how much it is possible to accomplish in human affairs.

Mistral died in Hempstead, New York on January 10, 1957. She was mourned the world over.

It is as though she lived several lives concurrently: Mistral was an educator, a diplomat, a reformer and, perhaps most memorably, a poet whose work defined Latin American lyricism and passion.

TO FIND OUT MORE...

- Magill, Frank N., ed. *Great Women Writers*. New York: Henry Holt, 1994.

- Castleman, William J. *Beauty and the Mission of the Teacher: The Life of Gabriela Mistral of Chile, Teacher, Poetess, Friend of the Helpless, Nobel Laureate*. Smithtown, NY: Exposition Press, 1982.

Marianne Moore, 1887–1972

The poet Marianne Moore spent the last two decades of her life as an eccentric sort of American icon. Dressed in her trademark long cape and three-cornered hat, she attended Brooklyn Dodgers games faithfully and maintained the proper air of a gracious spinster. Although she spent the last two decades of her life in comfortable celebrity, she was a deeply private woman in the years before her 1951 Pulitzer Prize brought her to popular attention.

In 1894, Marianne Moore's mother moved her and her brother Warner to Carlisle, Pennsylvania when their father deserted them and their Kirkwood, Missouri home. Marianne forged an intensely close bond with her mother, and after her graduation from Bryn Mawr in 1909, would live with her until her mother's death in 1947. At age nine, Marianne showed signs of her budding talent when she wrote Santa Claus on behalf of her brother and herself: "Dear St. Nicklus: / This Christmas morn / You do adorn / Bring Warner a horn / And me a doll / That is all."

After several years spent teaching commercial law and secretarial skills, she found work at the New York Public Library, and she and her mother moved into a apartment near work in Greenwich Village. The job supported her poetry hobby. By 1915, she had quietly published several poems in magazines in Chicago and London, and was beginning to win friends and admirers among the New York literary crowd. One of these, the poet and Moore's former Bryn Mawr classmate **H.D.**, connived with Moore's friend Winifred Ellerman (pen name Bryher) to have the first book of Moore's poetry, *Poems*, published in London in 1921.

Once pushed into the public eye, Moore overcame her reticence enough to produce and publish another book of poems, *Observations*, in 1924. It won that year's *Dial* magazine award, and the year after that brought her the position of editor of the prestigious New York literary magazine, which she held until 1929. As editor of the *Dial*, Moore spent less energy on her own poetry, but found the experience of working with modernist writers like James Joyce and

Ezra Pound helpful to her own later work.

Like Joyce and Pound, Moore is considered a modernist poet. Her work, like T. S. Eliot's, often quotes extensively from other sources. Unlike Eliot, however, she always meticulously placed her quotes—which she drew from sources as diverse as sixteenth-century poet Edmund Spenser's verse, Tolstoy's diary, and magazine advertisements—in quotation marks.

In 1935, Moore's *Selected Poems*, with an introduction by T. S. Eliot, was published. By that time, she had established contact with a young poet and Vassar student, **Elizabeth Bishop,** and formed a long friendship with her that was recorded in their letters. Moore took on the role of motherly mentor to Bishop, which suited her increasingly proper and calcified public image. She was slowly freezing into the dignified figure that John Ashbery once called "the Mary Poppins of poetry."

By the time she won her 1951 Pulitzer Prize, she strongly resembled the much-loved character—almost a caricature—who was interviewed on the *Today* show by Joe Garagiola in 1967. He questioned her, among other things, about why she chose her trademark hats. "Because they hide my face somewhat," was her response. She was certainly aware of her eccentric image, and encouraged it, throwing out balls at her beloved Brooklyn Dodgers games and continuing to live alone in the Brooklyn apartment she and her mother had shared from the late twenties until her mother's death in 1947.

Despite this chaste, spinsterly public image, which perhaps began at the *Dial*, where her editing was considered "puritanical," and despite the fact that there is no record of her ever having had an intimate relationship, it seems that a more complex person existed in private. When, at sixty years of age, she buried her mother, she left room on the headstone for both herself and a possible partner. Critic Kenneth Burke commented admiringly after her death that he "never saw a more sexual woman."

> *At 9, she wrote Santa: "Dear St. Nickalus:/This Christmas morn/You do adorn/Bring Warner a horn/And me a doll/That is all."*

TO FIND OUT MORE...

- Gilbert, Sandra M., and Gubar, Susan, eds. *The Norton Anthology of Literature by Women: The Tradition in English.* New York: W. W. Norton & Company, 1985.

- Molesworth, Charles. *Marianne Moore: A Literary Life.* New York: Atheneum, 1990.

Mourning Dove, 1888–1936

Her Okanogan name (Hum-ishu-ma) presenting too much of a challenge for a generation of scholars and critics, the first Native American woman to compose and publish a novel came to be known as Mourning Dove—the translation of her tribal name. She was born in rural Idaho in 1888, sent to a series of grim governmental and religious educational institutions, and encouraged by her grandmother to respect the legends and traditions of her tribal forbears. Accordingly, Mourning Dove set about the work of recording and preserving the legends of her tribe.

She interviewed friends and relatives, setting down what they told her of the tribe's lore. Eventually, she went to a local business school to improve her typing and, pressed financially, worked on the stories whenever she could after work. When she met, in 1914, an Indian advocate named Lucullus McWhorter, she made a contact who would change her life. McWhorter not only offered strong encouragement that she continue in her work, but offered to help her develop her collected tales into a publish-

able novel. McWhorter also suggested that she expand her work to include the collection of tales from tribes from other parts of the country. Mourning Dove took the advice and traveled throughout the Pacific Northwest collecting stories. (These would later appear in a collection of their own.)

She completed the novel based on the Okanogan stories in 1916; despite a good deal of press attention, neither she nor McWhorter could arrange for a publisher. The project was apparently in limbo for the better part of a decade. The Four Seas house in Boston eventually agreed to publish it, under what would today be considered a kind of modified vanity house arrangement: Mourning Dove and McWhorter would have to put up sizeable chunks of cash themselves. Mourning Dove, who had been supporting herself by working as a migrant farm laborer, put in extra hours to raise her share. Finally, in 1927, the book was released: *Cogewea the Half Blood: A Depiction of the Great Montana Cattle Range*. There followed a book of stories based on the various tribal tales she

had collected, *Coyote Stories*. These simple, compelling pieces are probably a better representation of Mourning Dove's own writing style than the novel for which she is celebrated; she complained long and loud about McWhorter's heavy-handed influence on her original manuscript for *Cogewea*.

Mourning Dove's achievements are substantial; she worked ceaselessly, both at her typewriter and in the fields, to bring to public notice stories and legends that might otherwise have passed into oblivion. (In this respect, her work is reminiscent of that of the Brothers Grimm, without whose work many now-classic European folk tales would almost certainly have been lost.)

> *She worked ceaselessly, both at her typewriter and in the fields, to bring to public notice Native American stories and legends that might otherwise have passed into oblivion.*

Her autobiography, *Mourning Dove*, was not published until 1990. It is fascinating reading for anyone interested in the efforts of one culture to preserve itself in the face of absorption by another. Mourning Dove died in 1936.

TO FIND OUT MORE...

- Gilbert, Sandra M., and Gubar, Susan. *The Norton Anthology of Literature by Women: The Tradition in English*. New York: W. W. Norton & Company, 1985.
- Mourning Dove (Hum-ishu-ma). *Mourning Dove: A Salishan Autobiography*. Lincoln: University of Nebraska Press, 1990.

Ruth Baldwin Cowan Nash, 1901–1993

. .

Journalist Ruth Cowan Nash was one of the rare women war correspondents during World War II. Despite the fact that the draft had made male reporters scarce, only a few select women, including Pulitzer Prize winner **Marguerite Higgins**, reported from the front lines. At the age of fifty-five, after three successful decades in journalism, Ruth Cowan Nash quit writing for a new life: a marriage and budding careers in politics and business.

Ruth Baldwin Cowan was born in Salt Lake City, Utah and raised in San Antonio, Texas. She graduated from the University of Texas. She landed her first newspaper job in 1928, writing weekend movie reviews for the local *San Antonio Evening News*. Soon, she was publishing freelance articles as well in larger papers like the Houston *Chronicle*, writing under the masculine-sounding name "Baldwin Cowan" to make it easier to place her work. In 1929, she was hired on the strength of her work by United Press, a forerunner of United Press International.

When United Press found out that "Baldwin Cowan" was a woman, she was fired.

She was hired within a few months by the Associated Press, which had no objections to her gender. For the next twenty-seven years, she worked for a series of Associated Press bureaus. Cowan's first decade with the AP was spent mostly in Chicago, but by 1940 she had made a reputation for herself and transferred to the Washington, D.C. bureau. The biggest story in the early forties was, of course, the war, especially after Pearl Harbor. Many American readers suddenly had a personal motive—a son, or a sweetheart, or a brother—to read stories from the front.

The war had opened up employment opportunities to women in all fields, but even with the new openness women were only supposed to serve at the front in relatively demure ways. Ruth Cowan made herself one of the exceptions. From 1943 to 1945, she was one of the only accredited U.S. Army war correspondents, and she

face of strict social stereotyping, the nature of female sexuality, the proper role of psychotherapy, and the best way to respond to the occasionally stifling limitations of personal relationships. When writing on these and similar issues, Nin not only spoke for herself, but, as it turned out, for whole generations of women. (Her legions of defenders are quick to point out, too, that a diary is a wholly appropriate place for self-absorption.)

But the *Diary*, as central as it is to any understanding of Nin's place in literary history, was unpublished for most of Nin's often trying career as a writer. Truth be told, Nin's critical and commercial performance, prior to the release of the first volume of her journal, was modest indeed. She published a study of D. H. Lawrence in 1932 (it led to her acquaintance with Miller). Beyond that, there were a few novels, including *Winter of Artifice* (1939) and *A Spy in the House of Love* (1954), and a number of short stories. These were poetic and innovative, to be sure, and contained some striking portraits of female characters, but none of her works resulted in much mainstream success. For most of her career, Nin struggled for attention, and at her best moments

> *Much of the appeal of her diary, first published during the early years of the modern women's movement, lies in Nin's detailed chronicling of her own "erotic awakening."*

boasted only a small but dedicated following of readers. With the publication of the first installment of her *Diary*, however, she tapped a remarkably broad and appreciative audience. That audience elevated her to a position of prominence in the world of letters.

Nin was awarded the French Prix Sevigne in 1970, and was elected to the National Institute of Arts and Letters in 1974. After the publication of her *Diary*, interest in Nin's previous work was intense, and a number of reissues and repackagings of unpublished material were quite successful. (Two volumes of erotica, both published after the writer's death, were particularly popular.)

TO FIND OUT MORE...

- Evans, Oliver Wendell. *Anaïs Nin*. Carbondale, IL: Southern University Press, 1968.

- Gilbert, Sandra M., and Gubar, Susan, eds. *The Norton Anthology of Literature by Women: The Tradition in English*. New York: W. W. Norton & Company, 1985.

- Nin, Anaïs. *The Diary of Anaïs Nin*. New York: Harcourt Brace Jovanovich, various dates of publication.

- Snyder, Robert. *Anaïs Nin Observed*. Chicago: Swallow Press, 1976.

Flannery O'Connor, 1925–1964

iction writer Flannery O'Connor's stories and novels were composed during a relatively short period of time—she died young, at thirty-nine. Her emphasis on the grotesque, her uncompromising, disturbing portraits of religious fanatics, and her often-bizarre fantasies all lent her work an unmistakable style, a style that won enthusiastic praise from readers and critics alike. O'Connor's theme was life in the modern South, by turns violent and tender, sublime and deformed, hilarious and tragic.

She was born in Savannah, Georgia, the only child of Regina and Edward O'Connor. Her father dealt in real estate. In 1941, while Flannery was only fifteen, he died of disseminated lupus, the same debilitating disease that would end her life twenty-three years later.

O'Connor showed artistic promise as a college student, and published her first story at twenty-one. After a few years on her own in the North, her illness was diagnosed. In 1951, she returned home to live with her mother in Georgia. She would be in her mother's care for the remaining thirteen years of her life. It was during this period, while being treated with drugs intended to slow the ravaging disease's assault on her body, that Flannery O'Connor wrote the darkly comic fiction for which she is remembered.

Combining both gothic and grotesque elements, O'Connor's writing usually had a strong religious element. Her 1952 novel *Wise Blood* presented a striking portrait of a renegade "preacher" obsessed with the denial of Jesus. In her short story "A Good Man Is Hard to Find" (also the title one of her collections of stories), a strange figure known as The Misfit, agonized by doubt and on the run from the law, has a fatal encounter with a dour vacationing grandmother and her family—but not before he wins a measure of grace and acceptance. Other important works of O'Connor's include the novel *The Violent Bear It Away* (1960) and the posthumously released col-

lection of short stories *Everything That Rises Must Converge* (1965).

Flannery O'Connor was a devout Roman Catholic for whom the acceptance of the grace of God was the fundamental reality of both her life and her fiction. Her most memorable protagonists were haughty women whose externally correct religious piety was shaken by the appearance of an unexpected, usually threatening, outsider. The journey toward grace, though it often concludes violently, is a powerful guiding force in her fiction.

O'Connor's work combined Christian themes and struggles with an unnerving willingness to look at the sudden, unexpected twists, the distortions, and the ludicrous contrasts of Southern life. As contrast and reversal are two of the chief elements of humor, it's not surprising that the worlds she created are often quite funny—but she usually rode a dark current of violence, anger, and longing for redemption to reach that humor. Her evocative, moving work received a good deal of praise during her brief life (she won several awards for her short stories); since her passing, her fiction has been the subject of innumerable critical studies, and has attracted a large audience of readers. Al-

> *Her most memorable protagonists were haughty women whose externally correct religious piety was shaken by the appearance of an unexpected, usually threatening, outsider.*

though her body of work is comparatively small, she is considered one of the most important writers of fiction of the post-World War II era.

TO FIND OUT MORE...

- Fickett, Harold. *Flannery O'Connor: Images of Grace.* Grand Rapids, MI: Eerdmans, 1986.
- Magill, Frank N. *Great Women Writers.* New York: Henry Holt, 1994.
- O'Connor, Flannery. *Conversations with Flannery O'Connor.* Rosemary M. Magee, ed. Jackson: University Press of Mississippi, 1987.
- Walters, Dorothy. *Flannery O'Connor.* New York: Twayne Publishers, 1973.

Dorothy Parker, 1893–1967

Dorothy Parker is probably best known for her acid tongue. Always ready with a quip, she was the wit who wrote the well-known couplet "Men seldom make passes / At girls who wear glasses." She was a member of the group of writers, including her *Vanity Fair* colleagues Robert Benchley and Robert Sherwood and the sportswriter Ring Lardner, who met to have lunch and match wits at the Algonquin Round Table in New York, and she worked at *The New Yorker* and *Vanity Fair*. Despite this glittering professional image, however, Parker's personal life was extremely stormy.

Parker was born Dorothy Rothschild on the Upper West Side of Manhattan. Her Scottish mother died when she was very young, and she felt alienated from both her father and his next wife. Dorothy attended Catholic school, then Miss Dana's School, a private girls' school in Morristown, New Jersey.

Her star rose quickly after she returned to Manhattan. By the time she was twenty-four, she was slicing up the pages of *Vanity Fair* as the magazine's drama critic. She en-tered with ease into a charmed circle of celebrated New York writers. She also got married for the first time when she was twenty-four, to stockbroker Edwin Pond Parker. The pair separated soon after his return from fighting in World War I, and were finally divorced in 1928 when she was thirty-five.

Meanwhile, she continued to produce magazine pieces, short fiction, and crisp, acerbic poems. The seamless gloss of these pieces and their enthusiastic public reception belies the trouble Parker had in producing them. The total body of her work is surprisingly small, although she spent nearly five decades as a professional writer. She became infamous for missing her deadlines. According to one biographer, she attempted suicide in 1930 by drinking a bottle of shoe polish when she realized that she would be unable to finish a novel she had promised an editor at Viking Press.

That was only one of several suicide attempts. There were others involving razors and Veronal, all of them unsuccessful unless you count her alcoholism in her final years.

She never found peace in her love affairs; several ended unhappily and her longest relationship was as mercurial as the rest of her life. She married bisexual actor/writer Alan Campbell in the 1930s, divorced him in 1947, remarried him in 1950, separated from him in 1953, and finally returned to him in 1956. The marriage lasted until Campbell died in 1963.

Parker and Campbell, like many other writers of their time, were blacklisted in the 1940s. Parker had been intermittently politically active throughout her career. In the late 1920s, she had protested along with **Edna St. Vincent Millay** and others against the execution of accused murderers Nicola Sacco and Bartolomeo Vanzetti. During the Spanish Civil War, she was a vocal anti-Fascist. When she followed Campbell to Hollywood in the late 1930s, their high salaries (Samuel Goldwyn paid them as much as $5,200 a week) made them targets.

The last years of Parker's life were sad ones. She lived alone with her dog and her alcoholism. "Listen," she reportedly told a friend, "don't feel badly when I die, because I've been dead for a long time." But she left behind her unforgettable voice in her few collections of poetry and prose and in countless, often repeated sharp quotes.

> *She reportedly attempted suicide in 1930 by drinking a bottle of shoe polish when she realized that she would be unable to finish a novel for an editor at Viking Press.*

TO FIND OUT MORE...

- Gilbert, Sandra M., and Gubar, Susan, eds. *The Norton Anthology of Literature by Women: The Tradition in English.* New York: W. W. Norton & Company, 1985.

- Keats, John. *You Might As Well Live: The Life and Times of Dorothy Parker,* 1970.

- Meade, Marion. *Dorothy Parker: What Fresh Hell Is This?* New York: Villard Books, 1988.

Louella Parsons, 1881–1972

At one time reported to have been the highest paid woman journalist in the country, columnist Louella Parsons was, during her heyday, the most influential woman in the movie industry. The feared studio heads of the day all regarded her with a kind of wary awe, as her column could boost or sink the popularity—and therefore the careers—of both aspiring and established stars.

Born Louella Oettinger, her father, an Illinois clothier, died when she was eight years old. Parsons married a local realtor, Jack Parsons, in her twenties, but the marriage was not a happy one. Although the details are unclear as to whether or not it actually ended in divorce, Jack Parsons died during World War I. A second marriage also failed to work out.

Parsons began her journalistic career in 1910 with the *Chicago Tribune*; by 1915 she had written a guide to developing screenplays in the young movie industry, and had inaugurated one of the earliest newspaper columns devoted exclusively to happenings in filmland. As the industry grew, so did Parsons's clout and prestige. Despite frequent attacks from her critics about her willingness to bend the truth if it meant securing a good item for her column, she was soon the best-connected writer on the scene. (The complaints about her accuracy, by the way, would continue to follow her for the rest of her long career. She never seemed to pay them much mind.)

In the emerging world of Hollywood, where image-making carried immense financial consequences, Parsons found herself a brand name of sorts when it came to assessing the merits of various film stars. Put more plainly, her readers trusted her opinions and could be counted on to adopt them, more or less, as their own. It is no overstatement to say that, in the thirties and forties, no major star could be expected to survive long as a studio commodity if Parsons took a dislike to him or her—and no new star could expect to make a career of it without Parsons's endorsement. Louella Parsons could (and did) decide the fates of stars who had worked for years to make it to the big time, and in whom studios had

invested hundreds of thousands of dollars. She was as feared and respected as any man in the industry.

A woman of amazing energy and resolve, Parsons found time to host radio programs, appear in a movie herself, and compose a fanciful account of her own life and times. Her ongoing attempts to scoop her archrival, Hedda Hopper, provided her with plenty of motivation to stay at the top of her game during Hollywood's golden era—a period she can rightly be said to have influenced as much as any studio head or movie star.

In the late 1950s, her influence began to wane. (Interestingly, this occurred at roughly the same time the studio system began to recede after meeting its first serious competition for the public's entertainment dollar: television.) On the surface, all seemed to be going well in her life. Her third marriage, to a physician, had been going strong for some time; she was immensely proud of her daughter. But these personal considerations could not change the fact that the woman who had helped to create Hollywood was now forced to cover a very different kind of entertainment scene. It was a difficult period. Although Parsons continued to write columns until 1964, she would never again reach the position of prominence and influence she held with such zeal and authority in the thirties, forties, and early fifties.

She died of a stroke in California in 1972 after a long illness.

In the 30s and 40s, no major star could be expected to survive long as a studio commodity if Parsons took a dislike to him or her—and no new star could make a career of it without her endorsement.

TO FIND OUT MORE...

- Belford, Barbara. *Brilliant Bylines: A Biographical Anthology of Notable Newspaperwomen in America.* New York: Columbia University Press, 1986.

- Parsons, Louella O. *The Gay Illiterate.* Garden City, NY: Garden City Publishing Company, 1944.

- Sicherman, Barbara, and Green, Carol Hurd, eds. *Notable American Women: The Modern Period. A Biographical Dictionary.* Cambridge, MA: The Belknap Press of Harvard University Press, 1980.

- Obituary. *The New York Times,* December 10, 1972.

Josephine Peabody, 1874–1922

. .

Born in Brooklyn, New York, Peabody, best known for her 1909 verse drama *The Piper* was the daughter of Charles and Josephine Peabody. The future playwright had two parents who were ardent theatregoers, and who encouraged their daughter's artistic leanings from an early age. Her father, who was a descendant of Francis Peabody, died in 1884, leaving the family in severe financial straits and causing Josephine to begin to withdraw into the world of imagination. Her mother and sister relocated to Massachusetts, but Josephine found the public school there less than challenging; she began writing in earnest at about thirteen, and regularly sent her poetry off to various magazines. She received her first important acceptance at the age of nineteen, when a poem of hers was printed in the *Atlantic Monthly*.

In 1896, she undertook a serious writing career. Her first book of poems, *The Wayfarers*, was published in 1898; a play based on Shakespeare's sonnets, *Fortune and Men's Eyes*, was released in 1900. This was followed by her most ambitious work to date, *Marlowe*, a drama about the Elizabethan dramatist. An ambitious effort in blank verse, it led to a teaching position at Wellesley College. On the rise in the literary world, Peabody released *The Singing Leaves* (1903) and saw her play *Pan* performed (1904).

Marriage to Harvard professor Lionel Marks in 1906 led to a year abroad, during which Peabody worked on the first draft of *The Piper*, a retelling of the folk story about the people of the village of Hamelin and the traveling musician who offers to end the plague of rats that has descended on the town. She worked on it intermittently between 1906 and 1909, when she entered the completed draft in the prestigious Stratford competition in England. In 1910, shortly after giving birth to her first son, she learned that her play had been selected out of over 300 entries for the award. Popular productions of the play were mounted in Stratford,

London, and New York.

Active as a proponent of social reform movements and progressive causes, Peabody joined the Fabian Society at about the time she completed *The Piper*. She was an ardent supporter of the women's suffrage movement and worked for a variety of pacifist and charitable movements.

Other important works of Peabody's include the poetry collections *The Book of Little Past* (1908), *The Singing Man* (1911), and *Harvest Moon* (1916), and the plays *The Wolf of Gubbio* (1916), *The Chameleon* (1917), and *Portrait of Mrs. W.* (1922). Although some critics consider her poems to be the finest literary efforts to issue from her pen, Peabody is probably most notable as the American writer who kept the form of the verse drama alive at a time when writing in iambic pentameter for the stage was considered to be something of an academic novelty. Peabody proved that popular, stageworthy material could still be created within the genre, and left the door open for such later writers as Maxwell Anderson.

> *Peabody kept the form of the verse drama alive at a time when writing in iambic pentameter for the stage was considered to be something of an academic novelty.*

TO FIND OUT MORE...

- James, Edward, ed. *Notable American Women, 1607–1950: A Biographical Dictionary.* Cambridge, MA: The Belknap Press of Harvard University Press, 1980.

- Unger, Leonard, ed. *American Writers: A Collection of Literary Biographies.* New York: Charles Scribner's Sons, various dates of publication.

Irna Phillips, 1901–1973

Irna Phillips's plots kept television and radio audiences breathless for over forty years. She created such soap operas as *Days of Our Lives*, *As the World Turns*, and *The Guiding Light*, and was a formative influence as soaps made the transition from radio to television in the late forties and early fifties. Her much-repeated plot innovations included afflicting a character with amnesia and introducing a sudden, unresolved plot point at the end of an episode (the so-called "tease ending"). She was apparently the first person to popularize the idea of using doctors and other professional people, rather than working-class characters, as protagonists on serial dramas.

It may be tempting to dismiss the medium in which Phillips wrote as trite and inconsequential, but the fact is her scripts were generally a notch above the genre's typical fare. What's more, she reached—and moved—audiences of truly amazing numbers, and, in the early days of her medium, often did so before anyone else had. If it is a writer's task to involve the audience in the lives of characters, Irna Phillips may well be one of the first people to have accomplished this task successfully on the mass level we now associate with popular entertainment. The sermonizing tone of some of her scripts, which sounds a flat note today, was apparently exactly what her audience hungered for. A book containing the nuggets of wisdom dispensed by a clergyman on one of her programs sold nearly 300,000 copies one year.

Phillips, who grew up in Chicago and who lost her father at the age of eight, broke into radio by working during her vacations for free at station WGN. In 1930, she was asked to develop a "family drama" for the station. What she came up with was "Painted Dreams," a drama about a widower, her daughter, and their neighbors that seems to have been patterned after Phillips' own life. It was a hit. When a national network wanted to pick up the program, WGN blocked the move. Phillips simply went to work devising a new serial that changed character names but incorporated virtually all of the same elements of the first, and then sold it to the network. It was called "Today's Children," and it went on to be-

come the most popular daytime serial in the country.

Irna Phillips had learned how to write scripts that would connect with Depression-era listeners. She based her stories on basic human instincts: the effort to survive unexpected trauma, the struggle to support and maintain a family, the lure of sex. A series of successful serials followed; by the end of the decade, she was earning a quarter of a million dollars a year. When television came along some years later, she did not rest on her laurels, but set to work to master the new medium. She has been called "the single most important influence on television soaps," in no small degree because the programs she helped to launch became important parts of the lives of those who watched them. Phillips's many credits include the launch of the most successful daytime serial of the period, "As the World Turns." (It is, of course, still popular today, as are many other shows she helped to create.)

> **Her stories were based upon basic human instincts.**

Along with such innovative women as Elaine Carrington and Anne Hummert, Phillips helped to define a television genre that attracted millions upon millions of viewers. (Soap operas were then, and remain to this day, among the most profitable programs on television.) Although she was critical of what she considered to be the sensationalism of daytime scripts in the late sixties and early seventies, she had done a good deal of envelope-pushing herself during her long and illustrious career. "As the World Turns," for example, featured the first illegitimate baby of the genre. (Phillips's attempts to get soap operas to focus on the battle for black civil rights, however, ran into resistance from squeamish network executives.)

In marked contrast to the explosive events that marked the lives of the characters in her scripts, Phillips lived a quiet and relatively uneventful personal life. She had a number of relationships but did not marry. She adopted two children. When she died in 1973, she was seventy-two.

TO FIND OUT MORE...

- Dunning, John. *Tune In Yesterday: The Ultimate Encyclopedia of Old-time Radio.* Englewood Cliffs, NJ: Prentice-Hall, 1976.

- Edmondson, Madeleine, and Rounds, David. *From Mary Noble to Mary Hartman: The Complete Soap Opera Book.* New York: Stein and Day, 1976.

- Sicherman, Barbara, and Green, Carol Hurd, eds. *Notable American Women: The Modern Period. A Biographical Dictionary.* Cambridge, MA: The Belknap Press of Harvard University Press, 1980.

- Stedman, Raymond William. *The Serials: Suspense and Drama by Installment.* Norman, OK: University of Oklahoma Press, 1977.

Sylvia Plath, 1932–1963

The whole story of this withdrawn, socially awkward, and hugely ambitious poet has been remarkably difficult to establish. The one sure fact may be that Sylvia Plath accomplished in her best poetry a cohesion that was often sorely lacking in her relationships to those closest to her. Indeed, many of the poems used the author's intimate relationships as their source material. Plath took devastating pot-shots at her mother in one of her best-known poems, "Medusa," and at her long-dead father, who appears as an ominous, oppressive Nazi/sadist/vampire in "Daddy."

Her parents, Otto and Aurelia Plath, were German immigrants; both taught at Boston University. Otto, an entomologist, died of gangrene when his daughter Sylvia was only eight. The loss was a trauma that would haunt Sylvia for years.

Encouraged by her mother, Plath had been writing from an early age; her father's death seemed to inspire her to attempt to meet what most others considered impossible scholastic standards. Before she graduated from high school, she had published work in periodicals (including Seventeen magazine),
and she was writing energetically in a journal she would keep for the rest of her life.

Plath was a brilliant and much-lauded student at Smith College, and in 1953, before she had earned her bachelor's degree, she was asked to spend a month in New York City working as one of *Mademoiselle* magazine's "guest editors." It was a heady experience, but after she returned from New York, she had a devastating mental breakdown. She attempted suicide and spent the rest of the year in a mental hospital, where she was given electroshock treatments. The whole catastrophic period is recounted in the novel *The Bell Jar* (1962).

Plath was back at Smith in the fall of 1954; she graduated with highest honors and a Fulbright scholarship to Cambridge University in 1955. In her journal at Cambridge, she wrote, "I am so hungry for a big smashing creative burgeoning burdened love," and that seems to describe fairly accurately what she got. In 1956, she met and married the English poet Ted Hughes, and for a while the partnership seems to have been a passionate and supportive one,

Plath created another set of high ambitions for herself: intense creative and passionate partnership with Hughes, perfect "Earth Mother" motherhood, and public recognition for her writing. She turned down the "temptation" of an academic career after a successful year teaching at Smith, and settled in England with Hughes. Her first book of poems, *The Colossus*, was published in 1960. By the time her children were born, however, fissures had developed in her marriage. The couple separated in 1962.

As things got worse for Plath (Hughes's extramarital affair before the breakup was a particularly excruciating blow), her poetry became more intense. She is best remembered for the poems she wrote after 1959, when the early glow of her marriage was beginning to fade, and most particularly for the ones she wrote immediately before her suicide and after her separation from Hughes. These later poems were written in a rush; she wrote twenty-five in October of 1962 alone. They are the works that have helped to cement her place among the "confessional" poets (who include **Anne Sexton**). Yet "confessional" doesn't seem quite the right word in Plath's case; these poems are brutal, hallucinatory transfigurations, by turns furious and strangely gleeful. Plath isn't so much allowing her readers a peek at her dark dreams as she is throwing the curtain back with a flourish.

> She accomplished in her best poetry a cohesion often sorely lacking in her own life.

In February of 1963, during the bitterest London winter in decades, Sylvia Plath set mugs of milk near the cribs of her two young children, blocked off the kitchen with towels stuck into cracks under the doors, and turned on the oven gas. She was only thirty. Her death seemed to amplify all the intensity of the later poems, which were published in her second volume, *Ariel*, in 1965.

Depending on the biographer writing the account, Plath was either a vituperative woman whose suicide was the culminating act in a life filled with self-deception, or the innocent victim of an overbearing mother and/or a callous husband. The truth probably lies somewhere between the two extremes. Whatever the approach taken to assessing her life, Plath's visceral, unforgettable poems hold an enduring fascination for her many readers.

TO FIND OUT MORE...

- Malcolm, Janet. *The Silent Woman: Sylvia Plath and Ted Hughes*. New York: A. A. Knopf, 1994.

- McCullough, Frances, ed. *The Journals of Sylvia Plath*. Foreword by Ted Hughes. Consulting Editor, Ted Hughes. New York: The Dial Press. 1982

- Stevenson, Anne. *Bitter Fame: A Life of Sylvia Plath*. Boston, MA: Houghton Mifflin, 1989.

Eleanor Porter, 1868–1920

The woman who, in 1913, created the endlessly optimistic character Pollyanna was herself an upbeat, sunny sort. Eleanor Porter freely admitted that part of her literary mission was to highlight "the agreeable, decent qualities of life." She was born Eleanor Emily Hodgman and was raised in New Hampshire. After marrying the industrialist John Lyman Porter and settling with him in Cambridge, Massachusetts, she showed some interest in a career as a singer (music was her childhood passion), but eventually settled on a writing career in 1901. Over the next decade and a half her short stories were published in a wide variety of national magazines; by 1911, she had seen some commercial success as a novelist. But the publication of *Pollyanna* two years later established Porter as one of the country's most popular writers.

The book and its sequel, *Pollyanna Grows Up*, are often dismissed by modern critics as shallow, unambitious, and melodramatic. Shallow they may certainly be, but those who examine the books themselves, rather than the stereotypes that have arisen around them, are often surprised at their content. The perky, irrepressible heroine, who has an innate belief in the power of good intentions, purity, and unadulterated optimism, finds herself facing up to some of the thorniest social problems of the day. In *Pollyanna*, Porter's heroine encounters the hypocrisy of some of the women's charitable groups so prevalent at the time; in *Pollyanna Grows Up* she encounters the grim world of the slums. That she triumphs over such obstacles with little more than good feeling, faith in the essential goodness of others—and the intervention of a few fortunate plot twists—may read as unconvincing to modern readers. But part of Pollyanna's appeal lay in her appropriation of some of the more troubling headlines of the muckraking reporters of the era. That she allowed people to believe that dealing with such problems was relatively *easy* may have been a fault, but it was a fault shared by uncounted politicians from her time to the present. Perhaps because she never had to run for re-election, Pollyanna's appeal was enormous; readers couldn't get

enough of her.

Indeed, Pollyanna enjoyed a remarkably long and popular reign. The first novel was translated into a half-dozen or more languages, and was a national bestseller for two consecutive years. It was turned into a stage play in 1916 and a motion picture in 1920; both projects were big successes. After Porter's death at fifty-one of tuberculosis, her publisher hired writers to continue the series as a line of children's books, which sold millions of copies. It is worth remembering, however, that Porter's most successful literary efforts were aimed not at children, but at adults.

Porter's other work included the novels *Just David* (1916), *The Road to Understanding* (1917), *Oh, Money! Money!* (1918), and *Mary Marie* (1920). All of these works were popular successes; none of them is likely to be mistaken as a trailblazing effort in feminist literature. Porter, who knew how to write for the mass audience of her time, worked with stock characters and formulaic plot complications; she also relied heavily on the seductive appeal of the belief that any problem could be overcome with sufficient recourse to simple goodness. In the final analysis, her works are well crafted

> *Pollyanna, with an innate belief in the power of good intentions, purity, and unadulterated optimism, finds herself facing up to some of the thorniest social problems of the day.*

snapshots of a cheery and sentimental world that is entirely artificial, but that probably says as much about the predispositions of Porter's time and audience as any social critique or essay ever could.

TO FIND OUT MORE...

- James, Edward, ed. *Notable American Women, 1607–1950: A Biographical Dictionary.* Cambridge, MA: The Belknap Press of Harvard University Press, 1980.

- Unger, Leonard, ed. *American Writers: A Collection of Literary Biographies.* New York: Charles Scribner's Sons, various dates of publication.

Katherine Anne Porter, 1890–1980

"I specialize in what the French call 'la petite histoire,'" Katherine Anne Porter once said of her work; "I am interested in the individual thumbprint." She knew her strong suit, and she played to it—as a general rule. Although Porter received enormous amounts of positive critical attention during her career for her exquisitely crafted short stories and novelettes; her biggest commercial success, the ambitious novel *Ship of Fools* (1962), was met with a rare (for her) collection of mixed reviews. This book, which Porter herself referred to as "unwieldy," was probably as far from the individual-thumbprint school of writing as one could get; it used an ocean cruise taking place immediately before Hitler's accession to power as a metaphor for a world on the brink of disaster. It featured nearly fifty characters. If it didn't exactly play to her strong suit, it made her a lot of money.

Porter was born in Indian Creek, Texas. Her family was distantly related to Daniel Boone. After her mother died when Porter was only two years old, the young girl attended a series of convent schools. There was a brief early marriage that fell apart while she was still a teenager, some time as a reporter for a Denver newspaper, a period of ghostwriting on the east coast, and a sojourn to Mexico. In 1923, back in the States, she published her first story, in *Century* magazine. She was thirty-three years old, and she'd finally found her calling.

Her first book of stories, *Flowering Judas*, was well received by critics. There followed *Pale Horse, Pale Rider* (1939) and *The Leaning Tower* (1944). Her short pieces attracted notice for their mastery of language, form, and structure. Robert Penn Warren said of her work, "She is certainly unsurpassed in our century or country—perhaps any time or country—as a writer (of) fiction in the short forms." Porter released a collection of essays, *The Days Before*, in 1952, but it was her short fiction that secured her reputation for literary excellence. (*The Collected Stories of Katherine Ann*

Porter, released late in her career, won her the Pulitzer Prize.)

It would, however, be a mistake to see the huge commercial success of *Ship of Fools* as the result of a late-career attempt on Porter's part to cash in. Although it was not published until 1962, Porter had in fact begun working on the novel twenty-two years earlier, and she signed a contract in 1945 to complete the novel. Under various working titles, the book was announced for years as the major event of whatever publishing season was then six months away. After a while, industry insiders detected a pattern.

The novel seemed doomed to a lifetime of simply refusing to materialize. When, three Presidential administrations after she'd signed the contract, Porter finally emerged with a completed manuscript, it was with another publisher. Harcourt, Brace—whose accountants had no doubt tired of staring at the incomplete project in their ledger—had accepted an offer to sell the book to Atlantic-Little, Brown. Of the now-legendary delay in producing her book, Porter had this to say: "They keep saying, 'Why did you take so long?' They stand over you, in the United States, and breathe down your collar while you're working. They say, 'Why don't you finish that book?' as if you'd promised to turn one out every year. And I just say to them, 'Look here, this is my life and my work and you keep out of it. When I have a book I will be glad to have it published.'"

Such sentiments, although they may have driven her editors to distraction, offer a revealing insight into this gifted, fiercely independent Southerner. She was always her own woman and her own writer, and she was dedicated beyond description to attaining the very most she could within her craft. Of her life as a writer, she said, "For this vocation, I was and am willing to die, and I consider very few other things of the slightest importance."

> *Of the delay in producing* Ship of Fools, *she said to her publishers, "Look here, this is my life and my work and you keep out of it. When I have a book I will be glad to have it published."*

TO FIND OUT MORE...

- Givner, Joan. *Katherine Anne Porter: A Life*. New York: Simon & Schuster, 1982.
- Hendrick, George. *Katherine Anne Porter*. New York: Twayne Publishers, 1965.
- Obituary. *The New York Times*, September 19, 1980.

Dawn Powell, 1897–1965

Few talented, published women writers suffered so ignobly from the effects of sexism in the literary world as did Dawn Powell. Although she was hailed by figures such as John Dos Passos, Edmund Wilson, and Ernest Hemingway as one of the most gifted comic fiction writers of her generation, her sixteen novels simply never received the critical attention they deserved.

She was born in Mount Gilead, Ohio, the daughter of Roy K. Powell, a salesman, and his wife Hattie B. Sherman Powell. After her mother died when Powell was six, she and her sisters were raised for a time by various relatives until their father remarried.

Powell's interest in writing manifested itself early; she had a burning desire to become a playwright, but found it difficult to break into the theatrical world. (She did eventually manage to secure a few productions; the play *Jig Saw*, for instance, closed after running briefly in New York.) Her first novel, *Whiter*, was published in 1925. Among the later novels considered of greatest significance today are those of the so-called "New York cycle:" *Turn, Magic Wheel* (1936), *The Happy Island* (1938), *Angels on Toast* (1940), *A Time to Be Born* (1942), *My Home Is Far Away* (1944), *The Locusts Have No King* (1948), and *The Wicked Pavilion* (1954).

Her satirical, bitingly funny novels, filled with braggarts, schemers, and muddlers, touch on important themes such as the vagaries of love, the pain of unfulfilled artistic promise, and the pervasive role of money in human relationships. Another common feature of her work is a love of her adopted city of New York, which often seems to take on a life of its own in the pages of her best books.

Powell was never able to claim great popular or critical success from her work; she worked in advertising and public relations in New York City for the better part of forty years, waiting for the hit book that never came. Although she published a number of prose works, including some essays and reviews, in the major magazines of the day, she remained unknown to most readers until her death in 1965 at the age of

sixty-seven.

One of her most enthusiastic partisans, the novelist and critic Gore Vidal, published a long article in a 1987 issue of *The New York Review of Books* lamenting the fact that every single one of her novels was out of print. Vidal argued forcefully that her work had never gotten the success or recognition it deserved, and laid out his case for considering Powell the greatest American comic novelist ever. Shortly after the article appeared, a number of Powell's books appeared on bookstore shelves in new editions. The glowing reviews that were denied the author during her lifetime finally started to appear.

> *Gore Vidal lamented the fact that every single one of Powell's novels was out of print. He argued that her work had never gotten the recognition it deserved, and considered her the greatest American comic novelist ever.*

TO FIND OUT MORE...

- Frank N. Magill, ed. *Great Women Writers: The Lives and Works of 135 of the World's Most Important Women Writers, from Antiquity to the Present.* New York: Henry Holt, 1994.

- Pett, Judith Faye. *Dawn Powell: Her Life and Her Fiction.* (Ph.D. dissertation, University of Iowa, 1981.) Microform. SUBJECTS: *S1 Powell, Dawn—Biography.

- Vidal, Gore. "Dawn Powell, the American Writer." *The New York Review of Books* 34 (November 5, 1987): 52–60.

- Wilson, Edmund. *The Thirties: From Notebooks and Diaries of the Period.* New York: Farrar, Straus & Giroux, 1980.

Marjorie Kinnan Rawlings, 1896–1953

Marjorie Kinnan Rawlings, the author of the beloved coming-of-age story *The Yearling*, wrote evocatively of life in backwoods Florida in her novels and short fiction. Her portraits were so lifelike that a neighbor once sued Rawlings for the vivid portrayal of her in the Florida memoir *Cross Creek* (1942). She charmed readers of all ages with her love of the Southern country, which she expressed beautifully in her writing.

Marjorie Kinnan had a comfortable childhood in Washington, D.C., where her father was a lawyer in the United States Patent Office. She had an early interest in storytelling, and used to make up tales for audiences of neighborhood children. When she was sixteen, her father died, and the family moved to Madison, Wisconsin. Marjorie graduated from the University of Wisconsin in 1918, having excelled in drama and academics, and took a position in New York City as publicist and editor for the Y.W.C.A. at its national headquarters.

The next year, she married fellow writer Charles A. Rawlings. The couple moved to Rochester, New York, where Marjorie worked as a journalist and copywriter for papers including the *Louisville Courier-Journal* and the *Rochester Journal* until 1923. She also achieved modest success with a syndicated column, "Songs of a Housewife," which ran from 1925 until 1927. Cracking the fiction market proved a little more difficult.

In 1928, Marjorie Rawlings found her true love—the Florida back country—when she moved with her husband to an orange grove at Cross Creek, in north central Florida. Rawlings learned to care for the large grove, burning wood on cold winter nights to prevent the delicate trees from freezing and, in time, learning to barter with her neighbors for the help she needed on the grove. She thrived as a writer on the rich supply of local material, and proved adept at reproducing local habits and personalities in her work.

In 1930, she sold her first fiction to *Scribner's Magazine.* In 1933, she won the prestigious I. Henry Memorial award for the story "Gal Young Un," and published her first novel, *South Moon Under,* a tale of Florida moonshiners. By this time, it had become clear that Charles Rawlings was not quite as enraptured with rural Florida as his wife was, and the couple divorced. In 1941, Rawlings married Florida native Norton Sanford, but continued to write under the name Marjorie Kinnan Rawlings.

Rawlings was most successful when she stuck with her favorite material. For her second novel, *Golden Apples,* she visited England and wrote about an English protagonist. When the novel was poorly received, she returned to her rural subject matter and wrote *The Yearling* (1938), a well-loved story of a boy and a semi-tame fawn. After she moved to St. Augustine, Florida, with her second husband in 1941, she wrote a memoir of her years at Cross Creek (*Cross Creek,* 1942). The Florida Supreme Court ruled in favor of a former neighbor who cried libel when she found herself in the book, but Rawlings had to pay only an inconsequential fee.

In 1947, she bought a summer home on

She found her true love—the Florida back country—when she moved with her husband to an orange grove at Cross Creek in Florida.

a former farm in Can Hornesville, New York. Another novel, *The Sojourner* (1953), is set there. It received a rather lukewarm reception, perhaps because she was so firmly identified with the Florida setting of her best-loved stories. She died before she could carry out her plan to write a biography of novelist **Ellen Glasgow**, and was buried near Cross Creek.

TO FIND OUT MORE...

- Bellman, Samuel I. *Marjorie Kinnan Rawlings.* 1974.
- Bigelow, Gordon E. *Frontier Eden: The Literary Career of Marjorie Kinnan Rawlings.* 1966.
- Rose, Phyllis. *The Norton Book of Women's Lives.* New York: W. W. Norton & Company, 1993.
- Sicherman, Barbara, and Green, Carol Hurd, eds. *Notable American Women: The Modern Period. A Biographical Dictionary.* Cambridge, MA: The Belknap Press of Harvard University Press, 1980.

Alice Caldwell Hegan Rice, 1870–1942

The daughter of Samuel Watson Hegan and Sallie P. Caldwell Hegan, Alice Rice came from a deeply religious family. It was while working as a volunteer for her church in a run-down district of Louisville, Kentucky that she met an endearing, unconquerable old woman who was to serve as the model for the title character of her first novel, *Mrs. Wiggs of the Cabbage Patch* (1901). It became a bestseller and established Hegan as an author of popular light fiction.

The book takes a sentimental, optimistic approach to serious social problems—and can thus be seen as a forerunner of **Eleanor Porter's** later *Pollyanna* books, also widely popular. The Mrs. Wiggs of the title lives in a tough part of town (the real-life Louisville district in which Rice served was in fact known as the Cabbage Patch). Mrs. Wiggs is a widow with five children. She lives in appalling conditions and must face constant trial, trouble, and illness in her family; her eldest son dies of tuberculo-sis. The unsinkable Mrs. Wiggs smiles through it all and trusts in simple faith and unfailing good humor to carry the day. And as luck would have it, a wealthy couple engaged in a pointless spat decide to iron things out by helping the troubled Wiggs family escape the crushing poverty of the slums. The guiding principles of endurance and good humor have indeed led Mrs. Wiggs through her time of trouble to her day of deliverance. "Looks like everything in the world comes out right," she observes near the end of the book, "if we jes' wait long enough!"

While modern readers may have some misgivings about this philosophy as a recipe for social change, turn-of-the-century readers embraced Mrs. Wiggs and her unyieldingly upbeat outlook on life with great enthusiasm. The book was a huge success both in the United States and overseas. (Its American sales were aided in no small measure by Anne Flexner's popular stage adaptation.)

Shortly after the publication of her breakthrough book, Alice Caldwell Hegan married the poet Cale Young Rice, whose career took off at roughly the same time as his wife's. In coming years, the two writers put out a steady stream of books, and even a few collaborations. Alice's light fiction included *Mr. Opp* (1909), *Cavalry Alley* (1917), and *Quin* (1921), which was based on her experiences as a stateside medical volunteer during the First World War. For a time, after *Quin*, she did not write much; the royalties and income from her previous books, added with her husband's income from his writing work, allowed the couple to live comfortably in a prosperous section of Louisville. Like tens of thousands of other well-to-do citizens, however, the Rices endured a financial crisis during the Great Depression. In 1933, Alice published *Mr. Pete and Company*, one of a number of books she wrote primarily out of a need for cash. Rice died of a coronary occlusion at the age of seventy-two; her husband, profoundly shaken by his wife's passing, committed suicide shortly thereafter.

It may be tempting today to dismiss Rice's seemingly facile writings as hopelessly out of touch with reality, or, given the many unapologetically racist elements in some of her short stories, as simply irresponsible. One must remember, however, that the books for which she is remembered were notable because they threw a spotlight on serious social problems that often went undiscussed—most importantly the intolerable conditions of tenement life during the first years of the century. If she was a woman of her times, she was also a woman who cared deeply about what were, to her, obvious instances of cruelty and injustice. Rice saw her books, for all their gentle humor and unwarranted optimism, as a means of increasing public awareness and inciting action, as indeed they were.

> *"Looks like everything in the world comes out right,"* observed the title character of **Mrs. Wiggs of the Cabbage Patch,** *"if we jes' wait long enough!"*

TO FIND OUT MORE...

- James, Edward, ed. *Notable American Women, 1607–1950: A Biographical Dictionary.* Cambridge, MA: The Belknap Press of Harvard University Press, 1980.

- Unger, Leonard, ed. *American Writers: A Collection of Literary Biographies.* New York: Charles Scribner's Sons, various dates of publication.

Mary Roberts Rinehart, 1876–1958

Mary Roberts Rinehart wrote enormously popular crime fiction, blending humor and truly scary descriptions. She received fan mail from **Gertrude Stein** and Theodore Roosevelt, and became the main breadwinner in her family. Oddly enough, it was not burning ambition that propelled her to success. She first began writing her tales of murder and intrigue as a young mother, when her family's finances were pinched by a volatile stock market and extra cash was needed.

Mary Roberts and her younger sister grew up in Allegheny, Pennsylvania, where their father sold sewing machines and their mother took in boarders. Money was scarce, but Mrs. Roberts tried to keep a facade of gentility by keeping her house excruciatingly clean. Mary, inspired by a woman doctor who worked in her town, had ambitions to attend medical school, but the precocious student had to settle for nursing school in Pittsburgh. While she was away at school, her father committed suicide.

She graduated in 1896, at the age of twenty, and immediately married surgeon Stanley M. Rinehart. Nursing and a writing hobby were put aside while she was involved with the birth and early care of her three sons, born between 1897 and 1901. In 1903, however, a dip in the stock market prompted her to bring out her writing with new determination, and within a year she had placed forty-five stories. She quickly became a main source of the family's income.

She wrote her first novel, *The Circular Staircase*, in 1908. Over fifty more followed. Although they gathered an enthusiastic following, she downplayed her talent as a novelist, explaining that she was merely a "story teller." In the course of writing her light detective fiction, she created a new sub-genre of crime novel, the "had I but known" story. With their invariably happy endings and feminine heroines, Rinehart's novels proved immensely popular.

After Mary's wartime stint as a European correspondent, the Rineharts moved

to Washington, D.C., where Stanley Rinehart became his wife's full-time business manager. Mary Rinehart began to use her visibility to back causes she thought were important, arguing for economic equality between the sexes and threatening to write an exposé of the conditions of the Blackfeet Indians in Wyoming.

Rinehart tried her hand at plays as well as novels. Her 1920 play *The Bat*, written with Avery Hopwood, was made into three separate movies. With its dark, mysterious title figure and aristocratic setting, it seems a clear inspiration for Bob Kane's later creation of the popular comic book hero "Batman." In fact, there were few genres she did not attempt; she was an intensely prolific writer who had trouble finding a pen whose ink flowed as quickly as her thoughts. Novels, stories, plays and articles on diverse subjects were written with equal energy.

Her later years were saddened by a string of unfortunate incidents. Her husband died in 1932, and she left the Washington home they had shared for New York City. From 1947 to 1958, she endured the loss of her Maine house in a fire, the death of her mother in a terrible scalding accident, an attempt on her own life by the

The dark, mysterious title figure in her 1920 play, The Bat, seems a clear inspiration for Bob Kane's later creation of the comic book hero "Batman."

family cook, and a struggle with breast cancer. Undefeated, she wrote an article for the *Ladies' Home Journal* about her disease and surgery. She died in her sleep at her home in New York at the age of seventy-two. After her death, a prize for the year's best mystery novel was established in her name.

TO FIND OUT MORE...

- Cohn, Jan. *Improbable Fiction: The Life of Mary Roberts Rinehart*. Pittsburgh: University of Pittsburgh Press, 1980.

- MacLeod, Charlotte. *Had She But Known: A Biography of Mary Roberts Rinehart*. New York, NY: Mysterious Press, 1994.

- Rinehart, Mary Roberts. *My Story*. New York: Farrar & Rinehart, Inc., 1931

- Sicherman, Barbara, and Green, Carol Hurd, eds. *Notable American Women: The Modern Period. A Biographical Dictionary*. Cambridge, MA: The Belknap Press of Harvard University Press, 1980.

Ishbel Ross, 1895–1975

The kidnapping of the Lindbergh baby—and the subsequent arrest, conviction, and execution of Bruno Hauptmann. The record-setting round-the-world journey of the Graf Zeppelin. The visit of King Edward of England to the United States. The inaugurations of three Presidents. If there was a big news event that took place between 1919 and 1934, odds are good that Ishbel Ross wrote the front-page story covering it for the *New York Herald Tribune*. This was no mean feat during an era of virtually complete male domination of the nation's city newsrooms!

Ross was born in Sutherlandshire, Scotland. She attended the Tain Royal Academy, in Ross-Shire, at the age of twenty. After a stint as a publicist for a government agency, she won an assignment with the *Toronto Daily News* when she talked legendary suffragist Emmeline Pankhurst into sitting down for an interview. One of the most remarkable journalistic careers of the era had begun.

Her rise from untested rookie to reporter for one of the top papers in America was swift. By 1919 she had landed a job with the New York paper with which she would spend the next fifteen years. (Her own account holds that such jobs were relatively easy for women to come by, given the number of servicemen still in the army at the time. The mastheads of the newspapers of the day would seem to indicate otherwise.)

By all accounts, Ishbel Ross was fast, tough, accurate, and nearly impossible to stare down. One male colleague remembered her intense gaze, which, he said, "made you feel that she was sizing you up, coolly and completely." She was known as "Miss Ross" around the newsroom, and she was respected by superiors and fellow newshounds alike. One of her editors, assessing her career, observed that Ross (a colleague for a time of the legendary *Emma Bugbee*), showed "unfailing stamina on the toughest assignments."

She left reporting in 1934 with the intention of working on novels, but she found them difficult to write and received some tepid reviews for her work. In 1936, she

wrote *Ladies of the Press*, an account of early female journalists in the United States. It was well received, and she stuck to non-fiction writing from that point on.

During World War II, Ross worked with the Office of War Information; after the war, she found her stock as a writer rising faster than that of her husband, a *New York Times* reporter. After he died in 1962, Ross published as she had never published before: ten books in less than a decade in a half. They were accounts of the doings of remarkable people and families: Mary Tood Lincoln, the Taft family, Lola Montez, and others. With no academic credentials to speak of, Ishbel Ross had become an established—and popular—historical biographer. It was an exciting and rewarding phase of her career.

In 1975, Ross wrote a close friend to say that she was looking forward to celebrating her eightieth birthday; a few weeks later she died as the result of a fall from the window of her New York apartment. The police considered the death a possible suicide, a conclusion that stunned and confused the many friends of this remarkable, energetic, and ebullient woman. Did she have some motive to end her own life? No

> *She was impossible to stare down. One male colleague remembered her intense gaze, which, he said, "made you feel that she was sizing you up, cooly and completely."*

satisfactory one arose; and anyway, a good reporter would have been the first to tell you that you can't always trust the judgments of the men in blue.

TO FIND OUT MORE...

- Belford, Barbara. *Brilliant Bylines: A Biographical Anthology of Notable Newspaperwomen in America.* New York: Columbia University Press, 1986.

 - Schlipp, Madelon Golden, and Murphy, Sharon M. *Great Women of the Press.* Carbondale, IL: Southern Illinois University Press, 1983.

Muriel Rukeyser, 1913–1980

Muriel Rukeyser's verses captured the exquisite tension between the individual and the restless, ever-changing world surrounding her. Although she was a gifted writer of prose (she published a number of essays and biographies), her poetry is what earned her a reputation as one who, as a *Washington Post* reviewer put it, "leaves us with questions that open toward the future."

Sheltered as a child, Rukeyser was the daughter of a well-to-do New York couple. Hungry for experience, she seems to have determined to travel extensively as soon as practicable; she attended the Scottsboro Boys trial in Alabama in person at the age of nineteen, in what was to be the first of many such excursions to sites of important social or political events. (These were usually eventful journeys, one way or another; as a result of the trip to Scottsboro, she caught typhoid fever.) She was a brilliant writer very early in life: she published her first book of poems, *Theory of Flight*, at the tender age of 22. It received the Yale Series of Younger Poets award. In coming years, she published more than two dozen volumes of fiction, biography, criticism, translation, drama—and poetry. Major collections issued during her lifetime included *U.S. 1* (1938), *The Green Wave* (1948), *Body of Waking* (1958), *Waterlily Fire* (1962), and *Speed of Darkness* (1968). Her long, joyous, unselfconscious lines of verse have reminded more than one critic of those penned by Walt Whitman.

The feminist undercurrents (and overcurrents) in Rukeyser's work were remarkable, given the time in which she wrote, and there are connections between her poetry and such later writers as Adrienne Rich and Denise Levertov. Rukeyser also has the distinction as the person who first spotted potential in the writings of the young Alice Walker.

In addition to her poetry and prose works, Rukeyser wrote a number of evocative books for children, some scripts for film documentaries, and many privately circulated book reviews. She also wrote, in 1965, a novel, *The Orgy*.

In the preface to one of her works, Rukeyser wrote of a kind of "reaching" in

poetry that, through "unverifiable fact," helps both writer and reader "reach that place where...we all recognize the secrets." This sense of personal mystery, wonder, and unremitting action pervades the best of her work, and is one reason she has earned such a passionate following among her readers.

TO FIND OUT MORE...

- Magill, Frank N., ed. *Great Women Writers: The Lives and Works of 135 of the World's Most Important Women Writers, from Antiquity to the Present.* New York: Henry Holt, 1994.

- Obituary. *Washington Post,* January 21, 1979.

> *She wrote of a kind of "reaching" in poetry that, through "unverifiable fact," helps both writer and reader "reach that place where...we all recognize the secrets."*

Sigrid Schultz, 1893-1980

The scourge of the Nazis, the "dragon from Chicago," foreign correspondent Sigrid Schultz looked harmless enough. A mere five feet tall and blonde, with calm blue eyes, she grew up learning diplomacy and several languages in courts all over Europe. But her diplomacy would later be useful in drawing memorable quotes from Hitler's right-hand man Herman Göring at dinner parties. During the early days of the Second World War, she pretended to cooperate with German censors while secretly smuggling out stories of Nazi atrocities under a false name.

Schultz was the child of Norwegian parents, Hedwig Jaskewitz Schultz and Herman Schultz, who came to Chicago in 1893 for the World's Fair and stayed for the next seven years. Sigrid, born the year of the fair, was their only child. In 1900, Herman Schultz moved the family to Europe, where he made his living as a portrait artist whose patrons often included royalty. Sigrid attended school in Paris, graduating from the Sorbonne in 1914.

After her graduation, the Schultzes moved their base from Paris to Berlin, where they watched as the Kaiser declared World War I. While Sigrid pursued graduate work in international law and history at Berlin University, the family suffered through wartime rationing and, after America entered the war, the privations of enemy alien status. At one point, food was so scarce that Schultz became perhaps the only journalist to literally eat crow.

On her graduation in 1919, Schultz started work for the Berlin bureau of the *Chicago Tribune*. At first, she nearly got herself killed chasing down dangerous freelance assignments, but she eventually earned recognition and a staff position. For her first big scoop, an exclusive interview with the dying former president of the Weimar Republic, Schultz had herself admitted as a patient to the hospital where he was being treated.

In 1924, she became the first woman member of the board of directors of the Berlin Foreign Press Club, and the next year, at age thirty-one, she became one of the first two women (the other was the

THE REMARKABLE LIVES OF

charismatic **Dorothy Thompson**) to head a foreign bureau. As another war loomed, handling German censorship increasingly became a major problem for foreign correspondents.

Thompson got herself kicked out of the country in 1934 for a particularly negative assessment of Hitler, but Schultz was a different kind of correspondent. She was less a writer than a reporter, a tactful diplomat with a superb ability to sniff out a story. She threw dinner parties for her targets and managed to elicit startlingly brutal quotes from them. In an interview with Schultz, Hitler spoke unabashedly of himself as a sort of Messiah; at a party Schultz threw, Herman Göring described the pleasure he had felt at feeling his sword break the bones of a French soldier in the first World War. As Nazis worried more about the presence of American journalists, they concocted plots to destroy their credibility by framing them as spies. Schultz was agile enough to dodge such attempts on her credibility.

Sigrid Schultz sent her more inflammatory stories—the ones about the secret arrests and the concentration camps—to the Tribune under the pen name "John Dickson." She remained in Germany while a series called "The Truth About Nazi Germany" ran under her pen name, broadcasting heavily censored stories for WOR-Mutual. She left Germany in 1941 when she contracted typhus, but never stopped publicizing what she knew. Her book *Germany Will Try It Again* was published in 1944.

Long after the war was over, Schultz never really trusted German nationalism. In a 1977 interview, she continued to express concern about the possibility of a strong, reunified Germany. She lived out her last years in Westport, Connecticut, where she died in her home at the age of eighty-seven.

> *At one point in Berlin during World War I, food was so scarce that Schultz became perhaps the only journalist to literally eat crow.*

TO FIND OUT MORE...

- Belford, Barbara. *Brilliant Bylines: A Biographical Anthology of Notable Newspaperwomen in America.* New York: Columbia University Press, 1986.

- Schultz, Sigrid Lillian. *Germany Will Try It Again.* New York: Reynal & Hitchcock, 1944.

- Wagner, Lilya. *Women War Correspondents of World War II.* New York: Greenwood Press, 1989.

Florida Scott-Maxwell, 1883–1979

"We who are old," wrote Florida Scott-Maxwell, "know that age is more than a disability. It is an intense and varied experience, almost beyond our capacity at times, but something to be carried high. If it is a long defeat it is also a victory, meaningful for the initiates of time, if not for those who have come less far."

The woman whose writings on old age would win near-unanimous praise had an extraordinarily active early life. She was born in 1883, and her time as a young adult seems to have been lived with the objective of pursuing four or five careers in the same span of time most people manage one or two. She was an actress, a dramatist, a writer, an agitator for women's rights, and, eventually, a passionate adherent of Jungian psychology. (Indeed, she studied with Jung himself and became a psychologist at the age of fifty.)

When she was seventy, at a time when most of people have wound down their careers, Florida Scott-Maxwell set upon the most meaningful work of her life. She began keeping a remarkable journal, an extended meditation on the challenges and triumphs of the aging process. For Scott-Maxwell, the stereotypical notions surrounding growing older were the stuff of myth and legend, and had little or no basis in the actual—and essentially personal—experience of elderly life. She found that, far from descending into an inactive, ineffective stupor, she was profoundly aware and engaged in her life in her seventies and eighties. Many of her experiences, she wrote, were taking place at a heightened, concentrated level that surprised her. For Scott-Maxwell, the lifelong journey of self-discovery, as it entered its final stages, had taken on an unexpectedly colorful, informed, and even transcendent feel. She felt, as she put it, "nearer truth" as she got older, and she struggled to express the phenomenon in her journal. Often, accounting the precise experience of her surprisingly varied perceptions during old age was difficult, not

because of any imprecision on her part, but because the growth stages in which she found herself often seemed to be beyond verbal description. "It won't go into words," she wrote, "so how can I convey it? I can't, and I want to. I want to tell people approaching and perhaps fearing age that it is a time of discovery."

The journal was published under the title *The Measure of My Days*, and it was a significant contribution to the existing literature on the topic. Readers and reviewers alike were struck by the writer's ability to recount her intensely personal experience of aging and at the same time offer many wise and moving observations on growing older that seemed to have universal validity. Throughout the work, which proved to be the most important of her long career, Scott-Maxwell retained a tone of openness, inquisitiveness, and excitement on a subject that many viewed as stubbornly and unrelentingly dim. "Age puzzles me," she observed. "I thought it was a quiet time. My seventies were interesting and fairly serene, but my eighties are passionate. I grow more intense as I age."

She died in 1979, at the age of ninety-six.

> *For her, the lifelong journey of self-discovery, as it entered its final stages, had taken on an unexpectedly colorful, informed, and even transcendent feel. She felt "nearer truth" as she got older.*

TO FIND OUT MORE...

- Scott-Maxwell, Florida. *The Measure of My Days*. New York: Knopf, 1968.

- "Songs of Experience," *San Francisco Chronicle*, September 22, 1991.

Anne Sexton, 1928–1974

Poet Anne Sexton's life is often linked with **Sylvia Plath**'s. The two poets were near contemporaries, mutual admirers and competitors in the new field of "confessional" poetry—they even took a class together from fellow confessional Robert Lowell. Both suffered from mental illness, and both committed suicide. Sexton's life is unsettling, perhaps because so much is known about such intimate parts of it—she was never a particularly private person, and tapes of sessions with her therapist were made available to her biographer. If the most lurid episodes are simply listed—drug and alcohol abuse, sexual and physical abuse of her daughters, physical abuse by her husband, countless suicide attempts— she comes across as a literary witch. But between these episodes, she struggled through seemingly insurmountable odds to become a Pulitzer Prize-winning poet.

Sexton remembered her upper-middle-class Boston-area childhood as cold and oppressive. Her parents, Ralph and Mary (Gray) Harvey, seem to have been quite self-absorbed. Her mother competed with Anne, and she said in therapy that her alcoholic father molested her and criticized her adolescent acne. Her well-loved great-aunt Nana went mad and died in an institution, and Sexton felt guiltily sure that Nana's insanity resulted when she witnessed the molestation. She escaped by eloping, at age nineteen, with Alfred "Kayo" Sexton.

Anne Sexton set about acquiring the spotless life of a 1950s housewife. With her husband, a wool salesman, she settled down and had two daughters. But it was an impossible role for Sexton to maintain, and she broke down rapidly after the birth of her second daughter, Joy, in 1955. She battled for the rest of her life with addiction to alcohol and pills, including the mind-numbing Thorazine, prescribed for her illness in 1964.

She also battled with her abusive and equally alcoholic husband, and with her own destructive impulses towards her daughters and herself. She was terrified by her own violent reaction to her children's needs, and was deeply ashamed to remember incidents in which she had failed to con-

trol herself, including one in which she threw her older daughter Linda, then a toddler, across the room. She attempted suicide repeatedly.

She turned to poetry as therapy in 1956. She had been a mediocre student, and was only a high school graduate, but her sharp mind shone through her illnesses and addictions and her development as a poet was astoundingly swift once she applied herself. Like Plath towards the end of her life, Sexton tossed off poems at a rapid rate.

> Sexton was one of the premier "confessional" poets.

Both the poetry and the more traditional therapy seemed to do her little good. She continued to abuse herself with alcohol, pills, and various kinds of suicide attempts, and to pass her own suffering on to her husband and her children. One therapist slept with her during sessions (but continued to charge her the going rate for the sessions); another abruptly dropped her. There does not seem to have been a calm period during which she could recuperate, yet she continued to write poems that were much admired and widely read.

Her 1967 collection "Live or Die" won her a Pulitzer Prize. Her 1969 play "Mercy Street," which explored themes of family guilt and incest, was a hit. Her poetry was truly innovative beyond the simple feat of pouring her emotional ills out for the world to see. She was particularly notable as a poet who celebrated female sexuality, although when she wrote poems like "Menstruation at Forty" they were considered offensive. Male sexuality was an acceptable subject for literature; female sexuality was not.

When Sylvia Plath gassed herself in her oven in 1963, Sexton wrote a poem, "Sylvia's Death," in which she lamented the "thief" who found "the death I wanted so badly and for so long." She finally committed suicide successfully in 1974, two lonely years after she finally divorced her husband. She folded herself in her dead mother's fur coat and took a glass of vodka into the garage, where she started up her car. Like Plath, she has since been celebrated as a cult figure. Sexton is seen as the mad housewife-poet. But she lasted longer than Plath; she worked against the illness that finally drove her to suicide. And, in the meantime, she managed to become an artist.

TO FIND OUT MORE...

- Gilbert, Sandra M., and Gubar, Susan, eds. *The Norton Anthology of Literature by Women: The Tradition in English.* New York: W. W. Norton & Company, 1985.

- Middlebrook, Diane Wood. *Anne Sexton: A Biography.* Houghton Mifflin, 1991.

Kate Simon, 1912–1990

When asked once about the best way to enjoy a journey, acclaimed travel writer Kate Simon offered concise, straightforward advice. "Go slow," she responded. "If you have the time for eight countries, take five. If you're rushed to take five, take three." She was also an enthusiastic proponent of listening in on the conversations of strangers in public places, a practice which, she claimed, offered enormous entertainment potential and yielded a good deal of important inside information.

Such were the techniques of one of America's most successful travel writers, a woman who, in the words of the *New York Times Book Review*, turned "one of the dullest forms of literature into a brilliant work of art." Her guides were intelligent, lively, and insightful works that were often read as much for pleasure as for the hard information they contained; among her most important offerings in the category were *New York Places and Pleasures: An Uncommon Guidebook* (originally published in 1959, but updated several times), *Italy: The Places in Between* (1970, updated in 1984), and *England's Green and Pleasant Land* (1974). *Publishers Weekly* described her travel books as "distinctly personal guides of rare good taste and discernment." They were the elite entries in the genre—and they sold with the speed of mainstream successes.

Simon also wrote two acclaimed memoirs, *Bronx Primitive* (1982) and *A Wider World* (1986). In the former, she recalled her difficult childhood; in the latter, her often tempestuous adolescence. Taken together, the two make up an intimate and involving account of the immigrant experience (Simon was born in the Warsaw ghetto, and her family moved to New York when she was a young girl). A third volume of personal reminiscences, *Etchings in an Hourglass*, was published posthumously in 1990. Of *Bronx Primitive*, the *Christian Science Monitor* said, "Simon invests the stuff generic to childhood—school, play, sibling rivalry, parents—with new meaning, (and) forces imagery from her early years into photographlike clarity."

This engaging, gifted writer, whose tal-

ent was making readers feel that they themselves had experienced firsthand what she had, received awards from the National Book Critics Circle, the English Speaking Union, and Hunter College. She died of cancer at her Manhattan home on February 5, 1990, at the age of seventy-seven.

TO FIND OUT MORE...

- Simon, Kate. *Bronx Primitive: Portraits in a Childhood.* New York: Viking Press, 1982.

- Simon, Kate. *Etchings in an Hourglass.* New York: Harper & Row, 1990.

- Simon, Kate. *A Wider World: Portraits in an Adolescence.* New York: Harper & Row, 1986.

- Yang, Marianne Cristine. *From Ethnicity to a Wider World: The Education of Kate Simon.*

- Obituary. *The New York Times,* February 5, 1990.

She was an enthusiastic proponent of listening in on the conversations of strangers in public places, a practice which, she claimed, offered enormous entertainment potential and yielded a good deal of important inside information.

Agnes Smedley, 1892–1950

Agnes Smedley was an unusual sort of woman in the twenties and thirties. A student of radical politics and Asian culture, she brought her irrepressible personality and new-fangled ideas into Mao Tse-Tung's China in 1928. While there, she wrote several books and countless pro-China articles for American publications, marched with the Red Army and taught Mao to square dance.

She learned square dancing as a child in the rural Midwest. She was born into poverty in Missouri, one of five children of a miner and tenant farmer whose main recreation was drinking. Agnes's overworked mother took in boarders and laundry to bring in money. Agnes, who took a series of jobs to help support the family— cigar factory worker, washerwoman—never finished grade school. When Agnes was sixteen, her mother died, and Agnes left her family to look for better work. She was able to take stenography classes in Denver, and found secretarial jobs; finally, in 1911, she re-entered school at the Normal School in Tempe, Arizona.

She married a fellow student there and went with him to California, but the relationship was unhappy and resulted in two self-induced abortions and divorce. But important in the long run was the education in socialism she got from university friends in California, including labor novelist Upton Sinclair. In 1917, she moved to New York City, where she worked for a magazine, took classes at New York University, and became involved with the anti-British Indian Nationalist movement and Margaret Sanger's birth control movement.

From 1920 to 1928, Agnes Smedley lived in Germany, where she helped found the first German birth control clinic, taught English, studied Asian culture, and worked for the Indian Nationalist cause with her unofficial husband, Virendranath Chattopadhyaya (Chatto). During this time, she underwent psychoanalysis and became convinced that sexual freedom was essential. The price of her publicly proclaimed intention to "wear no man's collar" would often be public censure and vicious rumors about her promiscuity.

THE REMARKABLE LIVES OF

She left Chatto and Berlin in 1928, crossing the Soviet-Manchurian border into China for the start of an unparalleled career as America's most devoted champion of Chinese communism. She started out as a special correspondent for a German paper, but soon broke off to write her own freelance articles and a book, *China's Red Army Marches*, which was published in New York in 1934. When the Sino-Japanese War began in 1947, Smedley joined the Red Army to fight against the Japanese.

Smedley was a colorful presence in their mountain camp. Convinced that the army's top brass needed a boost in morale, she taught a group of them to square dance to tunes from her childhood: "She'll be Comin' Round the Mountain" and "On Top of Old Smokey." She also advised Mao in romantic matters, urging him to pursue an actress on whom he had a crush. Unfortunately, Mao's wife heard about the situation and got into a tussle with Smedley. Smedley won, but in the end all three women were removed from the camp. Smedley also organized medical centers and acted as a liaison with the Red Cross.

As a writer, her success waxed and waned with shifts in American prejudices. During the early forties, her book *Battle Hymn of China* was enormously popular since the Chinese were then considered American allies. After the war, however, growing anti-Communist sentiment made Smedley a figure of some suspicion. Her deep commitment to Chinese communism was seen as un-American, and Smedley was accused of acting as part of a Soviet spy ring. The charges were ultimately dropped, but the damage to her reputation was permanent. Embittered by her rejection and weakened by her increasingly poor health, Smedley confided to friends that she saw "no hope in sight" for either herself or the country of her birth. She died in England in 1950. Her tombstone in Peking's National Memorial Cemetery of Revolutionary Martyrs reads: "To Agnes Smedley, friend of the Chinese Revolution."

> *She taught top Red Army brass to square dance.*

TO FIND OUT MORE...

- James, Edward T., ed. *Notable American Women: 1607–1950: A Biographical Dictionary*. Cambridge, MA: The Belknap Press of Harvard University Press, 1971.

- MacKinnon, Janice R. *Agnes Smedley: The Life and Times of an American Radical*. Berkeley: University of California Press, 1988.

- Zhao, Yifan. *Agnes Smedley: An American Intellectual Pilgrim in China*. Ph.D. Dissertation, Harvard University, 1989.

Lillian Eugenia Smith, 1897–1966

Not many white Southern women of her time were audacious enough to tackle in print such topics as segregation and the prejudice against interracial relationships, but Lillian Smith was. She wrote about what she knew best—the South and its confusion over racial and sexual taboos. Her progressive principles raised the hackles of her fellow Southerners, and more than once her publications resulted in personal hardship for Smith. But she was a woman who stuck by her guns.

She was born in 1897 and grew up in a fundamentalist Florida family. Smith became quite close to her African-American nurse—even while being taught that the nurse's race made her a lesser human being. Smith attended Piedmont College until 1916, studied briefly in Maryland, and eventually returned to Georgia to manage the summer camp that her parents, who had grown ill, could no longer manage. In 1936 she started the magazine that would come to be known *The North Georgia Review*. It was the first white southern journal to publish the literary and scholarly efforts of blacks.

Her first novel, *Strange Fruit* (1944), which explored some of the tensions in her part of the country through a daring account of an interracial love relationship, was banned for "obscenity" not in the South, but in the Northern state of Massachusetts. (Only Eleanor Roosevelt's intervention kept censors from barring it from the mail throughout the country.) A second book, *Killers of the Dream*, was an unflinching attack on Southern segregation. Together the two books made her name—which had both positive and negative consequences. On the positive side, Smith's works were quite popular, and led to a wave of requests for lectures and articles. On the negative side, many Southerners considered her a traitor to her own people. Three times during her career, suspicious fires consumed files and irreplaceable manuscripts.

Later books failed to reach the wide

THE REMARKABLE LIVES OF

and appreciative audience of *Strange Fruit* and *Killers of the Dream*. To make matters worse, Smith was diagnosed with breast cancer in the early fifties and had to undergo surgery. Her 1959 novel *One Hour*, a veiled attack on McCarthyism, was apparently intended as a major comeback. It did not, however, receive anything like the success of *Strange Fruit*.

Smith was a strong adherent of nonviolent struggle in the struggle for civil rights. This stand won her the admiration of Dr. Martin Luther King, Jr., but led her to disassociate herself from the Congress of Racial Equality (CORE), on whose board she served for years, when that organization began to take a more militant stance in the late sixties.

Lillian Smith died of cancer before she could complete her autobiography, which one close associate felt would "have been (among) her major, deeply felt and pondered works." Certainly an account of the life of this principled, courageous Southerner, who endured the bitter enmity of the culture that had raised her for most of her adult life, would have been a fascinating volume. The two biographies that follow are perhaps the next best thing

Strange Fruit explored some of the tensions in the South through a daring account of an interracial love relationship; it was banned for "obscenity" not in the South, but in the northern state of Massachusetts.

for those interested in learning more about this remarkable woman.

TO FIND OUT MORE...

- Blackwell, Louise. *Lillian Smith*. New York: Twayne Publishers, 1971.

- Smith, Lillian Eugenia. *How Am I to Be Heard?: Letters of Lillian Smith*. Chapel Hill: University of North Carolina Press, 1993.

- Loveland, Anne. *Lillian Smith: A Southerner Confronting the South*. Baton Rouge: Louisiana State University Press, 1986.

- Sicherman, Barbara, and Green, Carol Hurd, eds. *Notable American Women: The Modern Period. A Biographical Dictionary*. Cambridge, MA: The Belknap Press of Harvard University Press, 1980.

Jean Stafford, 1915–1979

Although she was the daughter of one writer about the West and the cousin of another, Jean Stafford had no desire to become known as a "regional writer" of fiction. Her intricate, finely crafted short stories, many of which feature alienated adolescent protagonists, were set in a variety of locations and were issued in such collections as *Children are Bored on Sunday* (1953) and *Bad Characters* (1964). Her important novels include *Boston Adventure* (1944), *The Mountain Lion* (1948), and *The Catherine Wheel* (1952). In 1969, *The Collected Stories of Jean Stafford* won the Pulitzer Prize.

Born in Covina, California in 1915, Stafford spent a good portion of her youth in Colorado. After receiving her undergraduate degree from the University of Colorado in 1936, she studied at Heidelberg, taught briefly in Missouri and Iowa, and settled on the East Coast, where she wed the poet Robert Lowell. The marriage ended in divorce, as did her subsequent one to Oliver Jensen. In 1959, she married *New Yorker* columnist A.J. Liebling; he died in 1963.

One of Stafford's ongoing themes was that of illness—she incorporated it into a good number of her stories, and often let sickness or disability serve as a metaphor for a character's moral instability. Many of her supporting characters try to capitalize on their physical or psychological obstacles by portraying themselves as victims as a means of exploiting others. Typically, her innocent (and often naive) protagonists must find a way to escape from the influence of corrupt, overbearing, and downright menacing figures—many of whom take undue advantage of their handicaps or limitations.

Intolerant of elitism and snobbishness, Stafford often took the opportunity to portray haughty people as neurotic, disingenuous, or both. High-class Europeans, in particular, tend to come off rather badly in her stories; this may be the result of some of her own experiences in Europe.

In addition to her novels and short stories, Stafford wrote several books for children, including a retelling of the Arabian Nights stories (*Arabian Nights: The Lion and the Carpenter and Other Tales*, 1959).

THE REMARKABLE LIVES OF

She also conducted an extensive interview with the mother of Lee Harvey Oswald, published in book form as *Mother in History* (1966).

After the death of A.J. Leibling in 1963, Stafford took part less and less in the doings of the literary scene in which she had established herself. She settled in Springs, Long Island, and became something of a recluse. Jean Stafford died in White Plains, New York on March 26, 1979.

TO FIND OUT MORE...

- Roberts, David. *Jean Stafford: a Biography*. London: Chatto & Windus, 1988.

- Magill, Frank N., ed. *Great Women Writers: The Lives and Works of 135 of the World's Most Important Women Writers, from Antiquity to the Present*. New York: Henry Holt, 1994.

> *Sickness or disability often served as a metaphor for a character's moral instability. Many of her supporting characters try to capitalize on their physical or psychological obstacles by portraying themselves as victims as a means of exploiting others.*

Gertrude Stein, 1874–1946

Gertrude Stein, writer and critic, looms larger than life in stories of the expatriate artists who populated Paris in the early part of this century. A self-declared "genius," she was part of the group, including F. Scott Fitzgerald and Ernest Hemingway, that she memorably dubbed the "Lost Generation." She was one of the first to identify the importance of works by artists like Picasso, Matisse, and Cézanne, and her often difficult prose works are sometimes said to recall abstract art.

Stein was an omnivorous reader as a child in her family's Oakland, California home, devouring poetry and Congressional records alike. She was devoted to her nearest sibling, Leo, and after the death of their father in 1891 (Stein's mother had died three years earlier, when Gertrude was fourteen) she followed Leo to Harvard University. Studying at the Annex (later Radcliffe College), she took classes in philosophy from George Santayana and in psychology from William James. She followed Leo again back to Baltimore, where (with James's encouragement) she studied for an M.D. at Johns Hopkins. Two years later she quit, perhaps partly because of an unhappy three-way love affair with Mabel Haynes and May Bookstaver that she later recorded in the prose work *Q.E.D. or Things as They Are* (1950).

In 1902, she followed Leo to Italy, and a year later they settled in Paris, where they shared rooms at 27 Rue des Fleurus. The Steins were visionary art collectors who befriended the artists whose work they bought. Picasso painted Gertrude in 1906. Meanwhile, she began to write, developing techniques which sought to intensify experience. Her prose is often repetitive—the same phrase, occasionally slightly reworded, often echoes through a piece in order to underline an impression. Her three stories *The Good Anna*, *Melanctha*, and *The Gentle Lena*, good examples of this technique, were published in her 1909 book *Three Lives*.

Stein's proofreader for *Three Lives* was **Alice B. Toklas**, a fellow Californian who soon took Leo's place as the primary figure in her life and as her roommate at 27 Rue des Fleurus. They forged a 40-year re-

THE REMARKABLE LIVES OF

lationship that has been characterized as the epitome of a relationship between an artist and a self-sacrificing wife. Toklas gave Stein loving support, taking on the several roles of editor, secretary, housekeeper, fan, and devoted companion. Stein's formidable ego flourished under Toklas's care. She undertook original and sometimes remote poetry and prose works, some of which remained unpublished until Toklas started *The Plain Edition Press* to distribute them.

Stein is best remembered for her remarkable relationship with Toklas and her place in the art world. Her writing is notable for its boldly experimental nature, and was not always popular. Stein herself often seemed imposingly present in her own works. Her most famous work, *The Autobiography of Alice B. Toklas* (1933), is written in Toklas's voice (although it is more concerned with Stein, who is referred to as a "genius," than Alice) and based on their life together. In the *Autobiography,* Stein's Toklas discusses their famous acquaintances and Stein's literary and artistic influence.

The *Autobiography* was commercially successful and helped gain Stein a measure of celebrity. She had lectured at Oxford and Cambridge Universities in the 1920s. After the publication of the *Autobiography,* Stein was in demand both as an author and as a lecturer in the United States as well. She never did return to the country of her birth, however, and died in 1946 in the American Hospital at Neuilly-sur-Seine. Although Toklas was instrumental in building Stein's reputation, she was not herself a celebrity and lived another lonely two decades, lovingly maintaining Stein's estate. She was eventually pushed out of their famous Paris apartment by Stein's family, and died in poverty in 1967. She was buried alongside Stein in Paris.

> **Stein and Alice B. Toklas forged a 40-year relationship that has been characterized as the epitome of a relationship between an artist and a self-sacrificing wife.**

TO FIND OUT MORE...

- Gilbert, Sandra M., and Gubar, Susan. *The Norton Anthology of Literature by Women.* New York: W. W. Norton & Company, Inc., 1985.

- Lord, James. *Six Exceptional Women: Further Memoirs.* Farrar, Straus & Giroux, 1994.

- Rood, Karen Lane, ed. *The Dictionary of Literary Biography: American Writers in Paris, 1920–1939.* Detroit, MI: Gale Research Co., 1980.

- Rose, Phyllis, ed. *The Norton Book of Women's Lives.* New York: W. W. Norton & Company, 1993.

- Unger, Leonard, ed. *American Writers: A Collection of Literary Biographies. Volume IV.* New York: Charles Scribner's Sons, 1974.

Ruth Suckow, 1892–1960

Born in 1892 in the tiny town of Hawarden, Iowa, Ruth Suckow, the daughter of a Congregationalist preacher, passed a strict but loving childhood on the plains of America's heartland. In 1912 she left the Iowa college at which she had spent three years to spend two more at a special acting program in Boston; she returned to Iowa and earned her undergraduate degree in 1917.

Her ambitions for an acting career, however, passed; Suckow had hopes of becoming a poet, but quickly turned to fiction as the major focus of her creative efforts. She published her first story in 1921, and, at the urging of her editor, sent copies of her work to H.L. Mencken. He took an instant liking to her style. Publication of many new pieces followed, and her first collection of stories was issued in book form in 1926. It was called *Iowa Interiors*, and it established Suckow as a serious writer.

She published three novels in rapid succession: *The Bonney Family* (1928), *Cora* (1929), and *The Kramer Girls* (1930). Each followed the efforts of independent young midwestern women to establish their own identities in the face of the demands of relatives and friends. She was writing, in short, what she knew. In 1934, five years after she married critic and writer Ferner Nunn, Suckow published her major work: a novel called *The Folks*.

The story concerns the Ferguson family of Iowa, and chronicles the challenges and changes they face during the first tumultuous decades of the century. Suckow won praise for her ability to balance a strong assemblage of personal stories with the insight and scale of historical fiction. Her portraits of Iowans, rendered with love, detail, and sublime understanding of the causes underlying their unions and sunderings, reached their maturest expression in this book. Her later works included *New Hope* (1942), which also explored the lives of Iowans.

In 1936, Suckow was tapped by President Roosevelt to work on the Farm Tenancy Committee; her husband did work for the Department of Agriculture. When Europe erupted in war at the end of the decade, however, she found herself on the

opposite side of the political fence from the President. Both Suckow and her husbands were staunch pacifists, and she eventually joined him as a member of the Society of Friends. During World War II, she made a number of appearances in support of conscientious objectors. In the years after the war, partly as a reaction to her deteriorating health, she relocated with her husband to Arizona.

Suckow's literary output in the years following *The Folks* was not great. Her last novel, *The John Wood Case*, was released in the year before her death. She died at the age of sixty-seven on January 23, 1960.

TO FIND OUT MORE...

- Kissane, Leedice McAnelly. *Ruth Suckow*. New York: Twayne Publishers, 1969.

- Sicherman, Barbara, and Green, Carol Hurd, eds. *Notable American Women: The Modern Period. A Biographical Dictionary*. Cambridge, MA: The Belknap Press of Harvard University Press, 1980.

> *Three of her novels followed the efforts of independent young midwestern women to establish their own identities in the face of the demands or relatives and friends. She was writing what she knew.*

May Swenson, 1919–1989

A lesbian poet who came of age in the 1940s, May Swenson paid her dues as a struggling writer during the Depression, then worked in publishing until the age of forty-six, when she finally was able to concentrate exclusively on her poems. Swenson was the eldest in a large Mormon family in Logan, Utah. Her father worked at the state university as a professor of mechanical engineering. Swenson's first move after school was to Salt Lake City, where she worked for a time as a reporter for the *Deseret News*. Utah, however, was not the place for Swenson's poetic urgings, and she soon fled the West to move to New York City.

In New York, Swenson struggled with poverty and poetry for years before landing a job in 1959 as an editor for *New Directions*, a cutting-edge publishing house. She accumulated many rejection notes before getting some collections of poetry published. By 1960, however, she had won enough of a reputation as a poet to quit her job at *New Directions* and rely on fellowships to support her writing.

Romantically, Swenson's life was turbulent. After several volatile relationships, Swenson found her lifetime companion, R. Rozanne Knudson. Knudson became Swenson's literary executor and eventually published a biography of her.

Evocative poems such as "Year of the Double Spring" recounted sexual situations with her female partners, and won a place in the emerging postwar literary explosion, in which a number of lesbian writers were finally being heard. Swenson's poems often avoided the first person pronoun in favor of a second person viewpoint ("our breasts"); the technique made her erotic work seem less didactic and more joyous. As much as she celebrated physical love, Swenson knew it was a fleeting experience—and thus worthy of a near-religious intensity and respect. Her rapturous celebrations of the act of coming into contact with another human being are moving and sublime.

Swenson also won praise for her innovative use of typography as a means of elucidating the subject of her poetry. She said that one of her objectives was to provide

poetry with "an existence in space as well as time." Another important subject of her work was nature, for her treatment of which she won praise from the poet **Elizabeth Bishop**: "(Swenson is) one of the few poets who write good poems about nature...not just comparing it to states of mind or society." In 1987, near the end of the poet's life, *The Nation* praised her approach to this subject in the following terms: "Swenson sees the natural world with startling precision and, at the same time, endows it with a magical radiance...(In) her apprehension of common things....she discloses sacred presences."

TO FIND OUT MORE...

- Knudson, R. Rozanne. *The Wonderful Pen of May Swenson.* New York: Macmillan, 1993.

- Gilbert, Sandra M., and Gubar, Susan, eds. *The Norton Anthology of Literature by Women: The Tradition in English.* New York: W. W. Norton & Company, 1985.

- Article, *The Nation,* December 26, 1987.

As much as she celebrated physical love, she knew it was a fleeting experience—and thus worthy of a near-religious intensity and respect. Her rapturous celebrations of the act of coming into contact with another human being are moving and sublime.

Genevieve Taggard, 1894–1948

The daughter of missionaries who had been assigned to work in the Hawaiian Islands, Genevieve Taggard spent most of her youth in the tropical paradise of Oahu. She took to writing early, perhaps as a reaction against the strictures of her orthodox parents. When, in 1914, the family moved back to the mainland after several Hawaiian postings, Taggard enrolled at the University of San Francisco. She indulged her passion for poetry, studying under Witter Bynner and Leonard Bacon. In her final year, she was named editor of the prestigious *Occident* literary magazine, and came into her own as both a writer and a young adult.

Of her decision to cast off, at long last, her domineering mother's influence, she wrote, "Am I the Christian gentlewoman my mother slaved to make me? No indeed. I am a poet, a wine-bibber, a radical." In the same year, *Harper's Magazine* printed her poem "An Hour on a Hill." It was her first national magazine publication; there were many more to come.

In 1921, she moved to New York and became one of the founders of the poetry journal *The Measure*. After her marriage to writer Robert L. Wolf, Taggard published her first volume of poems, *For Eager Lovers*, which was very well received. Taggard gave birth to a daughter, Marcia, in 1922; her marriage to Wolf ended in 1934. In 1935 she married Kenneth Durant, an employee of the Soviet news agency Tass. (It is probably no coincidence that the marriage took place at about the same time Taggard's perceptions of the social injustices of the capitalist system began to emerge.) From 1935 until 1946, when she began to experience health problems arising from high blood pressure, Taggard taught at Sarah Lawrence College. She lived at Gilfeather, a Vermont farm not far from the town in which her grandfather had once lived.

Taggard's books of poetry included *May Days* (1925), *Travelling Standing Still* (1928), and *Calling Western Union* (1938). This last collection reflected her growing in-

terest in liberal politics and progressive movements. Taggard also published important books in the fields of poetry criticism and biography: *Circumference: Varieties of Metaphysical Verse, 1456–1928* (1929) and *The Life and Mind of Emily Dickinson* (1930).

William Rose Benet said that Taggard's poems exhibited "shy irony, the genuine mirth, the 'scorn of scorn'." The musicality of her work inspired such composers as Aaron Copland and Henry Leland Clarke to produce musical accompaniments for her poems. Whether they took the form of the deeply personal observations of an independent young woman or the socially conscious musings of a gifted and involved social critic, her verses were relentlessly original and infused with the spirit of life.

> *William Rose Benet said that her poems exhibited "shy irony, the genuine mirth, the 'scorn of scorn'." The musicality of her work inspired Aaron Copland and Henry Leland Clark to produce musical accompaniments for her poems.*

Taggard died in New York at the age of fifty-three.

TO FIND OUT MORE...

- James, Edward, ed. *Notable American Women, 1607–1950: A Biographical Dictionary.* Cambridge, MA: The Belknap Press of Harvard University Press, 1980.

- Unger, Leonard, ed. *American Writers: A Collection of Literary Biographies.* New York: Charles Scribner's Sons, various dates of publication.

Ida M. Tarbell, 1857–1944

"**M**uckrakers" was the name that Theodore Roosevelt gave journalists of the early part of the 20th century who exposed abuses in American business and government. Ida Tarbell, one of the original muckrakers, was able to help shut down the Standard Oil Company monopoly that had hampered her father's efforts in the oil industry in Pennsylvania. Standard Oil founder John D. Rockefeller, irked by her stinging exposé, dubbed her "Miss Tarbarrel."

Ida Tarbell was born in a log cabin on a farm in Erie County, Pennsylvania. She was still very young when the family moved to Rouseville to take advantage of Pennsylvania's budding oil industry. Her father was the first to set up a shop that produced the wooden tanks the oil businesses needed. In school, Ida became fascinated by her science classes. She majored in biology at Allegheny College, but on her graduation in 1880—the only woman in a class of forty—found little to challenge her and was forced to support herself by teaching.

After two disappointing years at Ohio's Poland Union Seminary, Tarbell came home to Pennsylvania and took a low-level position at the monthly *Chautauquan*, a teaching supplement for home study courses. By 1886 she had her own by-line and was the *Chautauquan*'s managing editor. In 1891, however, she had grown restless. She left Pennsylvania to do graduate work in French Revolution-era women's history. In Paris, Tarbell wrote articles for American papers and magazines to pay for her living expenses. Her series on Napoleon for *McClure's Syndicate* gained both Tarbell and *McClure's* wide acclaim. The series was published as a book in 1895, and was a commercial success. A similar series on Abraham Lincoln was also successfully published as a book in 1900.

Around the time the Lincoln series was wrapping up, Tarbell began to do some research for a series on Standard Oil, the company which had created a virtual monopoly in the Pennsylvania oil industry. When she was still a student, her father had suffered losses because of Standard Oil's dubious business dealings. Partly motivated

by her memories, she uncovered a long-standing arrangement between Standard Oil and the local railroads that gave Standard Oil enormous breaks on freight prices. Other refiners, hamstrung by high freight costs, couldn't compete with Standard and were driven out of business.

The sixteen-part series ran from 1901 until 1904, when it was published as a book. It attracted quite a bit of attention as a rather sensational indictment of the trust-ridden national oil industry (not just Standard Oil). It also brought attention to the court case against Standard Oil, which ended with a Supreme Court decision that set a new antitrust precedent. Goaded partly by the public reaction to Tarbell's and other journalists' muckraking, Congress passed a Congressional bill that established a Department of Commerce and a Bureau of Corporations.

The principal members of the staff of *McClure's* reorganized in 1906 to take over *The American Magazine*. Tarbell continued to attack trusts by showing that the United States tariff system often benefitted companies to the detriment of employees and consumers. Her 1911 book *The Tariff in Our Time* gained her the attention of President Woodrow Wilson, who in 1916 asked her to

> *Standard Oil founder John D. Rockefeller, irked by her stinging expose of the oil industry, dubbed her "Miss Tarbarrel."*

serve on the Federal Tariff Commission. She declined in order to continue writing.

After 1915, a large part of Tarbell's schedule included the lecture circuit. She became interested in the peace effort, serving on many committees. She continued to write and to teach biography, and she published on a wide range of topics into her eighties, including a 1926 interview with Benito Mussolini and an autobiography, *All In the Day's Work*, in 1939. She died at eighty-six on her farm in Connecticut.

TO FIND OUT MORE...

- Brady, Kathleen. *Ida Tarbell: Portrait of a Muckraker.* New York: Seaview/Putnam, 1984.

- Kochersberger, Robert C., ed. *More than a Muckraker: Ida Tarbell's Life in Journalism.* Knoxville, TN: University of Tennessee Press, 1994.

- Schlipp, Madelon Golden and Murphy, Sharon M. *Great Women of the Press.* Carbondale, IL: Southern University Press, 1983.

Dorothy Thompson, 1893–1961

Political columnist Dorothy Thompson was once paid the dubious compliment of being told that she had the "brains of a man." She responded, "Which one?" She was the subject of a 1939 cover story in *TIME* magazine which declared her one of the two most influential women in the world. The other woman was Eleanor Roosevelt. She was, along with **Sigrid Schultz,** one of the first two American women to head a foreign news bureau, and her passionately opinionated and widely read syndicated column, "On the Record," made her one of the most important journalists—of either sex—in her day.

Thompson's first fourteen years were spent in Lancaster, New York. Her mother died when Dorothy was seven, and her father, an English-born Methodist minister, married the church organist. Dorothy immediately locked horns with her stepmother, and at fourteen was sent to private school in Chicago. There was little money for college, so she took advantage of a scholarship at Syracuse College for the children of Methodist ministers and made up the rest of

her living expenses with menial jobs, waiting tables, working in a candy factory, and selling encyclopedias door to door.

On her graduation with honors in 1914, Thompson worked for the suffrage movement in Buffalo, then moved to exciting Greenwich Village in New York City. After six years of social service, copywriting, and dreaming of becoming a foreign correspondent, she had saved up $150 for a trip to Europe. In 1921, she had her first major scoop: an interview with the exiled Hungarian emperor just as he failed in a second attempt to recapture his throne. Other journalistic triumphs followed, and in 1924—four years after her arrival in Europe—Thompson was made the Berlin bureau chief for the *New York Evening Post* and the *Philadelphia Public Ledger*.

A 1922 marriage to Hungarian writer and playboy Josef Bard failed when he proved unable to remain faithful, and in 1927 she married celebrated novelist Sinclair Lewis, and moved with him to Twin Farms, a 300-acre estate near Barnard, Vermont. They had one child, Michael, in 1930, and

for a while Thompson referred affectionately to Lewis as "The Grouse" in her column. Although he was a powerful writer in his own right—he was the first American to win the Nobel Prize in literature—Lewis eventually became resentful of his wife's success and commitment to her work. His alcoholism and insecurity contributed to the breakup of the marriage in 1942, and he drank himself to death eight years later.

Meanwhile, Thompson had found a cause in the growing Nazi threat in Germany. A passionate and early anti-Nazi, she nevertheless won a rare interview with Hitler in 1931. Her attacks on him in her articles led to her expulsion from Germany in 1934; later, she proudly displayed the document ordering her removal in a frame on her desk. In 1933, she disrupted a rally of 22,000 American Nazis in Madison Square Garden with her loud, derisive laughter. She had to be escorted out by New York policemen.

Her column "Let the Record Speak," which ran from 1936 to 1958, made her a somewhat controversial figure. She was called a warmonger when she argued for American involvement in World War II in the late thirties, and after the war many papers dropped the column when she criticized the Zionist movement for uprooting Arab inhabitants of the land that became Israel.

> *A passionate and early anti-Nazi, she nevertheless won a rare interview with Hitler in 1931, after which her attacks on him led to her expulsion from Germany.*

Although her popularity waned in the final years of her career, her personal life was boosted by her 1943 marriage to artist Maxim Kopf. The happy marriage ended with his death in 1958, and Thompson finally folded her column that same year. In the farewell installment of "Let the Record Speak," she wrote, "I don't believe in regrets. I have written objectively and honestly." She died three years after Kopf and was buried next to him in Barnard, Vermont. She had chosen the epitaph for her tombstone: "Writer."

TO FIND OUT MORE...

- Kurth, Peter. *American Cassandra: The Life of Dorothy Thompson.* Boston: Little, Brown, 1990.

- Belford, Barbara. *Brilliant Bylines: A Biographical Anthology of Notable Newspaperwomen in America.* New York: Columbia University Press, 1986.

- Schlipp, Madelon Golden, and Murphy, Sharon M. *Great Women of the Press.* Carbondale, IL: Southern Illinois University Press, 1983.

- Sanders, Marion K. *Dorothy Thompson: A Legend in Her Time.* Boston: Houghton Mifflin, 1973.

Alice B. Toklas, 1877–1967

If the list of writers who made a literary splash with their first book is comparatively short, the one featuring those who caused a critical sensation in the world of letters by offering a *cookbook* as their first published effort can safely be said to contain a single name: Alice B. Toklas. Published in 1954, eight years after the death of her celebrated lifetime companion **Gertrude Stein**, *The Alice B. Toklas Cookbook* was not only a compilation of the various recipes Toklas and Stein had enjoyed with such figures as Ernest Hemingway, Pablo Picasso, Henri Matisse, Man Ray, and Dora Maar, but also an insider's recollections of the happenings in their legendary Paris salon during the twenties and thirties. Toklas's book is, in its own way, the perfect artifact of the couple's life together; much of its appeal is in its recreation (both culinary and otherwise) of the extraordinary atmosphere of their apartment at 27 rue de Fleurus in the Montparnasse district. Like Stein—the undisputed lead partner in the relationship, and the subject of most of the reminiscences in the cookbook—Toklas's first published work is unpredictable, opinionated, and relentlessly original. (One of the recipes was for hashish fudge, not exactly mainstream cuisine in the mid-fifties.)

One of the most celebrated relationships in twentieth-century literature began in the autumn of 1907, when Toklas met Stein on the night she arrived in Paris. Toklas had left the stifling confines of her San Francisco family life in search of a new mode of looking at life, and she certainly found these in abundance in the brilliant, complex writer and art collector with whom she was to share her life. The two moved in together in 1909.

It is no overstatement to say that Stein's justly praised literary career would have been impossible without Alice B. Toklas. The "wife" in this celebrated partnership—which was, unless the word "marriage" carries no meaning whatsoever, clearly among the strongest and most inspiring marriages in literary history—Toklas was Stein's untiring supporter and advocate, and an unflagging source of domestic support. Alice Toklas served not only as

Stein's protector, personal secretary, critic, and advance woman, but also as her publicist and business manager. She appears to have turned a small profit as a one-woman publishing entrepreneur whose sole mission was the distribution and sale of Stein's work. Both before and after Stein's death, Toklas was her famous partner's most energetic promoter.

Toklas provided Stein with the persona she used to write her first—and biggest—success, *The Autobiography of Alice B. Toklas* (1933). (It was in fact most notable as a collection of Stein's own autobiographical musings.) During Gertrude Stein's lifetime, Toklas never presumed to intrude on her partner's territory by writing a book; after the publication of the *Cookbook*, however, she produced a number of articles, a second cookbook, and a collection of reminiscences about Stein, *What Is Remembered*. This had begun as a *real* autobiography of Alice B. Toklas, and was initiated in concert with the writer Max White, but Stein's presence in Toklas's discussions of the past was so overwhelming that he eventually gave up on the project. Secretaries and associates pitched in to help

> **The Alice B. Toklas Cookbook *is the perfect artifact of her life with Gertrude Stein, recreating the extraordinary atmosphere of life in their Paris apartment. Relentlessly original, one of the recipes in it was for hashish fudge.***

complete the book.

Toklas died in 1967, having converted to Catholicism. Her friends reported that she did this in the hope of meeting Stein in the afterlife.

TO FIND OUT MORE...

- Magill, Frank N., ed. *Great Women Writers: The Lives and Works of 135 of the World's Most Important Women Writers, from Antiquity to the Present.* New York: Henry Holt, 1994.

- Rood, Karen Lane, ed. *Dictionary of Literary Biography: Volume Four. American Writers in Paris, 1920–1939.* Detroit, Michigan: Gale Research Company, 1980.

- Sicherman, Barbara, and Green, Carol Hurd, eds. *Notable American Women: The Modern Period. A Biographical Dictionary.* Cambridge, MA: The Belknap Press of Harvard University Press, 1980.

- Simon, Linda. *The Biography of Alice B. Toklas.* Garden City, NY: Doubleday, 1977.

Eleanor Van Wagoner Tufty, 1896–1986

J ournalist Eleanor Tufty was once mistaken for a European duchess, and the name stuck ever since. With her coronet of gold (later silver) braids, her pince-nez glasses, and her bright cloaks, "The Duchess" certainly had an air of royalty. She was a much-loved figure in Washington journalism for nearly sixty years, covering every President from Franklin D. Roosevelt to Ronald Reagan.

Eleanor Van Wagoner was born in Kingston, Michigan, and grew up in nearby Pontiac. She was still a teenager when she graduated from high school and went to work at the Pontiac Press, where she earned $7.50 a week as an assistant society editor. Van Wagoner worked her way through college at the University of Wisconsin, where she met Harold Tufty. They were married within months of her graduation, and had two sons together. Apparently the marriage did not turn out so well: Long after the couple was divorced, Eleanor Tufty cracked, "I've been in three wars, not counting marriage."

Esther Tufty was the managing editor of a paper in Evanston, Illinois before deciding on a big move in 1935 to Washington, D.C. where she opened up the Tufty News Service. Originally, the tiny operation had only twenty-six clients—small Michigan newspapers—but in Tufty's fifty years at the helm of the company, its client base swelled to over 300 papers. In Washington, Tufty made a name for herself as a determined reporter and a leader. Younger women journalists later cited her as a role model for them, as a woman who successfully managed both her children and a career.

During the Roosevelt administration, Tufty was one of the first women to cover the White House, along with **Doris Fleeson** and **Elisabeth May Craig**. The Roosevelt years were convivial for women journalists. Eleanor Roosevelt, who counted journalist **Lorena Hickok** among her close friends, made a point of holding some press conferences for women

reporters only—a practice that she hoped would promote the position of women in journalism. In press club skits, Tufty perfected an impersonation of Franklin D. Roosevelt that reportedly stunned Secret Service agents at a White House party.

Over fifty years in Washington, Tufty had more than her share of adventures. During Thomas E. Dewey's 1944 run for President, she was injured when a campaign train crashed. She covered World War II and the wars in Korea and Vietnam. When the Soviets blockaded Berlin after World War II, she perched on top of ten tons of coal in a plane airlifting supplies to the city in order to get in. Even in less extreme situations, Tufty was known as a go-getter. During the Democratic convention of 1952, she climbed on top of a table—in front of a national television audience—to get the attention of the person she wanted to interview.

Her leadership was recognized in the sixties when she became the first woman to head three national organizations for women in the media: American Women in Radio and Television, the American Newspaper Women's Club, and the Women's National Press Club. She continued to run the

> *Known as a go-getter, she once climbed on top of a table in front of a national television audience to get the attention of the person she wanted to interview.*

Tufty News Service out of her office in the National Press Building in Washington until only a few months before her death, although its client base had dropped back down to the original twenty-six by 1978.

In her final years, she was widely assumed to be the oldest working reporter in a city filled with reporters. She died in Alexandria, Virginia at the age of eighty-nine. After her death the Washington, D.C. chapter of American Women in Radio and Television created an award in her name for a woman broadcaster who excels as a communicator and a leader in community service.

TO FIND OUT MORE...

- Hunter, Marjorie. "They Call Her the Duchess." *The New York Times*, October 21, 1982.
- Obituary. *Chicago Tribune*, May 6, 1986.
- Obituary. *Los Angeles Times*, May 8, 1986.
- Obituary. *The New York Times*, May 5, 1986.
- Obituary. *The Washington Post*, May 5, 1986.
- White, Jean M. "The Old Guard of the New Deal." *The Washington Post*, March 6, 1978.

Yoshiko Uchida, 1920–1992

The vast majority of the 29 books Yoshika Uchida wrote during her forty-two year literary career were for children—but don't assume that they lacked important content or challenging themes. Of her work, the *New York Times* observed, "(Ms. Uchida) does not hold back from painful truths." Her writings were strong statements against racism and compelling accounts of the (often tragic) Japanese-American story. They gave their readers a sense of what is possible in the face of seemingly overwhelming obstacles, and offered a sense of heritage and history to young Japanese-Americans.

Her tales, although concerned with the Japanese-American experience, held universal appeal. "I hope my books will enlarge and enrich the reader's understanding of the human condition," Uchida wrote, "for I feel we must not only take pride in our special heritage—we must also strive to understand each other and to celebrate our common humanity."

Uchida published *The Dancing Kettle and Other Japanese Folk Tales* in 1949;

over the next years, she brought forth a number of other works for young people, including *Journey to Topaz* in 1971 and *Journey Home* in 1978. These two books dealt sensitively but straightforwardly with the topic of internment of Japanese-Americans during World War II. In each book, Uchida won strong emotional involvement by focusing her stories through the eyes of youngsters whose lives were changed forever by the wartime relocation. (The strong emotional content of her stories was based in all-too-real personal experience; Uchida's own family had been victims of the U.S. government's relocation policies.)

In one of her most moving tales, "A Jar of Dreams," two Japanese-American children are chased by a hateful bigot who, in an effort to persuade their mother not to start a small laundry business, kills the family dog. If such episodes seem incomprehensible today, they were brutally real to those who lived through the experience of state-tolerated racism. (Commenting on this particular story, the *New York Times* observed that "the Anti-Japanese Laundry

THE REMARKABLE LIVES OF

League was a fact of San Francisco life for several decades.")

In the later phase of her career, Uchida began to write for adults. Among her notable entries in this category were *Desert Exile* (1982) and *Picture Bride* (1987). In 1991, she published her autobiography, *The Invisible Thread*. During her long and productive career, Yoshiko Uchida received numerous awards, among them the Sequoyah Children's Book Award and the William Allen White Award, as well as honors from the Commonwealth Club of California and the American Library Association. Many of her works are listed on the California Recommended Reading list, a sign of the high esteem in which she was held in her native state. She died in Berkeley, California, the town in which she spent much of her childhood, on June 21, 1992.

> *Based on personal experience, Uchida won strong emotional involvement by focusing her stories through the eyes of Japanese-American youngsters whose lives were changed forever by U.S. relocation policies during World War II.*

TO FIND OUT MORE...

- Uchida, Yoshiko. *Desert Exile: The Uprooting of a Japanese-American Family.* Seattle: University of Washington Press, 1982.

- Obituary. *San Francisco Chronicle,* June 28, 1992.

- Obituary. *Los Angeles Times,* June 17, 1992.

- Obituary. *Atlanta Journal and Constitution,* June 25, 1992.

- Obituary. *New York Times,* June 24, 1992.

Mary Marvin Heaton Vorse, 1874–1966

Journalist and writer Mary Heaton Vorse was an unlikely radical. Born into wealth and gentility, her life changed in 1911 when she heard a commotion outside her Greenwich Village apartment. The noise turned out to be the cries of a horrified crowd that had gathered around the Triangle Shirtwaist Factory, a notorious sweatshop. The building was on fire, and Vorse watched helplessly as 146 people—mostly immigrant women in their teens and twenties—jumped or fell to their deaths or perished in the flames. As it turned out, management had routinely locked the doors to keep the workers in. The tragedy galvanized Vorse, who became a tireless advocate for the worker through her passionate writing.

The only child of Hiram and Ellen Heaton, Mary Marvin Heaton was born in New York City. Mary came late into her parents' lives; Ellen Heaton had much older children from a previous marriage and Hiram Heaton was retired when his daughter was still a child. Mary dutifully pursued the proper accomplishments of a young lady of her stature: schooling in Europe, art classes in Paris. In 1898, however, she left home and family to marry Albert Vorse, a bohemian writer and boat lover.

The couple owned a house in Provincetown, Massachusetts, and the town quickly became dear to Mary Heaton Vorse. She began raising two sons and writing light pieces—she called them "lollypops"—and in 1908 published her first book, *The Breaking in of a Yachtsman's Wife*. Later, on her enthusiastic recommendation, Provincetown became a mecca for New York artists and writers. The group that followed her there formed the Provincetown Players, which first staged Eugene O'Neill's plays. But her idyllic life was disrupted when, on the same day in 1910, both her husband and her mother died. Her family's wealth had been based in California real estate, and the 1906 earthquake there had left her without much of an inheritance. Vorse turned to writing seriously now as a means of support for

herself and her young children.

Suddenly thrust into the role of middle-class working mother, she had a new appreciation for those who managed with less income. She divided her time between her home in Provincetown and work in New York and on the road. She attended her first strike in 1912, reporting for *Harper's Weekly* on the Lawrence, Massachusetts conflict at the textile mills. From the start, she did not claim to be a dispassionate observer; her first pro-labor article on Lawrence cost *Harper's* advertising from the American Woolen Company. She reported on labor struggles across the country until 1959.

> *Suddenly thrust from her idyllic life into the role of middle-class working mother, she had a new appreciation for those who managed with less income.*

Two other marriages turned out badly. A wonderful romance with journalist Joe O'Brien was cut short by his early death, leaving her with a third child. Communist Party official Robert Minor left her after she miscarried after only two years of marriage, plunging her into a long depression. Meanwhile, she continued writing her relatively lucrative fluff fiction to support the family, turning out short stories and novels along with her more politically charged articles on strikes. In 1930, she produced a hybrid of her two genres in *Strike!*, a fictionalization of some of her experiences.

Vorse continued working until she was in her late eighties. In 1959, she was still on the road, taking a bus to North Carolina to cover yet another textile workers' strike. Even after she had for all intents and purposes retired to her beloved Provincetown, she continued to write almost until her death at the age of ninety-one.

TO FIND OUT MORE...

- Garrison, Dee. *Mary Heaton Vorse: The Life of an American Insurgent.* Philadelphia: Temple University Press, 1989.

- Sicherman, Barbara, and Green, Carol Hurd, eds. *Notable American Women: The Modern Period. A Biographical Dictionary.* Cambridge, MA: The Belknap Press of Harvard University Press, 1980.

- Vorse, Mary Heaton. *A Footnote to Folly: Reminiscences of Mary Heaton Vorse.* New York: Arno Press, 1980.

- Whitman, Alden, ed. *American Reformers.* New York: The H. W. Wilson Company, 1985.

Ida Bell Wells-Barnett, 1862–1931

W riter Ida Wells-Barnett was one of the most prominent African-Americans of her time. Like Rosa Parks, who in 1955 refused to give up her seat in the whites-only section of an Alabama public bus, Wells-Barnett defied a regulation segregating public transport. When she was roughly removed from a train in Tennessee, she filed suit against the railroad; the incident was a turning point, and this trailblazing woman soon began working to expose the many other inequalities facing black Americans. Her writings shone a spotlight on issues that would, a few decades hence, become causes of national outrage: lynchings and unequal education.

Ida Bell's maternal grandfather had been a Native American. She herself was born a slave in Holly Springs, Mississippi, the eldest of eight children. She managed to obtain a good grammar-school education at local Rust College, where her father became a trustee after he was freed. When her parents and some of her younger siblings fell victim to a local epidemic of yellow fever, she lied about her age (she was only fourteen) and found a teaching job to support her remaining brothers and sisters.

Several teaching jobs later, at twenty-two, she clashed with railroad officials when she refused to sit in the coloreds-only section of a Tennessee train. Although she won her suit against the railroad, the Tennessee Supreme Court overturned the decision three years later. Meanwhile, the publicity arising from this incident inspired her to write a string of articles for church papers. One of these, a sharp indictment of the inferior education offered African-American children in segregated public schools, got her fired from her teaching job in 1891.

Undaunted, Ida Wells used her savings to buy a one-third interest in a Memphis paper, the *Free Speech and Headlight*, and became its editor. When, in 1892, three of her acquaintances were lynched, she used the newspaper to protest their brutal deaths, and began looking into other episodes of

THE REMARKABLE LIVES OF

lynching, publishing her findings. Soon afterwards, while she was on a trip to Philadelphia, a mob destroyed the offices of the *Free Speech*. Wells herself was warned never to return to Memphis.

She took her antilynching work to New York, writing for the *New York Age* and helping to found antilynching societies. She worked in other cities as well, organizing antilynching activists in Chicago and lecturing in London. In 1895, she came out with a history of lynching, *A Red Record*, that included statistics on the lynchings of the previous two

She was an early and tireless anti-lynching agitator.

years. That same year, she slowed the pace of her work to marry Ferdinand Lee Barnett, Illinois's first African-American assistant state attorney.

In 1913, Wells-Barnett became the first woman probation officer in Chicago's municipal courts. In 1916, she marched at the head of her suffragist club, demanding a suffrage plank in the platform at the Republican National Convention. She also continued her anti-violence work, writing and speaking out against mob attacks. Less than a month after she wrote a letter to the *Chicago Tribune* warning against the potential for racial violence that summer, a riot injured hundreds and killed about forty people.

Like her contemporary Mother Jones,

Ida Wells-Barnett was an uncompromising idealist who was willing to fight for her convictions. She sided with W.E.B. DuBois against the more conservative Frederick Douglass, who preached compromise. After helping to found the National Association for the Advancement of Colored People (NAACP) in 1910, she distanced herself from the organization because she felt that it was too willing to acquiesce to white conditions and limitations. Her stance was not always popular, as was evident when she lost her 1930 bid for the state senate, but always provocative. Six decades after her death at the age of sixty-eight, her ideas, then radical, seem visionary.

TO FIND OUT MORE...

- Belford, Barbara. *Brilliant Bylines: A Biographical Anthology of Notable Newspaperwomen in America.* New York: Columbia University Press, 1986.

- Dannett, Sylvia G.L. *Profiles of Negro Womanhood. Volume II: 20th Century.* Yonkers, NY: Educational Heritage, Inc., 1966.

- Schlipp, Madelon Golden and Murphy, Sharon M. *Great Women of the Press.* Carbondale, IL: Southern Illinois University Press, 1983.

- Wells-Barnett, Ida. *Crusade for Justice.* Chicago: University of Chicago Press, 1970.

- Whitman, Alden, ed. *American Reformers.* New York: The H.W. Wilson Company, 1985.

Edith Newbold Jones Wharton, 1862–1937

Edith Wharton won praise for her ironic, finely crafted studies of New York society life as it established itself in the opening decades of the twentieth century. Her unerring feel for character development, her treatment of complex moral issues, her subtle descriptive touches, and her remarkable sense of detail led to some of the finest American fiction of the era.

Born Edith Newbold Jones in New York in 1862, she was the daughter of an elite family and the recipient of a top-level private education. She married a prosperous Boston banker named Edward Wharton in 1885; unfortunately, Edward, an unstable and less than brilliant man, suffered from mental illness after the first few years of the marriage, which was marked by long periods of separation. Years later, when she had settled permanently in France, Wharton obtained a formal divorce.

Wharton's stories sometimes show the strong influence of the writer Henry James, who was a close friend. Her voice, while it would always remind some critics of that of James, was, as a rule, intimately linked to a distinct subject matter that was uniquely her own. By the time of her confident novel *The House of Mirth* (1905), she had developed a mature style—and a command of her subject matter that other authors would envy for decades to come. Her extremely popular 1911 novella *Ethan Frome*, a departure from form, focused not on elite New Yorkers but rural New Englanders. *The Age of Innocence* (1920), however, showcased Wharton at her best, writing about the milieu from which she herself sprang: upper-class New York society. In this work, as in so many others before and after it, Wharton examined the cruelties and limitations of established social convention, and detailed the ethical implications of personal choices made for financial reasons. The novel is considered by many to be a masterpiece; it won her the 1921 Pulitzer Prize.

Although some of her best work concerns female characters trapped within mar-

riages that make social, but not emotional or sexual, sense, it would be a mistake to read too much current feminist theory into Wharton's work. The comings and goings of progressive movements were not of immense interest to this gifted writer. Her flair was the chronicling of social manners and conventions, and the accompanying constriction endured by those who must deal with difficult moral issues from within the confines of strict social roles.

A prolific writer, Wharton did not limit herself to fiction, but also wrote travel books, poetry, and literary criticism. Among her important fictional works are the novels *The Valley of Decision* (1902), *The Custom of the Country* (1913), *Hudson River Bracketed* (1929) and *The Gods Arrive* (1938), and the short story collections *Xingu and Other Stories* (1916), *Certain People* (1930), and *Ghosts* (1937).

Unlike Henry James, Wharton was able to achieve broad commercial success during her career. Praise for her work from critical corners was often quite strong, although it seems to have diminished after the unqualified triumph of *The Age of Innocence*. Today she is considered, despite the perceived

> *Although some of her best work concerns female characters trapped within marriages that make social, but not emotional or sexual sense, it would be a mistake to read too much current feminist theory into her work.*

unevenness of some of her later work, to be among the most important American novelists.

Wharton continued writing well into her seventies; she died in France after a brief illness on August 11, 1937.

TO FIND OUT MORE...

- Dwight, Eleanor. *Edith Wharton: An Extraordinary Life.* New York: Abrams, 1994.

- Lewis, Richard. *Edith Wharton: A Biography.* New York: Harper & Row, 1975.

- Magill, Frank N. *Great Women Writers: The Lives and Works of the World's Most Important Women Writers, from Antiquity to the Present.* New York: Henry Holt, 1994.

Elinor Hoyt Wylie, 1885–1928

She often seemed as striking for her eccentric demeanor and otherworldly beauty as for her writing, but Elinor Wylie's well crafted, resonant, and articulate verses were what won her a place with such eminent poets of the era as Sara Teasdale and **Amy Lowell**. She was born in Somerville, New Jersey in 1885 to a prestigious family that later moved to Washington D.C.; she lived the life of private schools and coming-out parties, and journeyed to Europe as a young woman. She married a well connected admiral's son while she was still relatively young, and found herself unhappy in marriage. In 1910 she ran off with a man named Horace Wylie, leaving her young son with Wylie's parents. It was the scandal of the city (her husband committed suicide two years later), but Horace opened Elinor's eyes to the world of literature and poetry.

The couple returned to the United States in 1915 and were married in 1916; the marriage, as it turned out, did not last, but she kept his last name in her literary work. In the late teens and early twenties, Elinor Wylie busied herself with writing and with cultivating friendships with other writers, notably Sinclair Lewis and William Rose Benet. (She married Benet in 1923.) Her first major collection of poems was *Nets to Catch the Wind* (1921). *Black Armour* (1923) followed, and these two volumes were well enough received for Wylie to secure a position as *Vanity Fair's* poetry editor. She wrote a good deal of fiction during this period, as well, including *Jennifer Lorn* (1923), *The Venetian Glass Nephew* (1925), and *Orphan Angel* (1926). *Jennifer Lorn*, in particular, was well received by critics and mainstream readers. Many critics, however, consider her fiction to be of lesser literary stature than her poems. (The novels did, however, pay a good deal better than the poetry did.)

The most mature volume of poems released during her lifetime, *Trivial Breath*, was published in 1928. These were the verses of a disciplined, clear-thinking writer whose life had touched both despair and resolve. Wylie's acceptance of mortality, her revelry in the world of physical things that

pass from the earth, is both compassionate and informed by a strange happiness that underlies the collection. Her final collection, *Angels and Earthly Creatures* (1929), features a series of nineteen sonnets (the so-called "One Person" section) that constitute a series of technically brilliant meditations on a new and all-consuming love encountered late in life. They came from her heart; she was apparently embarking on a new affair when she completed the manuscript.

She would enjoy neither the man's ongoing love nor the thrill of seeing her greatest work published. Wylie had suffered from high blood pressure for years; complications arising from a serious fall combined with the hypertension, and she suffered a stroke in October of 1928. She died in New York on December 16 of that year.

> *Her final collection features meditations on a new and all-consuming love encountered late in life. They came from her heart; she was apparently embarking on a new affair when she completed the manuscript.*

TO FIND OUT MORE...

- Gray, Thomas Alexander. *Elinor Wylie.* New York: Twayne Publishers, 1969.

- Hoyt, Nancy. *Elinor Wylie: The Portrait of an Unknown Lady.* Westport, CT: Greenwood Press, 1977.

- Olson, Stanley. *Elinor Wylie: A Life Apart: A Biography.* New York: Dial Press, 1979.

- Unger, Leonard, ed. *American Writers: A Collection of Literary Biographies. Supplement I, Part 2.* New York: Charles Scribner's Sons, 1979.

Anzia Yezierska, 1880–1970

Yezierska, a former sweat shop laborer and laundry worker whose fiction dealt with the difficult New York Jewish immigrant experience she herself knew, was born in the Polish village of Plinsk. She was the daughter of Bernard Yezierska, a down-at-the-heels Talmudic scholar, and his wife Pearl, who emigrated with their large family to the United States sometime in the 1890s. She attended public school for a short period of time, then went to night school and won entry to Teachers College at Columbia University in 1900. Yezierska's first published story was "The Free Vacation House" (1915), which chronicled the humiliating treatment afforded the city's poor by charitable institutions; "The Fat of the Land" (1919) dealt with a family's alienation upon reaching the United States, and won the O'Brien Prize as the most distinguished short story of the year.

Her first collection of stories, *Hungry Hearts* (1920), caught the attention of Hollywood mogul Samuel Goldwyn, who bought the movie rights to the book. A film based on the stories came out in 1922. Although

Yezierska made an attempt to relocate to Hollywood, California did not suit her, and she ultimately declined the opportunity to write the screenplay herself, preferring to return to New York and write fiction. But life would never be the same; she found herself alienated from both elite New York society and the humble tenement life she had struggled to escape. Much of her later writing would concern itself with the feeling of rootlessness and the implications of the struggle for, and possession of, financial security.

Another collection of stories, *Children of Loneliness*, appeared in 1923. Her novel *The Bread Giver* (1925) offered a portrait of the daughter of an immigrant father's attempts to escape from both her father's way of looking at life and the crushing poverty of her new country. Other important works of fiction include *Arrogant Beggar* (1927) and *All I Could Never Be* (1932). During the 1930s, Yezierska worked with the WPA's Writer's Project. The books she published were met with a good deal of enthusiasm, but there followed a long period of profes-

sional and critical decline.

Her work had been popular primarily in the 1920s, during a time when she and the people about which she was writing were both engaged in a passionate struggle to obtain social and economic acceptance as members of the American mainstream. Some later readers found her style forced and hackneyed, but there was an emotional validity to her stories that resonated powerfully for audiences of a particular time and place. Her later years were active; she offered the autobiographical *Red Ribbon on a White Horse* in 1950, as well as other reminiscences and essays on her own experience of aging. She published a short story, "Take Up Your Bed and Walk" shortly before her death. Yezierska's early work, for which she is best known, may not have aged well, but it is a vivid, heartfelt link to an important period in American history.

> *She felt alienated from both elite New York society and the humble tenement life she had struggled to escape. Her later writing concerned itself with rootlessness and the struggle for financial security.*

TO FIND OUT MORE...

- Henriksen, Louise Levitas. *Anzia Yezierska: A Writer's Life*. New Brunswick: Rutgers University Press, 1988.

- Sicherman, Barbara, and Green, Carol Hurd, eds. *Notable American Women: The Modern Period. A Biographical Dictionary*. Cambridge, MA: The Belknap Press of Harvard University Press, 1980.

- Anne Roiphe. "How I Found America," *Los Angeles Times*, September 8, 1991.

Marguerite Yourcenar, 1903-1987

She won fame as a novelist, but the prolific writer Marguerite Yourcenar also composed poetry, essays, interviews, short stories, plays, an autobiography, and just about everything else that had vaguely to do with letters being set down on paper for publication. The first woman ever elected to the Academie Francaise, Yourcenar's erudite, classically structured historical novels were widely praised during her lifetime. The most notable of these novels, *Memoires d'Hadrien* (*Hadrian's Memoirs*), took over twenty-five years to write. Although her efforts were numerous, she tended to grant them as much time as she felt was necessary for them to develop.

Her mother died just a few days after Marguerite's birth in 1903; her father raised and educated her at home. Not surprisingly, the two became quite close; as a Christmas present, he subsidized her first book, *Le Jardin des Chimeres*. After her father's death, Yourcenar's literary efforts became more intense. The first of her major novels,

Alexis, appeared in 1929; there followed *La Nouvelle Eurydice* (1931), *Denier du Reve* (1934), and *Le Coup de Grace* (1939). Then, in 1951, *Memoires d'Hadrien*.

Hadrien, which takes the form of a letter written by the second-century Roman emperor to a youthful Marcus Aurelius, deals in large measure with the connections between love and hate. The emperor's beloved, the youth Antinous, commits suicide. Has he done so in order to prolong the emperor's life in some mystical way, as the ritual of the act indicates—or does he destroy himself as a lover's final condemnation? Or perhaps, does Antinous manage both efforts at the same time? The dense, intricate, and exhaustively researched novel—which won praise from critics and scholars alike—pursues important questions having to do with the acceptance of mortality, the battle against the self, the nature of friendship, and the role of love in human affairs. It is hugely ambitious, which is really no surprise given the subject matter and the

amount of time the author lavished on it. The real-life Hadrian was an imposing and complex figure in both personal and historical terms; much of the novel's achievement lies in its convincing portrayal of its multifaceted protagonist and his many struggles.

Yourcenar's body of work is, like her most famous protagonist, multifaceted and ambitious; her novels often had multiple themes and purposes, and yet they usually exhibited a strong sense of internal connection and clarity. It is perhaps fitting, then, that Yourcenar chose to entitle her autobiography *Labyrinthe du Monde* (*The Labyrinth of the World.*). She may well have seen her time on earth as a puzzle-journey of sorts (even her pen name was an anagram of the family name Crayencour). Certainly, she seems to have taken a peculiar joy in scouting out the solutions to some of the more massive and intricate problems of human affairs—and incorporating these answers into intricately wrought structures that sometimes took her decades to complete. The literary paths she laid out, whose walls seemed composed of equal parts erudiction, perfectionism, and titanic effort, offer great rewards to those who journey them to their exit point.

> *She may well have seen her time on earth as a puzzle-journey of sorts: Her pen name was an anagram of the family name Crayencour, and her autobiography was entitled* **The Labyrinth of the World.**

TO FIND OUT MORE...

- Magill, Frank N. *Great Women Writers: The Lives and Works of 135 of the World's Most Important Women Writers, from Antiquity to the Present.* New York: Henry Holt, 1994.

- Savigneau, Josyane. *Marguerite Yourcenar: Inventing a Life.* Translated by Joan E. Howard. Chicago: The University of Chicago Press, 1993.

Index by Occupation

Autobiographers
Louise Bogan
Margaret Bourke-White
H. D. (Hilda Doolittle)
Rheta Louise Childe Dorr
Ellen Anderson Gholson Glasgow
Josephine Herbst
Shirley Hardie Jackson
Audre Lorde
Louella Parsons
Kate Simon
Gertrude Stein
Ida M. Tarbell
Alice B. Toklas
Yoshiko Uchida
Anzia Yezierska

Biographers
Gertrude Franklin Horn Atherton (fictionalized)
Natalie Clifford Barney
Catherine Shober Drinker Bowen
Alice Brown
Rheta Louise Childe Dorr
Lorena Hickok
Ishbel Ross (historical)
Muriel Rukeyser
Genevieve Taggard

Book publisher
Mary (Caresse) Phelps Jacob Crosby (poetry)

Book reviewer
Margaret C. Anderson

Children/young adult book authors
Margery Williams Bianco
Catherine Shober Drinker Bowen
Margaret Wise Brown
Emma Bugbee
Inez Lenore Haynes Gillmore Irwin
Eve Merriam
Muriel Rukeyser
Jean Stafford
Yoshiko Uchida

Children's book editor
Margaret Wise Brown

Comic fiction writer
Dawn Powell

Critics
Margery Williams Bianco
Louise Bogan
Mary McCarthy
Dorothy Parker (drama)
Louella Parsons (film)
Gertrude Stein
Genevieve Taggard (poetry)
Edith Wharton (literary)

Diarists/Journal writers
Anäis Nin
Florida Scott-Maxwell

Essayists
Natalie Clifford Barney
Gwendolyn B. Bennett
Margery Williams Bianco
Louise Bogan
Alice Brown
Willa Cather
Rheta Louise Childe Dorr
Elizabeth Merriwether Gilmer (Dorothy Dix)
Lorraine Hansberry
Audre Lorde
Mary McCarthy
Katherine Anne Porter
Dawn Powell
Muriel Rukeyser
Gertrude Stein
Ida M. Tarbell
Anzia Yezierska
Marguerite Yourcenar

Food writers/cookbook authors
Laurie Colwin
Mary Frances Kennedy Fisher
Alice B. Toklas

Fictionalized biographer
Gertrude Franklin Horn Atherton

Historians
Lillian Hellman
Inez Lenore Haynes Gillmore Irwin

Literary advisor
Elizabeth Garver Jordan

Literary editor (magazine)
Jessie Redmon Fauset

Magazine publishers
Margaret C. Anderson
Lillian Eugenia Smith

Magazine editors/managing editors
Willa Cather
Elizabeth Garver Jordan
Marianne Moore

Magazine feature writers/columnists/interviewers
Mary Hunter Austin
Djuna Barnes
Janet Flanner

Nature book author
Florence Merriam Bailey

Newspaper columnists
Winifred Black Bonfils
Elisabeth May Adams Craig
Alice Dunbar-Nelson
Elizabeth Merriwether Gilmer (Dorothy Dix)
Marguerite Higgins
Louella Parsons
Marjorie Kinnan Rawlings

Newspaper editor
Anne O'Hare McCormick

Newspaper reporters/correspondents (incl. foreign, war)
Nellie Bly
Winifred Black Bonfils

Emma Bugbee
Elisabeth May Adams Craig
Rheta Louise Childe Dorr
Edna Ferber
Doris Fleeson
Mildred Gilman Wohlforth
Josephine Herbst
Lorena Hickok
Marguerite Higgins
Peggy Hull
Elizabeth Garver Jordan
Anne O'Hare McCormick
Cabriela Mistral
Ruth Baldwin Cowan Nash
Marjorie Kinnan Rawlings
Mary Roberts Rinehart
Ishbel Ross
Sigrid Schultz
Agnes Smedley
Ida M. Tarbell
Dorothy Thompson
Eleanor Van Wagoner Tufty
Mary Marvin Heaton Vorse
Ida Bell Wells-Barnett

Nonfiction book authors

Mary Hunter Austin
Lillian Hellman
Peggy Hull
Anne O'Hare McCormick
Anäis Nin
Ishbel Ross
Sigrid Schultz
Agnes Smedley
Ida M. Tarbell

Novelists

Gertrude Franklin Horn Atherton
Djuna Barnes

Margery Williams Bianco
Catherine Shober Drinker Bowen
Kay Boyle
Alice Brown
Peark Buck
Willa Cather
Laurie Colwin
Jessie Redmon Fauset
Edna Ferber
Janet Flanner
Mildred Gilman Wohlforth
Ellen Anderson Gholson Glasgow
Susan Glaspell
Caroline Gordon
Josephine Herbst
Fannie Hurst
Zora Neale Hurston
Inez Lenore Haynes Gillmore Irwin
Shirley Hardie Jackson
Elizabeth Garver Jordan
Nella Larsen
Margaret Laurence
Frances Marion
Mary McCarthy
Carson McCullers
Mourning Dove
Anäis Nin
Flannery O'Connor
Dorothy Parker
Sylvia Plath
Eleanor Porter
Katherine Anne Porter
Dawn Powell
Marjorie Kinnan Rawlings
Alice Caldwell Hegan Rice
Mary Roberts Rinehart
Muriel Rukeyser
Lillian Eugenia Smith
Jean Stafford

Ruth Suckow
Mary Marvin Heaton Vorse
Edith Wharton
Elinor Hoyt Wylie
Anzia Yezierska
Marguerite Yourcenar

Photojournalist
Margaret Bourke-White

Playwrights
Djuna Barnes
Edna Ferber
Susan Glaspell
Lorraine Hansberry
Lillian Hellman
Georgia Douglas Camp Johnson
Carson McCullers
Eve Merriam
Josephine Peabody
Mary Roberts Rinehart
Marguerite Yourcenar

Poets
Djuna Barnes
Natalie Clifford Barney
Gwendolyn B. Bennett
Elizabeth Bishop
Louise Bogan
Kay Boyle
Alice Brown
Mary (Caresse) Phelps Jacob Crosby
H. D. (Hilda Doolittle)
Alice Dunbar-Nelson
Susan Glaspell
Georgia Douglas Camp Johnson
Audre Lorde
Amy Lowell
Anne O'Hare McCormick

Carson McCullers
Eve Merriam
Josephine Miles
Edna St. Vincent Millay
Gabriela Mistral
Marianne Moore
Dorothy Parker
Josephine Peabody
Sylvia Plath
Muriel Rukeyser
Anne Sexton
Gertrude Stein
May Swenson
Genevieve Taggard
Edith Wharton
Elinor Hoyt Wylie
Marguerite Yourcenar

Political columnists
Doris Fleeson
Dorothy Thompson

Publicist
Alice B. Toklas

Regionalized fiction writer
Alice Brown

Screenwriter
Frances Marion

Short story writers
Djuna Barnes
Gwendolyn B. Bennett
Kay Boyle
Alice Brown
Wila Cather
Laurie Colwin

HB 12 Z